W9-BYA-907

40 Days of Dating

Timothy Goodman & Jessica Walsh

ABRAMS, NEW YORK

PREFACE

One day in December of 2012, frustrated and disappointed with our love lives, we came up with the idea for an experiment. We had been good friends and peers in the graphic design world for years, and we were constantly surprised by how consistent our opposite relationship problems were. Based on the adage that it takes forty days to change a bad habit, we decided that "dating" each other for forty days, even though our relationship had always been platonic, would force us to explore our issues and maybe even break our own bad love habits. At the beginning of the experiment, we established six rules designed to enforce this emotional and physical investment in each other during the forty days, such as filling out a daily questionnaire, keeping a journal, and seeing a couple's therapist once a week. We thought that if we could carry this out with as much sincerity as possible, then maybe we could not only help ourselves, but potentially create a larger dialogue to help the many others out there, who, like us, are looking for love.

We did not make the decision to create the 40 Days of Dating blog until after our experiment. In the blog, we shared what we each had recorded in our journals while we were dating, which most sane people would never reveal to the world. Well, neither of us was prepared for the fact that the project would go viral, or that we would be featured in major news media all over the world. Suffice it to say, it's been an amazing journey!

One of the many positive outcomes of the blog is the book you now hold in your hands.

While this book contains the entire blog, it is so much more than that. We reveal, for the first time, everything that went on between us after the experiment, and after we launched the blog. We talk about everything that led up to the blog, going back to our childhoods and our parents' relationships and how they affected us. We asked lots of other people to tell us their own relationship stories—how they met the love of their life, how love fits into their life (or not), their worst dates—it's all here. We also added an extra layer to the blog, in the margins, that contains our personal remarks on each other's entries. Finally, there's a ton of new art throughout the book and other good stuff we thought you might appreciate.

This project has become a real labor of love for us, and we hope you get as much out of it as we have. It has been an incredible trip, as you will see, even the difficult, awkward, and weird parts. In many ways, *40 Days of Dating*—the book—is nothing like you might expect: It's honest, raw, funny, sad, but at the same time full of hope. While some dismissed the blog as a side-effect of the too-much-information generation, many more have been loyal followers of our journey—hating to love it, loving to hate it, or just simply loving it. You be the judge—and we hope you enjoy!

— *Tim + Jessie*

DON'T BE PARALYZED -BY- MAYBES!

When (we) WERE young

Relationship patterns are a little like fingerprints—we all have them and each is utterly unique. Like it or not, we're all shaped in one way or another by our families, our childhoods, our upbringing. Here's a snapshot of where we came from, who we were long before we met, and how we became friends over the years. It may provide some insight into our relationship struggles.

OUR PAST

Jessica Walsh

What were you like as a child? I was a curious and inquisitive child with an active imagination. Among close family and friends I was confident, outspoken, and boisterous. My mom called me "Monkey," as I was always climbing and jumping on things, exploring the outdoors, looking for my next adventure. At home I was assertive and confident, but around new people I was timid and reserved. Being very shy made it difficult to make new friends, and I often felt like an outsider in school. I was also the black sheep in my family: the artistic, sensitive, intuitive child in a family of rational-minded left-brained thinkers.

What memories do you have of your parents? When my mother was pregnant with me, my parents quit their jobs and started a software company together. I grew up with their business. I watched throughout my childhood as their hard work and perseverance paid off. My parents taught us to focus on what we want and go after it. They told us to never settle and never give up. I think this approach has affected my outlook in many areas of life, including dating.

Who were your heroes or role models when you were a child? I always saw my parents as perfect role models whom I should aspire to. They had a successful marriage and a successful business. They had great friends and family and were always great parents to us. But while I admired them, I was also intimidated by them. I sometimes worried if I'd ever live up to their success. I spent a lot of time trying to please and impress them when I was younger.

Were your parents strict? At times when I was younger I felt frustrated by how involved my parents were. I was jealous of my friends who had no after-school commitments or had laid-back parents who set no curfews.

Looking back, I feel lucky I had parents who cared so much. They loved us, looked out for us, and truly wanted the best for us. I think in many ways they just wanted us to have all the experiences and opportunities they couldn't afford growing up.

What did you want to be when you grew up? When I was very young it was clear my passion was in art. I loved to draw and paint, but I never imagined I could make a career out of it. I always assumed it would be

Timothy Goodman

What were you like as a child? Growing up in Cleveland, Ohio, in a family of modest means, I learned how to be scrappy as a youngster. When I was seven years old I'd spend hours building things with my blocks. Then I'd aggressively tear it all down. When I was ten years old I turned my room into a "game room" where you'd walk through a path of board games I had set up everywhere. Then I'd tear it all down. When I was twelve years old I got into heavy metal. I'd buy tons of music magazines, put the pages up all over my wall in a very curated way, then tear it all down. To me, everything seemed ephemeral; nothing really meant anything. I was fascinated by that. But I'm still doing that: I build up romantic relationships, and then I tear them down.

Were your parents strict? For a long time, when I was really little, it was just my mother and me. She would let me watch stuff like *Rambo*, Eddie Murphy stand-up, and *Cheech and Chong*. At eight years old I could literally recite all of *Eddie Murphy Raw*. That might sound troubling to some, but my mom really turned me on to pop culture, and I think it's had a big influence on my work, not to mention helping me have a good sense of humor about things. I also ate too many sweets, like Lucky Charms, on most mornings. For fun, I would egg cars, steal from stores, and generally convince my friends to get in trouble with me. When I was an adolescent my older cousin, who was probably seventeen at the time, would spike my Coca-Cola at Thanksgiving. It was so much fun. But my poor mom. Jeez, I can't believe I came out relatively normal! No addictions, weird fetishes, or jail sentences.

Who were your heroes or role models when you were a child? My heroes were characters like Ferris Bueller and Zack Morris, and I reveled in the idea of pulling a fast one on people in authority. I really looked up to rebellious characters, as well as to pro athletes, and rock and rap stars. My three uncles on my mom's side were around and became my role models. For good or bad, they gave me some of the tools I needed to gain confidence in my life. While it was a bit hard to process while I was going through it as a child, looking back I'm thankful for them, partly because they were so eccentric and diverse. One of them was

JW:

a hobby, and I'd follow in my parents' footsteps and go into business or sales.

When I was eleven years old, I became obsessed with computers and taught myself how to code websites and to use graphic art software. When I was twelve, one of the websites I created became very popular. I started making money off the site through advertising. I remember opening one of the large checks that came in the mail and thinking it was the greatest thing in the world that I could make money doing something I loved. This success as a child gave me the courage and confidence to pursue a career in design and the arts.

Were you a good student? Yes, I was a bit of a perfectionist in every aspect of life. I was one of those annoying kids obsessed with organizing books and class notes, color-coding folders, and always doing the extra-credit assignment.

Are your parents together? What is their relationship like? My parents found love at a young age and have had a long and happy marriage. So did my grandparents and great-grandparents. They have it all: shared goals and values, love, mutual respect, commitment, and attraction. They are not only lovers, but best friends, and were partners in all aspects of life, including their business. Throughout my childhood, there were almost no fights or major disagreements between them. They always respected each other, listened to each other, and supported each other.

Do you think your parents' situation directly influences your relationships? Having parents who were perfect models for how a relationship should be has made it hard to settle for anything less. This past year, my mom mentioned that I should be less picky or I might wind up alone. However, I know what I like and what I am looking for, and I'm not sure I'm ready to compromise. I am also aware that while previous generations of my family married young, I live in a very different time than they did. The Internet has popularized casual dating and hookup culture. Most people I know are focusing on careers, and marriage seems to be losing its relevance in modern times. All of this makes me wonder what it is that I really want, outside of the expectations from family and society.

Where did you go to college? My heart led me to the Rhode Island School of Design. I was dating a guy who lived in the area, and he had a big influence on my decision to enroll. While things between us didn't work out, I'm glad I ended up there. I really grew into

TG:

a mechanic. Another was a lieutenant general in the army. The third one was like a big brother to me. He's six-foot-six, and back then he had an awesome dog and a talking bird, and he was always single and lived in a different city. Finally, my wonderful and unusually hip grandparents have been a stable thread throughout my entire life.

Were you a good student? I was a really horrible high school student; I barely graduated. That's how my graphic design career started: In high school, I would steal hall passes, replicate them in Microsoft Word, and print out whole packs of them. Later, I forged teachers' signatures. I was a cheater. At one point, I skipped Spanish class twenty-eight days in a row and had a 0.7 GPA. I was all about partying, and I had no focus. I regularly smoked weed throughout my junior and senior years. I even got suspended on the last day of my high school career. I took it all in stride; actually, I thought it was funny. When all my friends went to college, though, losing them depressed me. It was a reality check, and I began to look at my life in new ways and ask myself different kinds of questions.

What did you want to be when you grew up? It's funny, I don't remember wanting to be anything in particular. There was an old man in my neighborhood, back when I was growing up, who would call me Dead End Kid, a reference to the characters played by teenage actors in the Broadway play Dead End in 1935. They were newsboys who smoked cigarettes and their faces were always covered in dirt. I was sort of a 1980s version of that. I do remember, for a brief moment, wanting to be a police officer. And I remember really liking the label "cop." My friends and I would play around in the neighborhood—hopping fences, running through backyards, climbing up on garage roofs—and in the movies, cops would do this kind of activity as they were chasing the bad guys. I really liked the idea of that. Not catching bad guys, but hopping fences and running through backyards. I was a dust kicker.

Where did you go to college? After barely graduating high school, I started working for a guy named Dave who ran a painting and home improvement company. He was my first great mentor and is still like a father to me to this day. In the beginning, I was a laborer, hauling buckets of wallpaper glue up ladders for twelve to fifteen hours a day. That taught me a strong work ethic. It also has helped me appreciate how fortunate I am to be doing what I love, and how lucky

DAD + ME

3 YEARS OLD

WITH MY SISTER, LAUREN

I LOVED DRAWING

"MONKEY"

THE FAMILY

TIMOTHY

2 DAYS

ME + ZACH

2 YEARS

MOM, 1982

ME + JEREMY

5 YEARS

JW:

myself during this time. I met great friends, gained confidence, and had amazing experiences. I also met my first true love in college. It was the beginning of sophomore year, and I fell for him at first sight. His upbringing was very different from my own: He grew up in a small hippy town in northwestern Washington. I was drawn to his unusually laid-back attitude. He taught me a new perspective on life and was unbelievably kind. From the moment we met, we rarely spent a day apart. We lived together and talked about getting married after school and one day having kids. For the longest time, I truly thought he was "the one."

When did you move to New York City? After college, I moved to New York City with my boyfriend. I started working at a design studio called Pentagram. It was my dream job, so I threw myself into the work, staying up all night, if necessary. Around this time, things started getting tough between us, and we began fighting more. I think deep down we both realized we wanted different things in life. He'd mention wanting to move back to the West Coast someday soon and start a family and live a simpler life. I was starting to realize that I wasn't really ready for marriage or kids and wanted to focus on my career. He moved on and eventually met a beautiful woman in Seattle, and they married and now have a kid. We've since become good friends. However, I've found myself comparing every new guy and every new relationship to what I had with him. It's been difficult to find someone who measures up to him.

What is difficult about dating in NYC? In a city filled with amazing men, you'd think it would be easy to find a great one. It's actually the opposite: Everyone here is too busy and thinks they can do better. I can be shy around new people, so I've had a hard time meeting guys here. A few years ago I tried online dating, and I did meet some great guys, but it didn't work out with any of them.

Do you like dating? Dating can be fun if you like the guy. I don't like to waste my time, or theirs, so I generally only go out with guys I really like, or with whom there's a real possibility for something more. I hate to sound so calculating, but even in online dating, I'll vet a guy thoroughly beforehand: Reverse-image searches on Google and Facebook makes that pretty simple these days.

What do you love about being in a relationship? It's not that I don't enjoy being single. I do. I just enjoy being in a loving, healthy relationship even more.

TG:

to be doing it in New York. I try not to take anything for granted. I think one reason I acted out so much as a kid was because I was missing that kind of father figure in my life, so it was a really profound experience to have Dave fill that void. Over the next four years, he taught me fundamental skills like painting, tiling, and drywalling during the day, while I took interior design classes at Cuyahoga Community College at night. I had to take a lot of different classes for my major, but my drawing teacher, Nancy Halbrooks, was especially supportive. She encouraged me to keep drawing, which then led me to study design with a teacher named Jacqueline Friedman. She was very demanding, and that gave me confidence at what I was doing, and I soon realized that I wanted to get out of Cleveland and move to a bigger city.

When did you move to New York City? I moved here when I was twenty-three to go to the School of Visual Arts. Being older, I kind of treated it like a job. I felt that I had this one shot to make something of myself, or else I would have to move back to Cleveland with all of these loans and start painting houses again.

What memories do you have of your parents? My mother taught me how to love and respect people, which is why I have so many meaningful and lasting friendships. She struggled at times, but she was strong. It was good for me to be around that. When I was twenty-one she was diagnosed with thyroid cancer, and I watched her overcome that. I learned that a woman doesn't need money to be strong, she just has to have love and faith. When I was twelve years old I vividly recall my mother hiding a roll of money with a rubber band around it in her sock drawer. It was about two thousand dollars, and it was all the money she had to her name. She did this because things started going bad between her and my stepfather, and she was worried about the future. This formed the basis of my relationship with money: I wouldn't say I'm cheap, but no matter how much money I make, saving is important to me. When money is tight, all you have is the idea of the way things could be. This made me crave success, I think.

Are your parents together? What is their relationship like? When my mother was three months pregnant with me, my father (her then boyfriend) told her she had to make a choice between him and me. Thankfully, she chose me. We didn't have any money, and we lived on the second floor of a duplex house. Someone told me that when I was a baby she had been on welfare and worked at a gas station. When

JW:

It's nice to have someone you can give and receive love and support with. To have someone you can laugh, learn, grow, and explore the world with... and cuddle with. Cuddling is the best.

When was your last serious relationship? My last serious relationship started in January 2010 and ended in January 2012. Besides my college boyfriend, it was the most serious relationship that I've been in so far. We were very much in love. We lived together, we adopted a dog together, and we talked about plans for our future together. One day I found out he had been lying to me for many months about some serious financial issues. While I tried to let it go, I just couldn't. I hold honesty above everything else. The relationship deteriorated, and I broke things off shortly after.

How do your relationships usually end? Most of them ended mutually and amicably, although I did break off a few. November 2012 was the first time a guy broke my heart. His name was Parsa. He was beautiful, intelligent, and mysterious, and I jumped into the relationship very quickly. Almost as soon as I fell for him, he broke things off. I was jolted by this; rejection is agonizing and embarrassing.

What are you looking for in your next relationship? After the last heartbreak with Parsa, I've also started to question why I wanted a relationship so much, and if I need one at all. Friends tell me I should slow down and enjoy being single, and at times I feel that way as well. But sometimes I feel restless, and something inside me doesn't want to give up on the search to find someone special. I am not so interested in marriage or kids yet, just someone wonderful and amazing to share life with.

When did you meet Tim? I met Tim five years ago in the design community in New York. It was right around the time I broke up with my college boyfriend. We always bonded over being the singles in a group of friends who were primarily couples. We'd hang out at least once a week or so for drinks. Our conversations were always focused on the crazy drama in our love lives. We'd listen to each other's stories, often dumbfounded at our polar-opposite views on love and relationships. We started to tease each other about these opposite issues. I'd call him a commitment-phobe; he'd call me a hopeless romantic. We started talking about these behaviors and patterns and started asking each other bigger questions about relationships.

TG:

I was five years old she married a man and they had two sons, giving me awesome brothers. When I was thirteen she divorced him, and when I was sixteen she married a really great guy, and they've been together ever since. I'm glad she finally found someone.

Do you think your parents' situation directly influences your relationships? Had I grown up in a more traditional family structure, I might have approached things differently. However, I wouldn't be who I am today without my mom, my grandparents, and the mentors and male influences in my life—and for that, I wouldn't trade anything in the world.

Why can't you commit? I'm a big fan of Winnie-the-Pooh. There's a quote where Owl says, "A girl sees what she likes, a boy likes what he sees." I guess I'm a little like a kid in a candy shop, liking what I see. I don't believe I can't commit; I just haven't met the right person. In many situations, commitment sadly translates to compromise.

What do you love most about being single? Freedom. The other day a friend of mine called me an "accidental player." She meant that I don't have an agenda when I get involved with women or have a need to add another notch on my belt. I just love meeting new people, and I love the company of women. But I admit I do find myself in these situations where I'm leading the woman on. I'm not trying to, but I realize I should hold myself back sometimes and exercise more restraint. When I become infatuated with someone in the beginning, I just love that dynamic, and it's hard to turn it off even though I may already be aware I'm not going to fall for that person.

Do you like dating? Yes. I'm very comfortable around all types of women, and I love the thrill of it all. The other day I watched a guy walk up to a woman he didn't know and strike up a conversation with her. He didn't meet her on the Internet; this was in the middle of the day in a public place. Yet he built up the courage to talk to her. Walking up to a stranger is a big risk. That's a lost art these days, but when you can work up the nerve to do it, the experience can be truly magical.

What is difficult about dating in NYC? I think the dating life here is only difficult if you're looking to settle down. If you're looking to date, it can be perfect. Everyone is so career hungry, and it's hard for some men to stay focused when there are beautiful and interesting women everywhere. That said, I think

SCHOOL ASSIGNMENT, 7 YEARS OLD

Tim Goodman

Yesterday I went home
and I did my everyday
things, First I went home
and play Nintendo. Then I
wached tv. Then I drew
like I everyday. Then I
eat lucky charms was good. Then
II wached more tv. Then
I went to bed.

SCHOOL ASSIGNMENT, 6 YEARS OLD

Jessica Walsh is
Funny, happy, friendly, smart
Daughter of Sarah and Joe
Lover of my dog, my sister, Grandma.
Who feels happy, surprised, sad.
Who needs love, sports, food,
Who fears fire, bees, roller casters.
Who gives love, peace, money.
Who likes hugs, love, sushi
Who works hard.

JW:

What do you think about Tim's current dating life? Tim disappears on girls soon after things start to get serious. I don't think there is anything wrong with him dating around if he is honest about it, but I do think he is leading some of these girls on, whether intentionally or unintentionally. It would be great if he could develop a more mature perspective toward relationships, so that if he does meet a great girl he loves, he doesn't fuck it up. I do think deep down Tim is looking for someone wonderful.

When did you come up with the idea for the experiment? In December 2012, Tim and I had a trip planned with a bunch of our close friends to go to Art Basel in Miami. The morning of the flight, Tim and I were waiting in line at JFK airport, and we started talking about the most recent developments in our love lives. Parsa had broken up with me a few weeks prior. Tim, on the other hand, was telling me about the "stress" he was having from all the girls he was dating at once.

Tim mentioned the possibility of doing a project about our dating lives and failures. I immediately thought it was a great idea that would combine our love for design with our personal lives. Once we boarded the flight, we immediately started brainstorming. We talked about our opposite relationship issues and questioned how we could help each other or maybe even meet in the middle. By the time the plane landed in Miami, we had a pretty solid plan set for the experiment.

Why did you want to participate in the experiment? Whether it's romantic love, a love for my work, or love for my family and friends, it's that intense feeling of love, of believing in something or someone, that excites me and keeps me going in life. I've also never experienced any comedown or hangover that compares to being heartbroken. Yet no matter how much pain it causes, and no matter how many times it has destabilized me or broken me down, the pain eventually subsides, and the cycle starts all over again. Love is like some sort of socially accepted addiction, and I keep falling into its trap.

Someone once said that when you do the same thing over and over, looking for different results each time, it becomes a kind of madness. After some failed relationships, a painful heartbreak, and most recently a year of disastrous dating attempts in New York, where I was both getting rejected and doing the rejecting, I feel a bit lost, and am looking for some answers: Am I fucking up all my relationships, or have I not met the right person? Do I really want another serious relationship? Why do I jump into relationships

TG:

there's a similar problem for women. I have many female friends who are in the "I'm single and I don't need a man" phase, refusing to recognize a great guy in their life.

When was your last serious relationship? About two years ago. Since then I've been on cruise control. I've had several long-term relationships (three years was the longest), been in love, and lived with women. But now that I'm a bit older, I feel like I'm much more in tune with my tastes. I think everybody reaches a peak in their life when everything aligns: confidence, age, success, and an ease about the opposite sex. Right now I feel like I'm close to, or at, the peak. Perhaps I fear commitment because I'm afraid it would compromise my place at the peak. Thing is, I am not anti-relationship; I just think I haven't met the right person yet. In the meantime, I might as well have some fun.

When did you meet Jessie? We met on email in October 2008. Jessie worked for *Print* magazine in NYC, and they were featuring my work in the magazine. She emailed me to get some images. After an informal conversation on email, I Googled her and thought she was really pretty, so I tried to stir up more casual conversation via email. I found out Jessie went to RISD, and I remember saying, "You seem so lovely and fun—I thought only self-deprecating people went there!?" I like to think that she was charmed, but probably not. From there, we started talking and hanging out more, but it was always just a friendship.

Was there initial attraction? Yes, for me there was. I've always been very attracted to and curious about Jessie and her mysterious ways. But I always really respected Jessie and her work, and she's one of my best friends. I didn't want to risk screwing that up. There was a healthy curiosity and an attraction before we started the 40 Days experiment; otherwise we probably wouldn't have agreed to do this together. She's the complete opposite of me—much more reserved and pragmatic—but we also have major things in common. Many people thought Jessie was participating in this experiment as an excuse to date me, and that I was doing this because I wanted to sleep with her, which is ridiculous, because if that were the case, I would have already tried to sleep with her! I'm not saying I would have been successful, but I definitely would have tried.

What do you think about Jessica's current dating life? Jessie broke up with a longtime boyfriend in late

JW:

so quickly? Why can't I enjoy dating more? How can love be so wonderful, powerful, and yet debilitating?

Of all the emotions or experiences I've had on this earth, love is the one I understand the least. The 40 Days experiment seemed like a perfect opportunity to explore some of my questions. I also wanted to challenge myself to face some of my inadequacies and fears in relationships and dating.

Was there an initial attraction between you and Tim? I am drawn to Tim in many ways. He's a great friend, he is a lot of fun to be around, and I respect him. While he's not my usual "type," I do think he is very attractive. Yet I've always been turned off by his dating style and track record with relationships. I've felt like it might not be worth taking the risk. However, I can't deny wondering, "What if?"

Were you nervous about the experiment? During our trip to Art Basel in Miami, we were having dinner with our group of friends when we told them about the experiment. They had a very negative reaction to the idea, and they pleaded with us to think about the ramifications. They thought we'd wind up hurting each other or breaking up our group of friends in the process. There was fighting and awkward stares, and the night ended in tears. Tim and I were pretty shocked at this response. The conversation made us stop and think: Was this experiment worth risking our friendship? Was it worth the possibility of splitting up our group of friends?

During the following weeks, Tim and I went back and forth several times about whether we should do the experiment or not. Finally, I sat down and really thought about it. Yes, it was a huge risk. It could be a total failure, it might ruin our friendship, and it would be emotionally difficult. However, I realized the even greater risk was not taking this chance and regretting it later.

I don't want to play it safe in life. I watch friends take on jobs they find boring only for the money, and I've seen friends settle into marriages because they worry they can't do better. Maybe those people will wind up happier in the end, but for myself, that version of life scares me. I don't want to wind up on my deathbed full of regrets for not taking crazy chances. I'd rather look back on a life of failures from these experiences than a life led by fear. This experience with Tim is really just a once-in-a-lifetime opportunity that I couldn't turn down or walk away from. So on February 20, 2013, we made our final pact to actually go ahead with this crazy idea. On March 20, 2013, we began the experiment.

TG:

2012. Since then, she's been juggling the dating scene and the single life. Ultimately, she just really wants to be in love. I don't quite understand her rush, but it's important for her. I've tried to encourage her to have some fun, date around, and let go of the expectations.

When did you come up with the idea for the experiment? It was an early Friday morning on December 7, 2012. We were waiting in line for egg sandwiches at JFK airport on our way to Art Basel in Miami with a group of friends. Jessie was telling me how heartbroken she was about a guy who called it quits a few days earlier. She had only been dating him for a month, yet she already had very strong feelings for him. After a few minutes, the conversation quickly turned to me and my own dating problems. I was dating several girls at the same time and was feeling kind of stressed about it.

Why did you participate in this experiment? On one hand, I'm having the time of my life being single. On the other hand, my inability to commit does concern me. I think this project is crazy and wonderful and risky, and Jessie is the only person I know who's as crazy and risky as I am. Furthermore, we've been the only single individuals in our group of friends for a while, which has allowed us to bond over our shortcomings. And, naturally, like everyone, I'm obsessed by the idea of love. It affects every human being and has for all time. For starters, the Bible is full of verses and passages about love. In Roman mythology, Venus, the goddess of love, is the mother of the Roman people. Shakespeare's *Romeo and Juliet* has become a synonym for love. *Gone with the Wind* earned more money than any other film in box office history. And Phil Collins has sold over 100 million albums singing about love and heartbreak!

Were you nervous about this experiment? A bit nervous, a bit excited, a good splash of curiosity. It felt to me like we were playing with fire. We're playing with a good friendship. It took weeks for us to build up the courage to do this. And through the same technology that many of us spend much of our lives using, and that many of us brush off as a detriment to modern dating, we wanted to throw ourselves into an experience that was very traditional. We wanted to make ourselves vulnerable but in a situation that is familiar to us all. We wanted to explore what it means to search for love, for what you want in a partner, the consequences of successful or failed relationships, and, hopefully, through this bizarre experiment, give ourselves the chance to change our "bad habits" in love.

20 YEARS W/JENNIFFER

JESSIE'S FAMILY

H

6 YEARS

JESSIE, MOM, LAUREN

JESSIE + POPPY + GRAMS

12 YEARS

JEEN, 6 YEARS

GRADUATION, 2007

16 YEARS

JESSIE'S FAMILY, GREECE

YEARS

6 YEARS

JESSIE + JOEL
(FIRST LOVE)

DATING TIMELINE

The assumption that we should fall in love *before* getting married is a relatively recent notion. Throughout most of history, up until the nineteenth century, marriage was seen as little more than a practical union, a contract between families to secure power and money that was set up by the parents. Dating, as we know it today, was virtually unknown until around the 1920s, the Jazz Age, when traditional mores began to loosen. Things opened up even more in the 1940s (post-WWII) and the 1950s. Ever since, dating protocol has continued to evolve dramatically. In the early days of dating, we met through family, friends, and our local communities. The digital age in general, but especially the Internet, has had profound effects on how we get together and communicate our feelings. We're convinced that 40 Days of Dating could never have happened without our cell phones, computers, and social media. But let's go all the way back to the beginning, starting with the very first couple, Adam and Eve.

ANCIENT TIMES

In ancient times, many of the first marriages were by capture, not choice. When there was a scarcity of nubile women, men raided other villages for wives.

270 AD

On February 14, 270 AD, Valentinus, later to become St. Valentine, is beheaded. Legend has it that before his execution he wrote a note to the daughter of a jailer and signed it "from your Valentine" as a farewell.

EARLY 500s

King Arthur, Lancelot, and Guinivere make the love triangle stylish. Arthur and his Round Table of knights create the template for courtly love and chivalrous behavior.

1491 BC

The first recorded marriage is in ancient Egypt in around 1491 BC between Thutmose II and Hatshepsut. They were between the ages of twelve and fifteen.

496 AD

In 496 AD, St. Pope Gelasius I declares February 14 "Valentine's Day."

WAY BACK

God creates Adam from dust and places him in the Garden of Eden. God places a tree in the Garden of Eden that he prohibits Adam from eating. Then Eve comes along, and the rest, as they say, is history.

12th CENTURY

The union between a man and a woman is described in the sacred texts of most religions. The Catholic Church in Europe becomes more involved, performing ceremonies and dictating who can get married.

1882

In 1882, England passes the Married Women's Property Acts, which allows women to keep money they earn during marriage and to inherit property under certain circumstances.

MAY 28, 1927

Rotary dial service begins and men start calling women on the phone.

7th CENTURY

Christian churches begin to take a more active role in the marriage process. In the centuries prior to 1000 AD, marriage is a good way to ensure your family's safety.

1837–1901

During the Victorian Era, romantic love is viewed as the primary requirement for marriage, and courtship becomes even more formal, almost an art form, among the upper classes.

1960

The Pill is released in the U.S.

DEC. 1965

The first dating show on TV, *The Dating Game*, airs on ABC.

1950s

With the rise of the automobile, dating becomes enormously popular.

18th CENTURY

The first personal ads, like this one, appear in papers. "To the ladies: Any young Lady, between the Age of Eighteen and Twenty-three, of a middling Stature; brown Hair; regular Features, and with a lively brisk Eye; of good Morals, and not tinctur'd with any Thing that may sully so distinguishable a Form; possessed of 3 or 400l., entirely at her own Disposal, and where there will be no necessity of going thro' the tiresome Talk of addressing Parents or Guardians for their Consent..."

1228 AD

Women first gain the right to propose marriage in Scotland, a legal right that then slowly spreads through Europe.

SEPT. 12, 1944

Barry White is born. He goes on to make hit songs like "Can't Get Enough of Your Love, Babe." More babies are conceived.

JUNE 28, 1969

Stonewall Riots, start of the gay rights movement.

OCT. 22, 2008

Tim and Jessie meet via email. Jessie works for *Print* magazine in New York, and they are featuring Tim's work in the magazine. She emails him to get some images. To date, they have shared over 5,000 emails.

MARCH 5, 2004

OkCupid is launched.

1993

The euphemism "hooking up" first appears in the *New York Times*; it can be used to describe anything from kissing to sex.

NOV. 6, 2008

They start an informal conversation on email. Tim finds out Jessie went to RISD, and says, "You seem so lovely and fun—I thought only self-deprecating people went there!"

1998

Speed dating is invented by Rabbi Yaacov Deyo.

MAY 2007

Tim graduates from the School of Visual Arts in New York City in graphic design.

1999

Texts can finally be exchanged between different networks, which increases its usefulness. By 2000, the average number of text messages sent in the U.S. increases to 35 a month per person.

1960s–1970s

The rise of second-wave feminism and the sexual revolution in the 1960s and 1970s brings an end to the cult of domesticity: More and more women begin to work outside the home. The flood of women into the workforce never stops.

1998

Titanic released!

MAY 2008

Jessie graduates from the Rhode Island School of Design in Providence in graphic design.

2010

Tim leaves COLLINS to work for Apple, Inc. in San Francisco.

JULY 10, 2013

Jessie and Tim launch the 40 Days of Dating website to the world.

JUNE 2, 2012

Jessie partners with Stefan to form Sagmeister & Walsh.

FEB. 25, 2009

Tim stops by *Print* to pick up the magazine issue and they meet for the first time in person.

MARCH 9, 2010

Tim breaks up with a girlfriend he really cares about, wonders if it was the right decision.

MARCH 20, 2013

Day 1. The 40 Days experiment begins.

JAN. 28, 2012

Jessie breaks up with her boyfriend of two and a half years who was living with her.

APRIL 28, 2013

Day 40. The experiment ends.

DEC. 7, 2009

Jessie leaves *Print* magazine to work for Stefan Sagmeister.

JAN. 4, 2012

Tim moves back to NYC to work for himself.

DEC. 7, 2012

Tim and Jessie fly to Miami for Art Basel with a group of friends. Jessie's heart has just been broken by a guy she really liked. Tim is casually seeing three different women and feels bad about it. Together they come up with the idea of dating each other for 40 days.

HOW THEY MET

We asked family and friends to tell us how they met.
Some have been together for a very long time (Jessie's parents,
Tim's grandparents), others for less time—we never get
tired of hearing these stories.

SW & JW

When I met my husband, Joe, thirty-two years ago, I thought he was everything I didn't want in a guy. He was a friend of one of my college girlfriends, and one night a group of us, including Joe, had plans to go to the movies. At the appointed time, Joe showed up at my front door alone and said no one else could make it. I didn't want to go, but I didn't want to be rude either, so we went out. The night turned out to be wonderful. For the first time in my life I felt completely at ease with myself. Joe made me laugh endlessly. We couldn't stop seeing each other after that. But every time we were together, I would say to myself, "What are you doing? This is not the type of guy you want to be with!" Six months after that first date, he asked me to marry him. I was the happiest girl on the earth. All these years later, he still makes me laugh. We are best friends, and I know we will always be there for each other. —Sarah Walsh, Jessie's mom

**AB&
HB**

Hugh and I met while we were in college. I was editor of the yearbook and he was a reporter on the newspaper. Our first date was on April 16, 1957. We went to the Cleveland Indians opening day baseball game. A month later we were engaged, and two months after that we were married. When it's right, you know it! We will be married fifty-eight years in June 2015. We have four children and eight grandchildren together. Marriage is not always easy but when your interests and goals are the same, it is possible to work through the difficult times… that has always been true for us. —Ann Caywood Brown, Tim's grandmother

DM & EM

Love at first sight? Dana and I had it, but it took a bit of time for us to share that important piece of information with each other. The first time I saw Dana, we were in my first college class. She had freshly dyed purple hair adorned with a set of broken headphones. I was smitten, but I didn't have the courage to ask her out; I figured my luck with an art chick like her was slim. Six months later, and forty-five days before she graduated, I finally made the move and asked her out. She said, "Yes. What took you so long?" Turns out she had felt the same about me all along. The rest is history. The best things in life are always worth holding out the longest for. —Erik Marinovich

Julia appeared like sunshine in the night at The Park restaurant in New York City eleven years ago. I fell in love instantly. Julia moved to Germany two months later, so we thought it would be no more than a spring fling. But at around that time I had stopped drinking, and I was seeing the world anew. So I visited her in Berlin, and on my last day, we swore that we would stay together. She moved back to New York six months later. We moved in together. She moved out six months later. I moved in with her again a little while later, yet we separated once again. It was a tumultuous affair those first five years. We've been together without breakups for several years now, and we've learned that facts don't mean much when it comes to love. What you build and how you care for this gift is all that matters. And of course LOVE—felt and expressed in strange ways sometimes—but love every second of these last eleven wonderful and crazy years. —Esteban Apraez

For several months before I met Nicole Jacek, I had been compiling a list of attributes and values of the kind of person I wanted to be with in a relationship on a chalkboard in my house in Los Angeles. At the time, I was on the board of the Art Directors Club (as was Nicole), and at one of their board meetings in New York, I finally got to meet Nicole. I was so nervous I made a silly comment about wishing I had hair like hers. At a lunch the next day, I was disappointed to find out she was straight, and more than a little annoyed that she had thought I was a "soccer mom." But I couldn't stop thinking about her. When we met for our first dinner out in LA, I quickly realized that the characteristics on my "relationship" list were embodied in the person sitting right across from me. After only four hours we decided to get married, and two months later we did it!
—Noreen Morioka

The RULES

Before we embarked on our experiment, we created a set of rules and parameters that would force us to engage with each other. These six rules also helped us face our fears and insecurities around relationships. What follows is the foundation for our entire time together.

One

We will see each other every day for forty days.

two

We will go on at least three dates a week.

three

We will see a couples therapist once a week.

four

We will go on one weekend trip together.

five

We will fill out the daily questionnaire and
document everything.

Six

We will not see, date, hook up, or have sex
with anyone else.

It takes
40 DAYS TO
CHANGE a
BAD HABIT

Experiment Dates: March 20–April 28, 2013
Blog Launch: July 10, 2013

It wasn't until a couple of weeks after the forty days had ended, when we finally compared a couple of our journal entries, that we realized we had enough interesting material to make a website. After some back and forth, designing and planning, we finally launched the website on July 10 with the first day and rolled them out one day at a time until we finished with Day Forty. The text that appeared on the blog is from our journals. Except for the first few entries, neither of us read what the other had written until the night before we posted it live for everyone to see.

WHEN AN OPPORTUNITY SEEMS SCARY... YOU MUST TRY IT

DAY ONE: MARCH 20, 2013

Jessica Walsh

Did you see Timothy today? Yes.

What did y'all do together? We had our first date at the Fat Radish on the Lower East Side. They have

DAY ONE: MARCH 20, 2013

Timothy Goodman

Did you see Jessica today? Yep.

What did y'all do together? We both teach Wednesday nights, so we went out to dinner after class to

the best roasted carrots, and my favorite tequila jalapeño drink.

Did anything interesting happen? Before the date, Tim had a messenger deliver a cute note: "Me + You x 40, Ready?"

ADORABLE, BUT I HATE CANDY. –JW

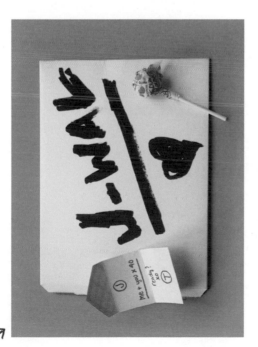

the Fat Radish. Jessie brought me a little care package of stuff to jokingly get me through the next forty days. (And she remembered that I like Clif Bars!)

Did anything interesting happen? Before the date, Tim had a messenger deliver a cute note: "Me + You x 40, Ready?"

I DON'T EAT CLIF BARS ANYMORE BECAUSE JESSIE CONVINCED ME NOT TO. –TG

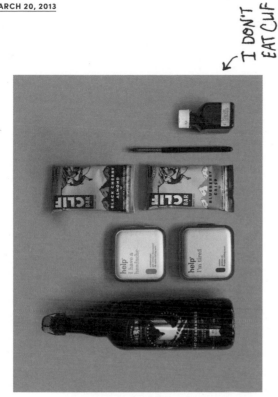

Did anything interesting happen? When we set the date for this project, I didn't realize it was actually the first day of spring. I feel like it's some sort of omen for us. Anyway, dinner tonight was pretty normal, not unlike other times we've hung out and had dinner.

Truthfully, I am quite nervous. However, I know that when an opportunity scares me, I must go for it. I don't like having fears. No matter what the outcome, it will certainly be an interesting experience. Hopefully we can have some fun along the way, too.

Did you learn anything new about Timothy? We discussed Tim's relationship patterns, and how he's in a constant cycle between three women. There is always one girl he's really excited about that he's trying to go out with, a second girl he's been seeing for a few weeks and is getting tired of, and a third girl he's been seeing a while and is getting ready to break up with.

Tonight

Timothy Goodman
to Jessica

Happy first day of Spring!
I had no clue when we set the date.
Coincidence??

Sc...Fat Radish to celebrate after class tonight?

Did you learn anything new about Jessica? We talked about our families more than we ever did before. I didn't know that her parents grew up poor. It was refreshing to hear this since I didn't grow up with a lot of money, either.

Did you learn anything new about yourself? Earlier in the day I sent a little note to Jessie by messenger. I wanted to honor our project together with something lighthearted.

How do you feel about this relationship/project right now? The new Justin Timberlake album came out yesterday and it's totally got me in the mood.... but really, Jessie and I should share a "JT" logo with him. Anyway, I feel like there was definitely a moment last night when we both said to ourselves, "Damn, are we actually doing this?!"

Is there anything that you want to do differently? No, not yet. I did insist that I pay for dinner since it was technically our first "date."

TIM LISTENS TO JUSTIN TIMBERLAKE!? —JW

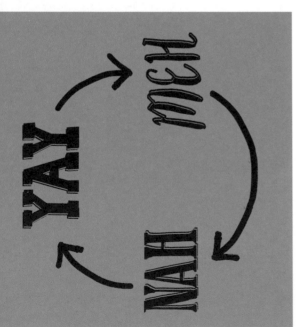

He told me that when his mother got pregnant, his father made her choose between keeping the child or staying with him. It seems to me his dating style could result from this. He breaks off relationships before they get too serious to avoid the risk of abandonment. He's built up this reputation for himself as "the player," but I see past the façade. He's been a great friend, and I know he's a very kind person. We all have our issues and cope with life differently. Sometimes I think the "normal" people are just people you don't know well enough yet.

Did you learn anything new about yourself? We talked about relationships with parents, and how many girls have "daddy issues." I don't have dad issues. I heart my dad!

My parents married at a young age and have a successful marriage. I wonder if that is part of the

reason I am always trying to find the right person and why I feel like such a failure when a relationship doesn't work out.

How do you feel about this relationship/project right now? I think I have some sort of guard up preventing myself from seeing Tim as anything more than a very close friend. As his relationship patterns are the opposite of mine, a part of me fears that if we were to really date, one of us might wind up getting hurt. I don't want to ruin our friendship. We also have a tight group of friends, and I think we are both afraid to compromise that.

Is there anything that you want to do differently? In my work and other aspects of life, I am uncomfortable with comfortable. But when it comes to relationships, I do seek secure relationships that are clearly defined. I know I should relax and open myself up to vulnerability, so I can learn to enjoy dating more in the future.

Additional comments? Tim insisted on being a gentleman and paying for dinner, which was very sweet of him, but I want to get the next one.

YES, SOME OF OUR MUTUAL FRIENDS DID NOT WANT US TO DO THIS. —T

Additional comments? I went out with a girl last night, as sort of a 'swan song' for my single-hood. Well, she and I ended up talking about the Forty Days of Dating project the entire time. Not exactly what I was anticipating. She was very excited. She thinks Jessie and I are going to fall in love. She texted me later that night:

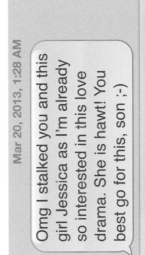

Mar 20, 2013, 1:28 AM

Omg I stalked you and this girl Jessica as I'm already so interested in this love drama. She is hawt! You best go for this, son ;-)

iMessage Send

DAY TWO: MARCH 21, 2013

Jessica Walsh

Did you see Timothy today? Yes, briefly.

What did y'all do together? We went to our first couples therapy session together. I go to therapy on my own, and have always enjoyed it. Life passes by so quickly, and I like having an hour a week to reflect in an attempt to learn and grow from it all.

Did anything interesting happen? The psychologist brought up many topics we wouldn't have talked about on our own. She asked us straight away if Tim and I were attracted to each other. This is something we've never discussed, although we have been flirtatious with each other in the past. After some awkward glances, we both admitted that we do find each other attractive.

DAY TWO: MARCH 21, 2013

Timothy Goodman

Did you see Jessica today? Yes.

What did y'all do together? We went to our first therapy session together. I think it was a bit soon for this, but our therapist, Jocelyn, wanted to have a consultation first.

Did anything interesting happen? Jocelyn hit us with a TON of questions that I'm not sure either of us were prepared to talk about with her so quickly:

1. Why are you doing this project?
2. What is the goal of this project?
3. Why don't you just really date each other?
4. Do you want to date each other?
5. Are you ready to be hurt?

HE WAS REALLY FREAKING OUT! —JW

6. What happens if you screw up your friendship?

And on and on and on! I almost had a panic attack. However, neither Jessie or I would have talked about this stuff so soon without having the therapist as a soundboard. I think it was helpful. I spent five years seeing a therapist, so this isn't strange to me. Jessie is currently in therapy, so it's all good with her too. However, this couples thing doesn't feel natural or easy.

Your signature below indicates that you have read the information in this document and agree to abide by these terms during our professional relationship.

TIMOTHY GOODMAN

Patient Name

Patient Signature

3/21/13

Today's Date

Did you learn anything new about Jessica? Jessie didn't like that I talked about how we approach money differently. I wasn't being critical, nor do I think it's a big deal. But I do save money, while I think she lives off her salary more.

Did you learn anything new about yourself? I get un-comfortable talking about what could happen in the next forty days. I'm not worried about the unknown, but about us falling into our usual roles, and how we deal with that.

How do you feel about this relationship/project right now? I was wondering the whole time during therapy, "Wait, why are we doing this?!" As Jocelyn said today, "Emotions know no project boundaries."

She then asked why we've never tried dating in the four years we've known each other. Tim immed ately rattled out numerous reasons:

1. He's not at a place in his life where he wants to settle down.
2. He loves the freedom of the single life.
3. He doesn't like how I spend money.
4. He sees it as a weakness that I love love.
5. He's afraid of his commitment issues and doesn't want to hurt me since he respects me.
6. He doesn't want to risk our friendship.

IT DOESN'T BOTHER ME, PER SE. WE JUST HAVE DIFFERENT WAYS OF LOOKING AT MONEY. —TG

Did you learn anything new about Timothy? I didn't realize that my spending bothered Tim! I know I don't have as much savings as he does, but I've always sup-ported myself financially, and I don't mind spending on great experiences.

I don't place value on the size of someone's bank account or material possessions. I've been in rela-tionships with guys both rich and poor, and a guy's wealth does not interest me. I learned early on that money does not make me happy. There are ac-tually statistics that show that salary increase only makes people happier until basic needs of food and water are met. After this is met (around $50,000 to $70,000 per year for a family), an increase in salary does not positively increase a person's happiness.

Did you learn anything new about yourself? Tim seems extremely overwhelmed by the idea of having to see me every day for this project. He almost had a panic attack when I sent him a list of date ideas for the next week! I do love to plan things and have a schedule. However, I also greatly enjoy spontaneity. So I'll plan for more spontaneity.

How do you feel about this relationship/project right now? So far so good.

Is there anything that you want to do differently? In therapy we talked about how I am extremely picky about who I date. However, when I do decide I really like someone, I am quick to jump into a relationship in order to test it out and see how it goes. I become extremely invested in people and things that I care about, which can cause me to fall for someone quickly. Tim thinks I should be more cautious...

Additional comments? Tim is right, I do love love. I've wondered where the feelings actually come from, so I did some reading about it tonight. Apparently, the feeling of falling in love is wired in us to help the survival of our species. While sexual desire exists to make sure we pop out babies, the feeling of love exists to promote bonding and pairing between mates to increase the survival rate of the children.

Is there anything that you want to do differently? I was sort of freaking out after therapy. I was texting with one of my best friends, Greg in Chicago, and he told me to just have fun with it. So, I want to make sure I just have fun with it.

Mar 21, 2013, 12:26 PM

I'm kinda freaking out. I have 39 days left! It's not Jessie, it's just the fact that I have to see someone EVERYDAY.

Just have fun and get used to it unless you want to die alone & sad & bald

Ha! That's your problem. I'll be George Clooney, getting better with age. You'll be like Marlon Brando, deteriorating on an island somewhere in the Pacific

iMessage Send

BRANDO ALSO HAD A LONG-TERM RELATIONSHIP WITH HIS HOUSEKEEPER. SO, THERE'S THAT TOO. –TG

Additional comments? I was thinking about some of my buddies who are in a relationship that doesn't completely stimulate them. So many men and women

accept this standard, it's no wonder that half of all marriages end in divorce. Are we so desperate for companionship that we'll compromise our happiness? Are we afraid to go after what we really deserve? And why don't we realize this until it's too late?

50% OF MARRIAGES IN AMERICA END in DIVORCE

57% OF MEN WILL COMMIT INFIDELITY

Love is not a matter of the heart, it's all in our brain. Chemicals like dopamine and norepinephrine are released when in love. The chemicals increase energy, increase focus, and help make us feel fucking awesome all the time. In fact, research shows brain activity in love is almost identical to our brain activity on cocaine.

Jessica Walsh

Did you see Timothy today? Yes.

What did y'all do together? I got us tickets to see *Really Really* at the Lucille Lortel Theatre in the West Village.

Did anything interesting happen? The play is about a bunch of college students going to parties, getting

Timothy Goodman

Did you see Jessica today? Indeed I did.

What did y'all do together? Between work functions and personal plans, I haven't had a night off in over ten days. I just wanted to stay in and watch the Knicks game. However, Jessie and I have something planned on Sunday, so it was probably best to do a date tonight instead of Saturday night. Anyway, we went to the Off-Broadway play *Really Really*.

Did anything interesting happen? We went out for a drink after the play. Jessie told me some very personal stuff that's happened in her life. I'm happy she did, and that she trusted me enough to tell me. When someone does that, your natural inclination is to tell them something extremely private back. I didn't do that, though. I just listened and asked a couple of questions, and let her talk.

Did you learn anything new about Jessica? Before the play, I was texting her. I waited, and waited, and waited.

drunk, having sex, and their complicated interpersonal relationships. The characters are either opportunistic, self-serving, entitled, indulgent, or power-seeking. Tim found it difficult to empathize with any of the characters in the play as there was no "hero" character. I found the complicated dynamic of these different personalities to be an interesting twist on the usual character development.

SPEAK FOR YOURSELF, JESSIE! :) —TG

Apparently she doesn't check her texts much, which I somehow did not know. How is that possible? I can't stand it if I have one red alert on my phone. The things you learn about someone that you think you know.

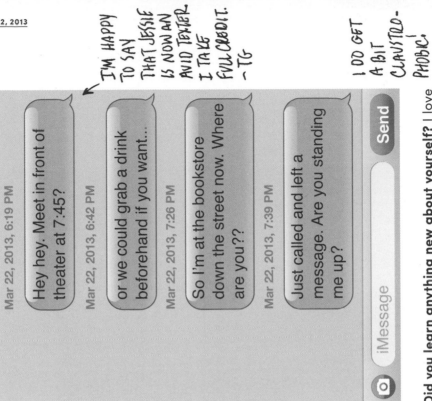

I'M HAPPY TO SAY THAT JESSIE IS NOW AN AVID TEXTER. I TAKE FULL CREDIT. —TG

Mar 22, 2013, 6:19 PM
Hey hey. Meet in front of theater at 7:45?

Mar 22, 2013, 6:42 PM
or we could grab a drink beforehand if you want...

Mar 22, 2013, 7:26 PM
So I'm at the bookstore down the street now. Where are you??

Mar 22, 2013, 7:39 PM
Just called and left a message. Are you standing me up?

iMessage Send

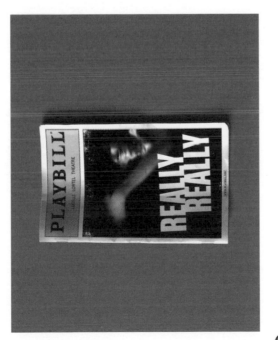

The play paints a pretty bleak picture of Americans in "Generation Me." Maybe slightly ironic in the context of this project...

Did you learn anything new about Timothy? After the play, we wandered over to a bar nearby in the West Village for a drink. Tim told me about his last serious relationship with a girl he dated in San Francisco when he worked for Apple. I feel like he broke her heart. Things were getting serious between them when she

Did you learn anything new about yourself? I love crowds. I don't think Jessie does. As we were sitting in the theater waiting for the play to start, I was looking around everywhere. Then I felt a bit constrained, like

I DO GET A BIT CLAUSTRO-PHOBIC! —JW

I should be giving all my attention to her. Good thing I brought some surprise candies to keep us busy.

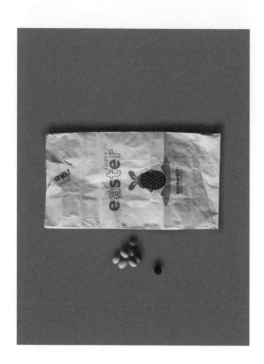

had to leave for business for a few months. The long distance scared him, and he broke off the relationship when she got back. He seemed to feel bad about it.

Did you learn anything new about yourself? One part of the play stirred up emotions from something that happened in my past. I was slightly shaken up after the play so I told Tim about it to explain why I was acting strangely. I try not to look back too much and get caught up in the past, but sometimes it does unexpectedly creep back up on me.

How do you feel about this relationship/project right now? It was cute that Tim insisted on being a gentleman and walking me home after the play. I am a sucker for the common dating courtesies.

Is there anything that you want to do differently? Tim seemed slightly annoyed that I missed his text messages before the play. I hate text messaging. My fingers get tired. The misunderstanding and the autocorrect drive me nuts. And what's with the new "read on xx" time-stamp on the iPhone? How much does it suck to see someone read your text and then they don't write back? When I have a crazy day at work, I often forget to check my cell phone. Actually, sometimes I don't bring it to the studio at all. I know this drives certain people a little crazy. I guess I should look into an app that downloads texts to the computer.

KNICKS WON! 99-94. –TG

Additional comments? Not Really.

How do you feel about this relationship/project right now? I feel much better than I did yesterday. Tonight was the first time things felt date-y, and I felt okay about it. The intimate talk and the crisp spring air made our walk home feel a bit romantic.

Is there anything that you want to do differently? Well I certainly won't text her if I need to get a hold of her.

Additional comments? I think Jessie caught me looking at the Knicks score on my phone during the play.

I ACTUALLY DIDN'T NOTICE THIS. – JW

Jessica Walsh

Did you see Timothy today? Yes!

What did y'all do together? Tim was finishing a mural in the morning. He needed to pick up groceries on his way home and suggested that we meet at Whole Foods. I had a long day gallery hopping in Chelsea and plenty of work to do after. I thought we could meet at Westside Market, which is on the bottom floor of

Timothy Goodman

Did you see Jessica today? Yup!

What did y'all do together? I was working on location all day drawing a mural. I wanted to go food shopping on the way home that evening, so I asked Jessie if she'd join me. I asked her to meet me at the Union Square Whole Foods, but she wanted me to go to the grocery store that's below her apartment

building. So we flipped a coin for it over the phone (I had a witness with me). She won.

my building. You can often find me there late at night in sweatpants and slippers making one of my most important decisions of the day: which after-dinner chocolate to buy. He really wanted to go to Whole Foods, since it's his favorite market. We couldn't agree, so we did a coin toss to determine which one. I chose heads, and I won. Laziness prevails!

Did anything interesting happen? Tim introduced me to Duvel beer while we were shopping, and I love it! I like to have a drink when I work on the weekends—it makes everything feel a little more relaxed.

Did anything interesting happen? I don't usually get groceries with someone else. She made fun of me for being so picky about my organic orange juice and my almond milk. She also made fun of me for eating too much cereal. I'm from Ohio—what do you want from me? I like my grains. We all have weird food shopping habits, we all have secret single behavior. ← SEX IN THE CITY REFERENCE. -TG :)

This reminds me of when I first started talking to Tim four years ago. I was working full-time at *Print* magazine, and we were featuring Tim in an article. After emailing back and forth with him to get content for his story, we started talking over Gchat. My Sunday ritual at the time was to drink a mimosa while doing freelance work. Tim also happened to be doing

I DON'T WEAR MUCH MAKEUP, BUT I ALWAYS HAVE A BIT OF POWDER ON. —JW

Did you learn anything new about Jessica? I noticed she had some powder on her face. I wonder if that was still on from her day, or if she put that on for me?

Did you learn anything new about yourself? I realized that I haven't had the urge to see or talk to any other girls yet. It feels nice.

How do you feel about this relationship/project right now? I feel good about it. However, I'm starting to realize how difficult/annoying it is to find time to see her EVERY DAY. We both have a million things going on, and it's another thing to put on the schedule.

Is there anything that you want to do differently? Not today.

Additional comments? Right before we started the project, Jessie went on a date with some guy. Apparently, he's been emailing her with a countdown every-day. Hilarious. 38 days left, 37 days left, 36 days left . . .

freelance work and drinking one Sunday, and we bonded about being "worka-alco-holics." He asked me if I wanted to get a drink at Grey Dog, but the timing never worked out. I couldn't tell at the time if he was asking me out on a date, or if it was work related. I wonder if he remembers.

Did you learn anything new about Timothy? Yes, I found out that Tim is ridiculously picky about the food he buys. He was intent on locating a certain type of almond milk and organic orange juice. He was fretting that they didn't sell his usual brands. He's quirkier than I thought, but I like that.

Did you learn anything new about yourself? There is no way I would have gotten together with Tim today if it wasn't for this project. There was just too much on the schedule. But we made it work, and it was fun!

How do you feel about this relationship/project right now? I'm feeling good. I enjoyed seeing him, even just briefly.

Is there anything that you want to do differently? I thrive on being busy—sometimes it seems the more I do, the more I can do. I want to keep doing more, but should be careful how far I go.

Additional comments? Tim also loves cheese puffs and corn muffins.

SERIOUSLY, ALMOND MILK IS MY JAM. —TG

Jessica Walsh

Did you see Timothy today? Yes, we spent most of the day together.

What did y'all do together? Relationship art therapy. We made illustrations and wrote out memories based on past relationships or people we've dated while eating ginger cookies and egg pastries.

Timothy Goodman

Did you see Jessica today? You know it.

What did y'all do together? We met in the morning. The plan was to spend the day illustrating our dating history.

Did anything interesting happen? While we're both familiar with each other's dating history, I have never

KEEP IN MIND, THIS WAS SINCE I WAS 16! —TG

dissected it quite like this. Jessie made me write out every girl I've gone on a "date" with, and there's something liberating about airing my dirty laundry.

EVERY girl I'VE EVER WENT on a DATE WITH

1. JENN	33. ALEXIS
2. LAURA	34. JEAN
3. CORALIS	35. LIESEL
4. LENA	36. KRISTIN
5. CHERRISA	37. ALEXANDRA
6. KRISTEN	38. CAN'T REMEMBER 1
7. ANGEL	39. CATHERINE
8. MELISSA	40. JESSICA
9. PAULA	41. LORETTA
10. HILLARY	42. JILLIAN
11. KAT	43. LORAINE
12. CLAUDIA	44. JOANNA
13. PERIA	45. AMANDA
14. REBECCA	46. CHARLOTTE
15. AUTUMN	47. CHRISTINA
16. MICHELLE	48. WHITNEY
17. EMELIE	49. THUY
18. ELANOR	50. CAN'T REMEMBER 2
19. ASHLEY	51. JULIA
20. AMANDA	52. CASSY
21. MARION	53. CATHERINE
22. KITTY	54. AMANDA
23. SARAH	55. CAN'T REMEMBER 3
24. ADRIANA	56. JO
25. GRACE	57. MICHAELA
26. NOEMIE	58. CEDAR

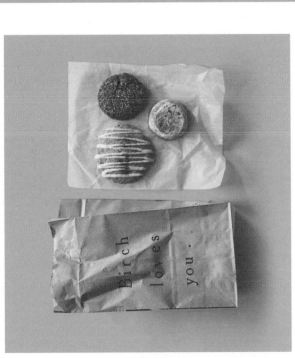

THE COOKIES AT BIRCH COFFEE ARE SO GOOD! —JW

Did anything interesting happen? Getting your exes out of your head is surprisingly therapeutic.

27. JENNIFER
28. CANDICE
29. CARMELINA
30. RACHEL
31. ISABELLE
32. LAINE

59. ABBY
60. NICOLE
61. DANIELLE
62. ERIN
63. MELISSA
64. ANDREA
65. THERESA

Did you learn anything new about Timothy? Yes, I learned that he's been on dates with over sixty-five girls. What a man whore.

Did you learn anything new about yourself? I've been on dates with twelve different people in my life. I've kissed eleven guys and one girl. I've had two serious long-term relationships. I've had three semi-serious relationships. I've slept with eight guys. I've lived with two boyfriends. I've never had a one-night stand. I've been in love twice. I've been on more dates this past year than the rest of my life combined.

More about my past relationships, flings, and mistakes:

Did you learn anything new about Jessica? We work really well together. We've already been working together for the last month—discussing and strategizing a lot of things surrounding this project—and I realize that I am NOT sick of working with her yet.

Did you learn anything new about yourself? Going through my dating history was a bit daunting. Jessie thinks I've gone out with a lot of girls, but I don't think it's that big of a deal. I have friends, both guys and girls, who have gone out with way more people than this. The bulk of my history has been in the last six years since I graduated college.

Some moments in history:

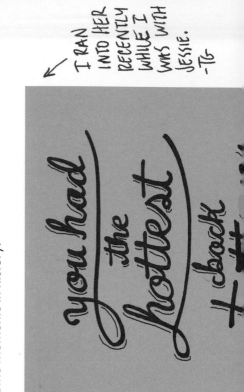

She was my first kiss and my first relationship. I dated her while I attended an all-girls boarding

[handwritten note, bottom left] YEARS LATER SHE WROTE ME ON FACEBOOK; SHE HAD NO IDEA HOW YOUNG I WAS AT THE TIME. —JW

[handwritten note, top right] I RAN INTO HER RECENTLY WHILE I WAS WITH JESSIE. —TG

She was half-Vietnamese and half-French. She had a large Buddhist scripture on her back, sort of like Angelina Jolie's tattoo. She started calling me "baby" on the second date. That's when I knew it was over.

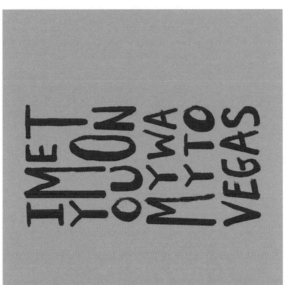

I MET YOU ON MY WAY TO VEGAS

I was traveling to Vegas for work, and so was she. She sat behind me on the plane. We had a fun couple of days.

you were a WATERCOLORIST, a DRUMMER,

school when I was thirteen. My parents found out and they were very upset. They've always been open-minded and supportive, but they said that I was too young to know if I was a lesbian. They were right.

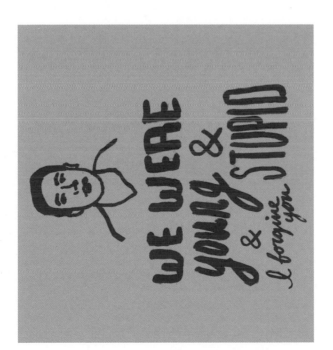

WE WERE young & & STUPID
I forgive you

He was a close friend's older brother. We dated in high school for a year. Something unfortunate happened the first night we were together. We both tried to put it behind us, but it eventually broke us apart.

51

SHE'S MARRIED NOW. —TG

A WAITRESS, a TAP DANCER, a screenwriter, a FILM DIRECTOR + a BARTENDER

She was a Lower East Side girl, a Renaissance woman, always on the hustle, full of great energy. I was really into her until she told me she talked to aliens. Seriously.

WE MET IN WHOLE foods. you BROKE IT OFF 2 WEEKS later

I really liked her. She wasn't over her ex-boyfriend. I was disappointed that she ended it so soon.

you were TOO GOOD TO ME. IT TIRED US BOTH OUT

My college sweetheart. We fell madly in love al-most instantly and didn't spend one night apart for six months straight. We lived together for two years. I've kept every handwritten letter I've ever received, so I read through his old love notes to me today. It made me realize he was too good to me and had made my happiness a priority over his own. We separated after college and have since stayed good friends.

I'LL NEVER FORGET that SUNSET IN ST MARTIN

SHE'S MARRIED NOW. —TG

you were BORN to take all my MONEY

She was stunning: Northern European, tall, stylish, full lips, educated, and charismatic. She also partied way too much, and she was completely broke. I was done after a month.

WE WERE WALKING WHEN WE SAW a LIMO PARKED. I PAID the DRIVER $100 TO DRIVE us OVER THE

I met him through my high school best friend. We became very close when I moved to New York City. He's a very smart and talented designer with a laugh that's as embarrassing as mine. We separated on good terms and he is now dating the high school best friend.

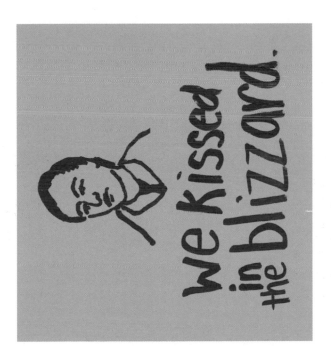

We kissed in the blizzard.

We were coworkers. He dated my close frienc who was living abroad at the time, but they broke up while she was gone. We were at a work party a few weeks later when he kissed me. I liked him, but I didn't want to compromise my friendship with my girlfriend, so nothing more happened.

BROOKLYN BRIDGE.

First dates are the perfect time to be spontaneous. After a couple months she was disappointed that I was working so much. Besides, I can't always be exciting.

I READ BUKOWSKI OUT LOUD TO YOU

She was literary and liberal, it was late, I had too much to drink, and I thought it would be a good idea to read out loud.

we met in COLLEGE FOR THE

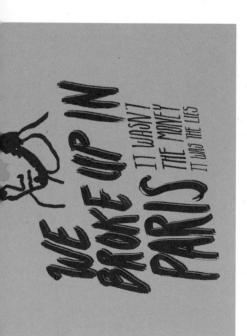

WE BROKE UP IN PARIS
IT WASN'T THE MONEY
IT WAS THE LIES

A Swiss-Croatian film director. He kept asking me out over email after we featured him in a design magazine I worked for. One day I stumbled across an interview he did with the BBC, and I fell in love with him before we even met. It was those intense dark eyes and his cerebral mind. We moved in together only a few months after we started seeing each other. Our relationship was passionate and deeply emotional. A few years later I found out that he had been lying to me, and it broke us apart.

WE had too

I LOVED THIS GUY, BUT HE WAS ALWAYS SUSPICIOUS OF ME. —JW

← SHE'S MARRIED NOW, TOO. —TG

WHEN WE WERE *single, we'd* BE THERE FOR *each other.*

It's nice to have someone to lean on when things get lonely. She and I did that for years after college without any sort of question, conflict, or expectation.

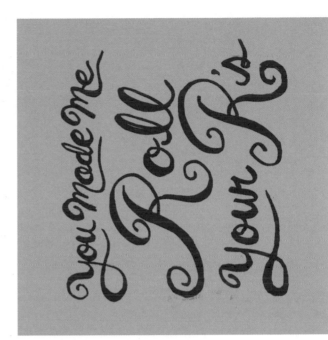

You made me Roll *your* R's

you taught me to DANCE.

He is a very kind and outgoing Cuban photographer who loves the nightlife. He taught me to live a little more, to smile more often, and to dance. We ended the relationship four months in, but have stayed good friends.

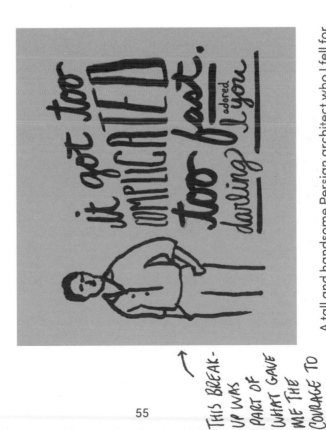

it got too COMPLICATED too fast.
darling I adored you

A tall and handsome Persian architect who I fell for way too quickly. We'd exchange long romantic letters almost daily. We'd stay up late making music playlists for each other. He called me "Honey Bunny," and I called him "Darling." He broke it off quite suddenly, and I was devastated. There is nothing more painful than being rejected by someone you adore.

→ THIS BREAK-UP WAS PART OF WHAT GAVE ME THE COURAGE TO DO THIS EXPERIMENT. —JW

She had the beauty, the essence, the attitude, the passion, the complexity, and the dark features. But I was moving to San Francisco at the time and it wasn't going to work.

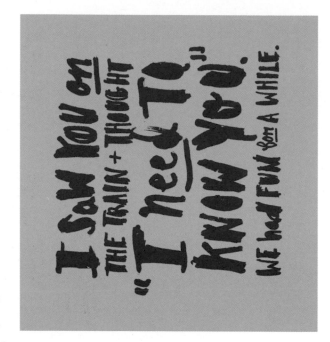

She had an amazing TriBeCa loft, and she'd even steam my shirts in the morning.

He was a tall guy from Rhode Island who had an unusually thick beard. He designed quirky furniture and liked to drink whiskey on the rocks. We went on a few dates and spent New Year's Eve together. I have not heard from him since.

who GOT away

light bulbs

A handsome ER doctor who loves to surf and take photographs. He told me that he was accepted to a residency program at a hospital in Australia and would be leaving in six months. At the time I didn't want to risk getting close and possibly hurt.

I guess it's easy to romanticize the past, but sometimes it's impossible to know how important someone is until it's too late. If I had to do it all over, there are two or three girls I'd try again with.

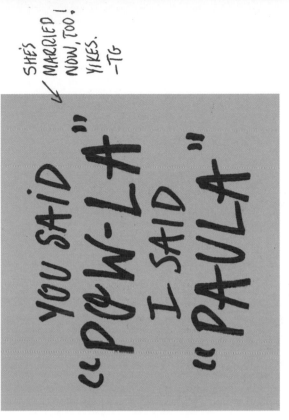

YOU SAID "POW-LA" I SAID "PAULA"

SHE'S MARRIED NOW, TOO! YIKES. —TG

She photographed me for a design magazine I was featured in. We had a great connection, but she wasn't over her ex-boyfriend, and I wasn't being serious enough.

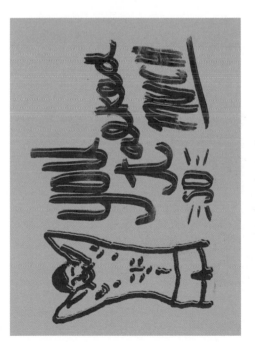

you talked it much =SO= MUCH

We had long late-night chats before we even met. We'd throw around crazy ideas for personal projects we could do together. On paper he seemed to have it all. He was a gorgeous underwear model, an architect, and a furniture designer. He was kind, smart, and owned the cutest dog. But when we met in person, our personalities didn't click. I became very shy, and he talked too much to compensate.

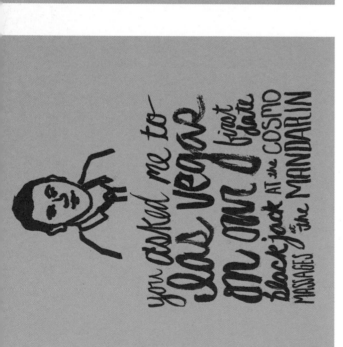

We drove the Pacific Coast Highway from Los Angeles to San Francisco, blasting Tom Petty the whole way, stopping in Big Sur to take in the awesomeness.

A good-looking math genius and professional poker player. The first night we met he took me to the Soho House, and he asked me to be his date for the opening night of a big tournament in Las Vegas. I'm a sucker for crazy, spontaneous proposals. We boarded the plane a few days later.

How do you feel about this relationship/project right now? Good, we had a really nice day. I used to collaborate creatively with my college boyfriend quite often, and this is something I missed in my last few relationships. It reminds me of the Charles and Ray Eames philosophy: Life is work is life is work is life. I am so grateful my work is my play and my hobby. The whole "life and work balance" concept always seemed so overrated.

... WERE IN *singapore*

Is there anything that you want to do differently?
We've taken the term "personal project" to a new level. I like that. I want to do more projects that test this boundary.

Additional comments? While all these romantic relationships have come and gone over the years, the relationship with my work is constant and never fails me. I was talking to my mom about this. She told me that as a child, I was always at my happiest when I was creating things. She dug up this old essay I wrote in school and mailed it to me.

We've all been on both sides of the coin. I can only think of the Bob Dylan line, "I didn't mean to make you so sad, you just happened to be there."

How do you feel about this relationship/project right now? Jessie has always been in the "friend-zone" to me, because I wouldn't want to screw up our friendship. But I must say that I was really enjoying her company today. I started thinking about possibilities.

HE WAS DEFINITELY BEING FLIRTY WITH ME ON THIS DAY. –JW

Is there anything that you want to do differently? Do I really like all this dating or is it just my ego? Do I really want to settle down or is that just pressure from society? Either way, I want to slow it down. I do miss having that one person you can connect with.

Additional comments? I left Jessie's that night and met up with my good friend and his boyfriend. As the three of us ate dinner, I observed how much consideration and respect they had for each other. They were happy. After spending a whole day analyzing my past relationships, I couldn't help but want that, too.

SHOUT-OUT TO WILL + EDU! xo –TG

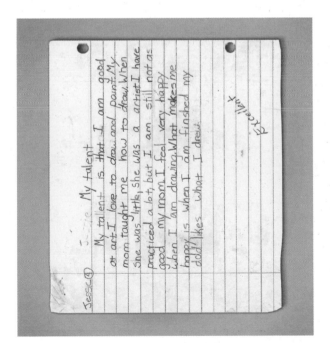

JESS@

My talent is that I am good at art I love to draw and paint My mom taught me how to draw. When she was little, she was a artist I have practiced a lot, but I am still not as good my mom is. What makes me happy when I am drawing. What makes me happy is when I am finished my dad likes what I drew.

Excellent +

Jessica Walsh

Did you see Timothy today? Yes.

What did y'all do together? We went to the Ace Hotel for drinks with a few mutual friends.

Did anything interesting happen? Earlier in the day I heard negative feedback from a few friends and

Timothy Goodman

Did you see Jessica today? Yes.

What did y'all do together? I had to be at the Art Directors Club for a Young Guns meeting tonight, and we planned to meet up afterwards at the Ace Hotel with our mutual friends Michael and Dan.

colleagues about this experiment. They all want to know if Tim and I are "really dating." They don't believe that it can be a real relationship if we are not physically intimate. They think it's a necessary part of the project. While I disagree, all the talk about sex and relationships did pique my curiosity as to what Tim's interests in me are. Beyond admitting that he found me attractive in therapy, I haven't sensed any desire from him to push it further.

I know from past experiences that I can be blind to these types of things. If a guy is interested in me, why can't he just be straightforward about it?! I hate trying to interpret ambiguous messages and signals. I'm too old and too busy to play these dating games.

Tim must have been able to tell something was on my mind as he asked what was wrong. I shared some of the criticism I heard earlier. I told him I thought it would be fine if we did the entire experiment just as friends but was open to possibilities. In retrospect, it was not the most opportune time to discuss this, since we had already had a few cocktails. Tim became defensive and argumentative. I think he felt pressured. I tried to talk him down and calm things down, but it felt as if he was misconstruing every word. Before we knew it, we were in our first fight.

I ACTUALLY DON'T MIND PRESSURE. I JUST DON'T LIKE PRESSURE FROM JESSIE! —TG

Did anything interesting happen? Michael and Dan left after a quick drink, so we stayed for another one with my friend Rich. I could feel some uneasy energy coming from her, so I asked her about it. Apparently some of her friends think this project is fake because we're not in a "real relationship." They all want to know if we are doing this project as friends, or if we're doing it as a couple. Jessie was clearly bothered by it. It's obviously something that she'd been thinking about as well.

I felt pressured to give her an answer, and we began to bicker about it. I don't want to fulfill some idea that her friends have. That's not what this project is about. We already are friends, so why do we need to define it any further right now? I can't just say "Voila!" and be in a relationship.

We left the Ace in a bit of a tiff. I walked her to a cab, and we gave each other a half-assed hug. Things felt super weird. It was the first time Rich had heard about this project, so he asked us a ton of questions about it. Then he was contemplating whether or not we should be having sex, which made things a bit awkward. Anyway, he sent this old movie trailer to

I WASN'T PRESSURING HIM, I JUST WANTED TO KNOW HIS THOUGHTS! —JW

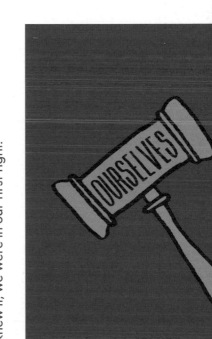

us afterwards. I can't stand Jeff Bridges, but this is hilarious in context.

SORRY TO ALL YOU JEFF BRIDGES FANS. —TG

Did you learn anything new about Jessica? She likes to define everything. She likes to doubt everything. I think she listens to her friends too much. This is an experiment—and you can't really define an experiment until it's finished, right? It's like getting a brief from a client; a client gives you the parameters, and it's up to you to play.

Did you learn anything new about yourself? Her doubts make me doubt, which makes me anxious. I just want to have fun. I don't need to define it all. Truth is, I probably could date Jessie in "real life" if I didn't already know too much. I know how quickly she falls for guys, how fast she wants things to go. I have commitment issues as it is, so this scares me. I need to drive slow.

How do you feel about this relationship/project right now? It's fine, I just don't feel great about it right this second.

Is there anything that you want to do differently? I felt pressured tonight, but I need to react differently.

Additional comments? Bad night, but at least we made some fun memories in the Ace Hotel photo booth!

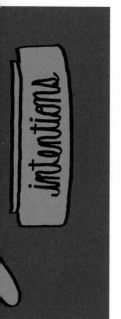

I've read that the source of most misunderstandings is that we judge others by their actions and ourselves by our intentions. I am sure Tim thought I was looking for answers, but I just wanted to talk things through. I'm just sorry I couldn't explain myself more clearly tonight.

YES, ADMITTEDLY I DO LIKE A BIT OF DRAMA. :) —TG

Did you learn anything new about Timothy? Tim seems to enjoy conflict on some level.

Did you learn anything new about yourself? I hate conflict and avoid it at all costs. Probably to a fault.

How do you feel about this relationship/project right now? After all this questioning about whether or not we are in a "real" relationship, I decided to look up the official definition. Gotta love Urban Dictionary.

Re·la·tion·ship
/riˈlāSHen,SHip/ 🔊

1. The ability to put up with somone else's bullshit, usually of the opposite sex, for a long period of time.

2. A bunch of obligations that two people have for each other that make both of them feel worse about themselves.

3. A bond between two people, that at first looks like happiness and joy but always ends in failure and pain. Usually caused by miscommunication or lying.

4. The reason for 70% of suicides in America.

5. A trap

Is there anything that you want to do differently? I can't let other people's opinions bother me if I want to make it through these forty days. I need to go with my gut—it has always served me well in the past.

Additional comments? Stefan (my business partner) left this on my desk. Hoping tomorrow will be better.

THESE
BADGES
ARE MADE
BY
BEST MADE
COMPANY.
~JW

Jessica Walsh

Did you see Timothy today? Yes.

What did y'all do together? Tim met me at the Art Directors Club gallery in Chelsea for the SVA student show. A few of my students had work displayed in the exhibition, so I wanted to be there to show my support.

Did anything interesting happen? My fellow teacher Kevin O'Callahan asked his 3D design students to re-design gumball machines based on a theme of their choice. When I put a quarter in, I received a capsule with something unique inside relating to their theme. The machine I was most excited about was themed "Curiosity." Inside the capsules were anonymous secrets from SVA students. I entered quarters and received two capsules for Tim and myself. It was almost too good. We had to laugh at the irony!

Timothy Goodman

Did you see Jessica today? Yeah.

What did y'all do together? I met her at the Art Directors Club SVA student show. Yes, it's the second day in a row I've been there—but we both teach at SVA, and I like to support our chairman, Richard Wilde.

Did anything interesting happen? We walked around the gallery and admired all the fun 3D projects. One of them asked students to transform or reimagine gumball machines in an unexpected and memorable way. My favorite concept was a machine that said, "Are You Curious?" For every quarter we put in, we got back a random handwritten secret in a capsule.

ONCE, WHILE DATING A GIRL WHEN I WAS 18, I STOLE HER UNDERWEAR. SHE WAS NOT HAPPY, TO SAY THE LEAST. —TG

Well, Jessie put a quarter in and got back a note that said something like, "I worry that I will never find love." We had a nice laugh about it, but I could see that it bothered her, that a part of her really feels this way. When I put a quarter in, I got back a note that said, "I take pictures of all my panties." Ha! Now that's my kind of a note.

I take pictures of all my panties

Here was the secret I received:

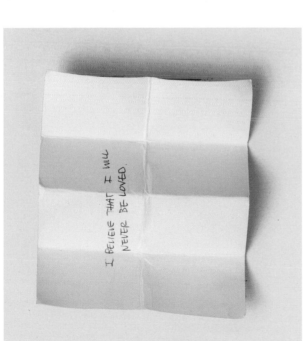

I BELIEVE THAT I WILL NEVER BE LOVED.

Here was the secret Tim received:

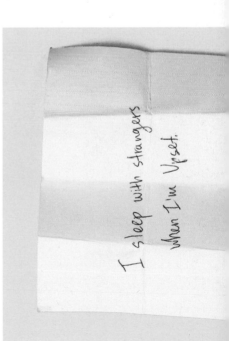

I sleep with strangers when I'm Upset.

Did you learn anything new about Timothy? Later in the evening Tim sent me a bunch of text messages asking me if I had met any hot guys after he left. I was kind of confused by them—was he jealous?! I had an ex-boyfriend who was extremely jealous and it drove me nuts. Why date someone if you don't trust them?

Did you learn anything new about yourself? My secret message made me think. This past year of dating has been tiring. The guy I was crazy for lost interest in me, and I wasn't as interested in the ones crazy for me. Why does it always seem to go that way? I researched it tonight, and there is quite a bit of science behind why we are so attracted to what we feel like we can't have. It's called "The Scarcity Principle." I guess this is how Tim gets all those girls!

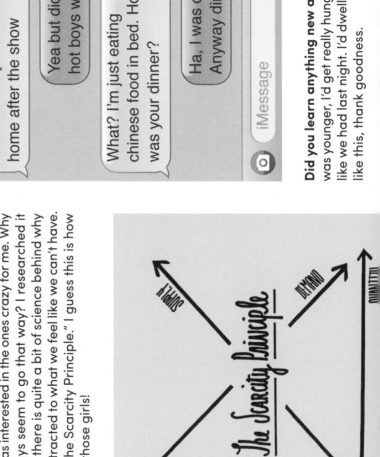

Did you learn anything new about Jessica? Later that night, I tried to flirt with Jessie a bit via text message. I enjoy flirting and being playful, but Jessie either takes me a bit too literally, or she just doesn't like to play back.

Did you learn anything new about yourself? When I was younger, I'd get really hung up on little arguments like we had last night. I'd dwell on them. I'm no longer like this, thank goodness.

THIS HAS
TO BE
ONE OF
THE MOST
AWFUL
WORDS EVER
~JW

According to this principle, if I want to attract guys, I should make myself scarce, play hard to get, and pretend I am not interested. This seems tiring! I'm hoping that if the right guy comes along, this won't be necessary.

How do you feel about this relationship/project right now? Tim and I exchanged a few emails this morning after our disagreement. I am feeling better about it all!

One more point ⬚

Timothy Goodman
to Jessica ▶

If we are doing this project as friends, then I see how that's "fake" to some people. But if we have sex on day 3 or 4, well that's fake, too. What happens is what happens no matter what that is.

⬚ ⬚ ⬚

Is there anything that you want to do differently? To-day made me think about the topic of secrets. I had kept a few very personal things to myself throughout my life, but getting them out lately via therapy has been a huge weight off my shoulders. I want to be more open. Keep no secrets.

Additional comments? I don't care how bad it is for you, MSG delivered straight to my door makes me happy. Nom nom nom.

IT'S ONLY
TRUE IF
YOU
PRETEND.
~TG

How do you feel about this relationship/project right now? Much better than I did yesterday! We talked during the day, and we said our "sorries." Although we did get into this discussion over email this morning.

Re: One more point ⬚

Jessica Walsh
to Timothy ▶

I agree. It's an experiment, lets just see how things go. I wasn't saying I wanted sex. I was just trying to talk through things that were brought up by other people, and better understand your intentions and feelings about how we are approaching it.

⬚ ⬚ ⬚

Is there anything that you want to do differently? I couldn't wait to get out of the Art Directors Club. I just need my own space after the last couple days. But I want to confront this energy because we still have a long way to go.

Additional comments? Seriously, the word "panties" has to rank among the top ten words. I even did some research on the word because I liked it so much. I'm not going to share said research, though. Some things are better left unaddressed.

Jessica Walsh

Did you see Timothy today? Yes.

What did y'all do together? We went to our second therapy session together. I felt bombarded with questions from the therapist. Although these question sessions are highly uncomfortable, they do push us to unexpected places.

Timothy Goodman

Did you see Jessica today? Yes.

What did y'all do together? We had our second appointment with our therapist.

Did anything interesting happen? I feel like Jocelyn was less intense with the questions this time. Jessie and

SHE JUST WENT EASIER ON TIM.
—JW

I talked about our families, and how our own relationships have been affected by our parents' relationships. We come from different family backgrounds, so we tend to think about things differently. I never met my biological father, and I grew up with two different stepfathers. Jessie's parents are still happily together.

Jocelyn said we need to use our time with her as a "safe place" to talk about things openly. I was much more open discussing things today than Jessie, who seemed distant and removed. I know she's very tired from dealing with a lot of stress at work. This project seems to only add another layer of stress to her life these days. I felt bad, so after therapy I went home and made her a little video.

Did you learn anything new about Jessica? Jocelyn said this project is good for Jessie. She said that Jessie dislikes the discomfort or awkwardness in the beginning of a relationship, which is why she gets serious so fast. I guess I knew this, but the way the therapist described it really made me have an "aha moment."

Did you learn anything new about yourself? We talked about the boundaries I put up in the different relationships in my life. I am good at being a friend, and I'm good at jumping in and out of a woman's life, but the emotional intimacy is where I've gone astray lately.

← THIS ISN'T ALWAYS THE CASE. SOMETIMES THE BEGINNING OF A RELATIONSHIP CAN BE FUN. —JW

Did anything interesting happen? I'm an overly curious person who questions everything from the workings of the universe to what's in my morning latte. I like to keep questioning, it keeps me learning. However I know I can take it too far and overanalyze things. When I can't figure something out, it can drive me a little crazy!

Since our disagreement at the Ace Hotel the other night, I've been overanalyzing the situation. Does Tim have an interest in me romantically? If he does, will he make a move, or will I? Why is it so hard for him to figure out what he wants? Is he really what I want? Why am I becoming insecure? Is this project crazy? Is this project making me crazy?

Our therapist asked Tim about whether he wanted an intimate relationship with me, which spared me having to ask the question. He admitted he was interested, but that he was confused about what he wants. He became anxious, he hates any kind of pressure. I may have to accept that I won't figure this one out anytime soon.

Did you learn anything new about Timothy? Truthfully, I didn't want to go to therapy today. I had a terrible headache and I am overwhelmed with work. The therapy session was emotionally draining, and afterwards I was feeling really down. Tim must have recognized this, as I came home after work to find this video in my inbox. It was super cute and reminded me how perceptive he can be.

WATCH IT ON OUR "40 DAYS OF DATING" VIMEO! PAGE ° →

I JUST WANTED HIM TO BE MORE OPEN ABOUT WHAT HE WANTS. —JW

WEIRD, RIGHT? I'M STILL FASCINATED.

How do you feel about this relationship/project right now? I'm totally fine with what's going on between us, but I don't think Jessie is. I can tell she wants more from me, even if she doesn't say so.

Is there anything that you want to do differently? The therapist asked me to try to give more intimacy to Jessie. I'm going to try. We just gotta keep on pushing!

Additional comments? After therapy, I was thinking about my childhood. I was a scrappy kid, always looking for the thrill of doing something "bad." When I was ten years old, I started stealing my stepfather's cigarettes and his old copies of *Playboy*. I would run into the garage and look at them with my friends in astonishment. It felt risky and grown-up. My favorite was the March 1989 issue with La Toya Jackson on the cover. I was a huge Michael Jackson fan as a kid and I found the La Toya issue to be so completely fascinating and dirty. Why would his sister pose nude for the whole world to see? Isn't that embarrassing for Michael? And moreover, why was I so turned on by this?

Did you learn anything new about yourself? In therapy we discussed my family dynamic. Both my parents and my grandparents married in their early twenties and had long, loving, happy relationships. The therapist talked about how this can unconsciously create pressure.

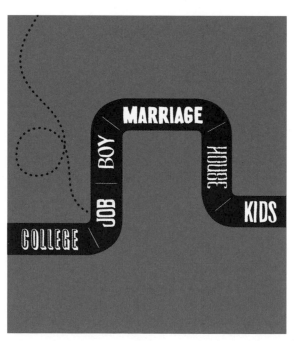

When I was younger, I did imagine following my family's path. I really thought it was just like The Game of Life: I'd go to college, meet a nice boy there, get married to him in my twenties, and have kids by the time

70

I was thirty. However, I moved to New York, where it's not as common for people to get married or have children in their twenties. I'm completely dedicated to my work right now, so I'm not sure what I want anymore.

How do you feel about this relationship/project right now? I can't deny that it's been stressing me out a bit, but Tim's video lifted my mood.

Is there anything that you want to do differently? I talked about the future with my own therapist, and why I feel any sense of urgency or pressure. My therapist says it's because I am a problem solver at heart. I am the kind of person who likes to figure things out, and I like things settled. I'm happy in most other aspects of my life, but romantic relationships is the one area that's been up in the air. He said I should accept the mystery of it all, and just enjoy the journey.

Additional comments? Still a big grin on my face from the video Tim made me.

Jessica Walsh

Did you see Timothy today? Yes.

What did y'all do together? I was working at Go Studios in Chelsea. Our studio was doing a creative session for Adobe for their new Creative Cloud branding. The photo shoot involved locking ourselves in a photo studio for twenty-four hours straight to "play" and see what we could make. I wasn't allowed to leave the studio space, so Tim came to visit me.

Did anything interesting happen? At one point in the afternoon I decided to use paint to cover our arms and legs, which we photographed as source material to create typography. The moment I finished painting myself blue, the elevator doors opened and Tim entered the studio space. I was pretty embarrassed! However, after four years of friendship, he already knows that I can be pretty strange.

Timothy Goodman

Did you see Jessica today? Yes.

What did y'all do together? Jessie was doing a twenty-four-hour event/installation for Adobe at Go Studios on 29th Street. I stopped by the space around 6:30 PM to say hello and hang out for a little bit. I brought my buddy BJ, who is a young man that I've been mentoring for the last four-and-a-half years through Big Brothers Big Sisters. I thought he would like to see the fun Jessie and her studio can have with creativity.

BJ LOVED IT ALL! —TG

Did anything interesting happen? We hung out, ate, and watched Jessie and her studio mates cover themselves in body paint. After an hour, BJ and I left to go see a movie.

Did you learn anything new about Jessica? I was thinking about our therapy session yesterday, and

72

how badly Jessie wants to be in love. I don't understand what she's worried about. She's a great catch: talented, smart, honest, attractive, humble, and successful. Last year I created a project where I attempted to draw a unique valentine for every single one of my Twitter followers on Valentine's Day. It's funny to think about the card I made for her.

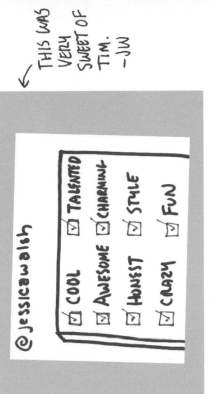

THIS WAS VERY SWEET OF TIM. —JW

@Jessicawalsh

☑ COOL ☑ TALENTED
☑ AWESOME ☑ CHARMING
☑ HONEST ☑ STYLE
☑ CRAZY ☑ FUN

Did you learn anything new about Timothy? Tim brought BJ, a sixteen-year-old kid he mentors through Big Brothers Big Sisters. I found it very sweet that he is a part of BJ's life. I know Tim has amazing mentors who have been an important part of his personal and professional development. It's great he is in a place where he can do the same for others.

Did you learn anything new about yourself? Usually I am an overplanner when it comes to photo shoots like these. But reflecting on past work, often the best results came when I wasn't trying so hard. They came out of periods of spontaneity, play, boredom, or even mistakes. So today was about just getting off the computer and just making shit. There was definitely a fear of failure, but we produced some unexpected and interesting things.

This makes me realize that I too often rely on working with a plan. I operate off of to-do lists. I can't even remember a meeting or dinner date if it is not in my iCal. These apps have become a second brain and they're starting to run (and arguably ruin) my life.

Did you learn anything new about yourself? I like to flirt, and it really hit me tonight that my flirting can't be used as a tool for anything more right now. Not exactly groundbreaking, but it's been a while since I had to filter myself. This is probably a good thing because I don't want to be the old guy in the club one day thinking that my flirting is cute when, in fact, it's just creepy.

How do you feel about this relationship/project right now? I feel good. It was nice to see her today. I don't know why I thought of this, but I noticed that we're both punctual people. As much as I don't love all her

YOU ARE REALLY

overzealous planning, I do appreciate that aspect. I feel like 90 percent of the girls I date are constantly late.

Is there anything that you want to do differently?
Nope, I think I was perfect today.

Additional comments? BJ is seventeen now, and I like to bring him around my work life sometimes, so he understands all the opportunities that are possible. As a teenager I was in constant search for an identity, always looking to fill the shoes of my missing father. I soon found an array of mentors in my life that I copied character traits from. They couldn't teach me how to shave, as a father might have, but they gave me the tools to gain confidence in my life. And it's no surprise that my relationship issues come from the same place, but perhaps a level of sincerity and a search will help that, too.

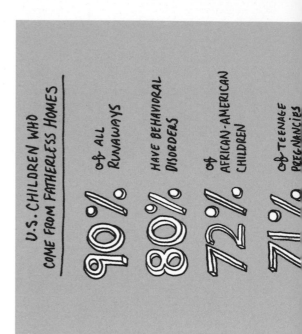

U.S. CHILDREN WHO COME FROM FATHERLESS HOMES

90% OF ALL RUNAWAYS

88% HAVE BEHAVIORAL DISORDERS

72% OF AFRICAN-AMERICAN CHILDREN

71% OF TEENAGE PREGNANCIES

RUINING MY LIFE

Even romance has become overly planned these days. Almost every single friend of mine has used online dating to find their partners, including myself. These websites collect your data, analyze it, assign you numbers through arguably arbitrary algorithms, and give you an ordered list of likely lovers. They tell you percentage-wise how much of a match they are, even how likely the person is to respond. We no longer search for romantic partners, we shop for them. Just like when looking online for a new pair of shoes, one can sort men by highest rated, size, popularity, even by color. While I admit it's all very practical, I have to wonder if it's caused me to miss out on spontaneous interactions or chance encounters. I don't even think to look around for guys in the real world anymore!

EXACTLY WHY I DON'T DO ONLINE DATING. —TG

How do you feel about this relationship/project right now? As I've been thinking about risks today, I keep coming back to something Jocelyn said in therapy. She thinks that in a way this project is cowardly. She asked why not just take the risk and just try to actually date, like the rest of the world. I think she senses there is interest on both ends, and she's trying to push us together.

Is there anything that you want to do differently? Risk failure in my life more often.

Additional comments? The photo shoot is over, and I haven't slept in forty hours. I might crash from exhaustion soon...

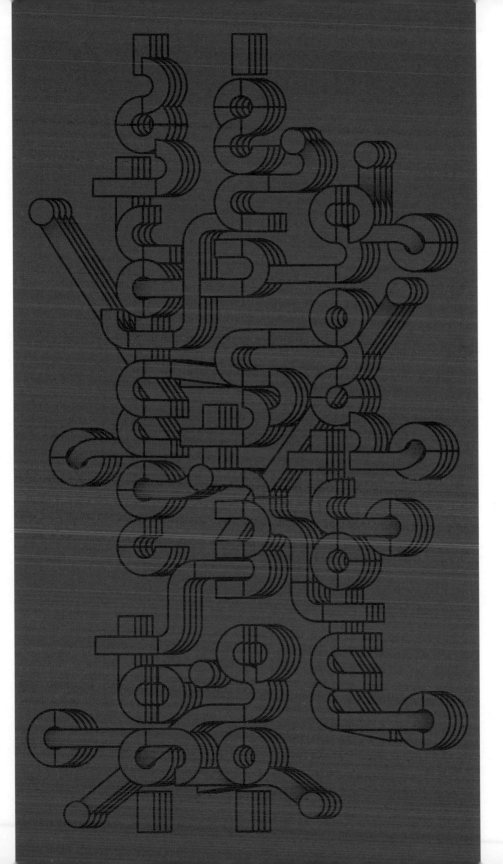

DAY TEN: MARCH 29, 2013

Timothy Goodman

Did you see Jessica today? Word.

DAY TEN: MARCH 29, 2013

Jessica Walsh

Did you see Timothy today? Yes.

What did y'all do together? Tim suggested ~~forced~~ me to go to a Knicks game at Madison Square Garden. I would never go to a basketball game on my own. Considering I haven't slept in days due to the Adobe shoot, I can't really say I was super excited about going. At least Tim was!

What did y'all do together? I took Jessie to her FIRST Knicks game. I mean, she's never been to the "The World's Most Famous Arena"!? Needless to say, I was excited. I love going to NBA games (this is my third game this month). Nothing is further away from the design community, nothing relaxes me and lets me escape more.

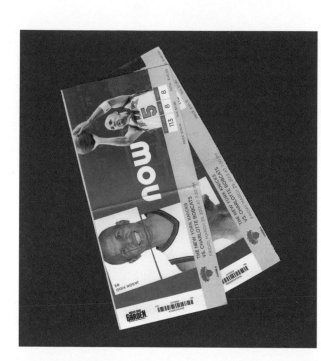

Did anything interesting happen? We talked a lot during the game. Luckily, the Knicks were destroying the Bobcats, so all this talking was totally fine.

SO THANKFUL FOR THIS, IT WOULD HAVE BEEN SO BORING OTHERWISE.

Did you learn anything new about Jessica? She bought sushi at a Knicks game. Really? I, on the other hand, ate a huge hot dog and a pile of bread pudding. I was proud that she ate a cupcake in the third quarter,

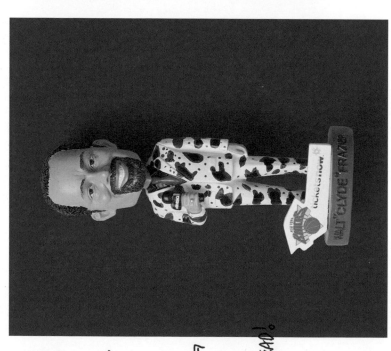

Perhaps it helped that I had very low expectations, but it turned out to be a really fun evening! I loved the food vendors and all the people-watching. We ended up talking through most of the game, which was fun.

WALT FRAZIER! –TG

WHAT A CREEPY BOBBLE HEAD! –JW

76

I also couldn't help but smile seeing how giddy Tim was about being at the game. It was really quite cute.

Did anything interesting happen? I ate sushi at a Knicks game. Yes, I went there, and it was pretty awesome. After the sushi, I was craving something sweet. I suggested that we split bread pudding from Magnolia Bakery, which is one of my favorites.

Did you learn anything new about Timothy? He is not very good at sharing. As we were paying for the bread pudding, he decided he wanted it all to himself and told me I should get my own! I didn't think I could finish a whole bread pudding, so I bought a cupcake instead.

though! Also, I noticed that Jessie and I rarely talk about design, which is refreshing.

Did you learn anything new about yourself? I have an affinity for NBA basketball because it reminds me of watching the Cleveland Cavs with my grandfather when I was a young boy. I think there's a bond that two people form together while watching a game among twenty thousand people.

How do you feel about this relationship/project right now? We're one-quarter of the way through this project, and I thought that seeing each other every day would be more difficult. I'm fine right now, but I can still feel that she is uncertain.

Did you learn anything new about yourself? I used to love sports, and I had an extremely active childhood. I played varsity soccer and lacrosse. I spent summers hopping from one fitness boot camp to the next. I

77

OF COURSE
I'D SHARE
AND GIVE
HER SOME.
I OFFERED
TO BUY
HER HER
OWN, I
WAS JUST
CRAVING!
-TC

[handwritten, top right] I KNEW IT, HE WAS VERY FLIRTATIOUS AND TOUCHY. —JW

Is there anything that you want to do differently? I wanted to invite her back to my place, but I was unsure of my intentions. So I didn't. I didn't want to lead her on. This is getting tricky.

Additional comments? It was still early in the night when the game ended, so I went down to Whole Foods to take care of some food shopping. I was thinking about the times I've actually met women in Whole Foods. (In the last six years, I've gone out with four women in six attempts.) The experience there is one that's designed for consumers to feel completely comfortable and friendly: the dark mahogany woods, the cool choice of music, the scents, the utilization of several floors, having a place to eat, and of course the organic food. It slows you down, almost to the point where you want to be there.

Now, you'd think a grocery store is a horrible place to meet a woman, right? They're focused on shopping, and the last thing they want is some guy hitting on them. Women are much more open to meeting someone if they're comfortable, though. The more comfortable women are, the less of a rush they're in, the more friendly they become. Whole Foods maximizes this collective effort of comfortability better than any of their competitors. Trust me, no one is friendly in a Safeway. The problem is that most guys don't know how to meet women outside bars, their workplace, or OkCupid. Meeting a woman in a public place can be difficult, and the guys who do hit on women in public places are usually creepers. However, women are undoubtedly impressed with a confident and spontaneous guy who has the courage to spark up a conversation in an atypical place like Whole Foods. It's much more exciting to meet someone when it's spontaneous. Men, you should learn how to create serendipity.

trained privately for eight years in Tae Kwon Do. I did hundred-mile cycling trips, ran track, played tennis, golf, and even basketball. Then I went to art school. Our basketball team was a joke at my school. Our basketball team was called "The Balls." The swimming team was "The Wet Dreams." The hockey team was called "The Nads." (You'd cheer "Go Nads!") Needless to say, I phased out of my sporty past, and in the past few years I've had no exercise. Lately I've been dealing with terrible headaches, back pain, and feeling sluggish all the time. Tim keeps nagging me to try exercising, and I do wonder if setting aside time for physical activity might be helpful.

How do you feel about this relationship/project right now? I could sense Tim being a little flirtatious during the cab ride home, but something was holding him back. I suppose it goes back to what we discussed in our therapy session. He's interested, but he's afraid to take the risk since he doesn't know what he wants. I think he's overthinking things.

Is there anything that you want to do differently? It was nice to get out of my comfort zone and try something new. I want to diversify my interests, as there are so many interesting things to do in NYC! Salsa dancing classes, anyone? Rock climbing? Mixology classes? Kickboxing?

Additional comments? The game tonight reminded me of my parents' relationship. They always said you need a "give and take" attitude in a long-lasting relationship. They are both business people, and early on in their marriage they developed a credits-and-debits "point system" to keep things in balance. Here's an example:

[handwritten, bottom left] NO THANKS! —TG :)

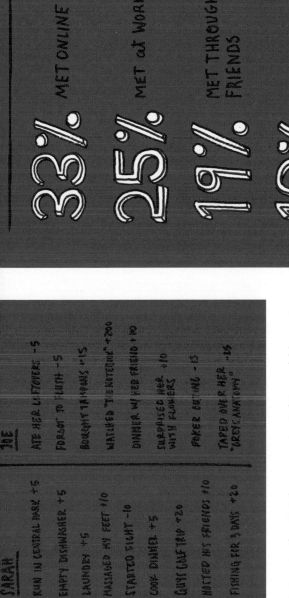

33% MET ONLINE

25% MET at WORK

19% MET THROUGH FRIENDS

10% MET at A BAR

SARAH

RAN IN CENTRAL PARK +5

EMPTY DISHWASHER +5

LAUNDRY +5

MASSAGED MY FEET +10

STARTED FIGHT -10

COOK DINNER +5

GUYS GOLF TRIP +20

HOSTED HIS FRIENDS +10

FISHING FOR 3 DAYS +20

JOE

ATE HER LEFTOVERS -5

FORGOT TO FLUSH -5

BOUGHT TAMPONS +15

WATCHED "THE NOTEBOOK" +200

DINNER W/ HER FRIEND +10

SURPRISED HER +10 WITH FLOWERS

POKER OUTING -15

TAPED OVER HER -25 "GREY'S ANATOMY"

Going to the Knicks game tonight would have to-tally earned me at least twenty points. I've already started plotting my revenge date. Gotta keep the T&J score in balance.

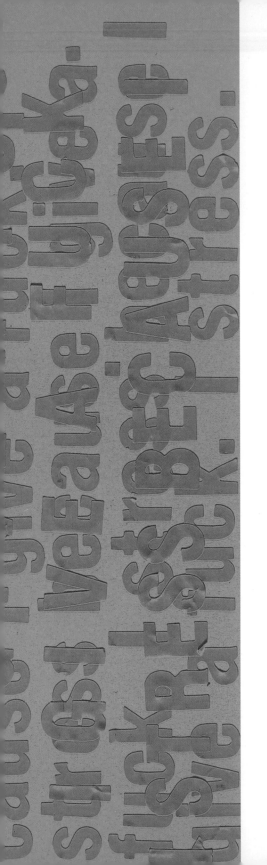

Jessica Walsh

Did you see Timothy today? Sigh.

What did y'all do together? Our friends Lotta and Jonathan were hosting an Easter potluck dinner with "the family." That's the nickname I gave our group of friends. We joke that I'm "Grandma," since I've been known to go to bed super early. Tim named himself the "Slutty Sister."

Mar 30, 2013, 3:57 PM

Tim, I think it's time to define the roles within our family. I am definitely grandma. What about you?

I'm the slutty sister.

Timothy Goodman

Did you see Jessica today? Oh boy.

What did y'all do together? Our friends Lotta and Jonathan invited us over to their place for an "Easter Feaster" dinner party with some other friends of ours, three other couples.

ALL OF OUR FRIENDS ARE COUPLES EXCEPT US. —JW

Easter Feaster 2013

Lotta
to Timothy

Hey all! This is what's cooking:

Loren + Dan
Asparagus Tart
Ravioli

Lotta + Jonatan
Carrots (w/herb and cream)
Lamb Stew

wife. Dan is the drunk uncle. Maayan & Lindsay are the distant cousins.

crackers / whatnot) and dessert?

Michael + Caroline
If you can make it, bring anything to complement the above!

xx L

Did anything interesting happen? Earlier today, I went to see the NYC 1993 show at the New Museum and the Gutai show at the Guggenheim. Gutai was a Japanese artist group led by Yoshihara Jirō. They did a large body of experimental work together in the fifties and sixties including paintings, installations, exhibitions, and films.

Did anything interesting happen? Jessie and I shared a cab on the way over there. I was already in a crabby mood from my day, and I ended up picking a fight with her. The last couple days she's been stressed, and when this happens, I can really feel that energy. This can be frustrating for me, so I think I took it out on her. Anyway, Jessie was in a great mood and she was inspired from museum hopping all day. She even brought me a bag of gifts. It was very sweet. I'm sorry I was being an asshole.

After the shows, my mind was racing with new ideas that Tim and I could collaborate on. I wanted to share a little of this inspiration with him, so I picked up several books for him at the museum gift shop. I thought it would be a nice "thank you" after the sweet video he made me the other day.

I gave him the books on the cab ride to Brooklyn and started to tell him some of my ideas. As he opened the gifts he became irritated and tried to pick a fight. Not the reaction I was hoping for! He said my fluctuating

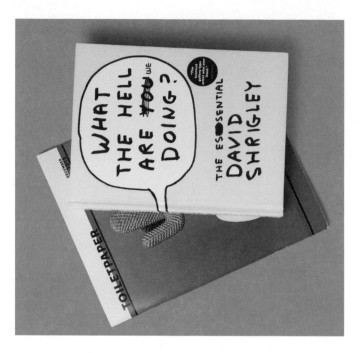

mood was stressful. I was a little tense leading up to my big photo shoot the other day but have since been upbeat and happy. His own moods fluctuate quite a bit, too. Yesterday he was happy, today he's crabby. Anyway, I was able to calm things down, but it definitely killed my mood. At least the dinner was wonderful! We feasted on asparagus pie, ravioli, and lemon cocktails.

Right after we finished eating, a few things happened in succession. First, a wave of exhaustion hit me. I didn't sleep at all the night of the Adobe shoot, and I only slept a few hours per night for the rest of the week. Secondly, I've been getting these terrible headaches lately, and it became unbearable after dinner. Next, I started to mull on Tim's reaction to the gifts from earlier in the evening. And lastly, I got a text message from that ex who broke my heart last year:

Mar 30, 2013, 9:57 PM

Hi Jessica. I just wanted to let you know that I will be moving away from NYC very soon.

iMessage Send

My heart sank. I thought I was over him, but I guess I've been holding on to hope. All I wanted to do was go home and crawl under my covers. Everyone was having such a great time, and I didn't want to kill the mood. I pulled Lotta aside and let her know what was going on, and then I left.

After the cab ride, I figured it couldn't get worse. Well, it did. Things were great until dinner, when everybody started asking us about the project. Jessie seemed uncomfortable talking about it, and she became very aloof. She eventually left without much explanation to anyone. Now, I'm at the dinner party feeling like the bad guy, and everyone is asking me why she left. D-R-A-M-A.

Thirty minutes later, she called me to say that we needed to "stop playing games." What does that even mean? I'm not playing games, I'm being cautious! As I keep reiterating, I'm not interested in leading her on or hurting her. Can't we just hang out, be cool, and see what happens naturally? I told her that we should

Did you learn anything new about Timothy? Tim can be grumpy and moody. I don't hold it against him, though. We can all get that way.

Did you learn anything new about yourself? I stress because I give a fuck. Whether it's in my work or my relationships, I'm very passionate. When I care about someone, I tend to care and empathize with them very deeply. Tim is starting to enter this "I care about you" zone, so I internalized his crabby mood. I let it get to me.

How do you feel about this relationship/project right now? Later that night, I decided to call Tim and tried to talk to him directly about what he was feeling. He's been overthinking everything and sending me mixed signals. He's both interested and scared to become intimate, yet he's still being flirtatious and showing signs of wanting more. Why is this so difficult? The back and forth is confusing, and I'm tired of playing guessing games about what he wants. He said he had had a few too many cocktails, and that he'd prefer to talk about everything in the morning.

I HATE DRUNK "TALKS." —Tc

Is there anything that you want to do differently? I shouldn't internalize the moods of the person I am with so deeply, it's been a source of stress in my past relationships.

Additional comments? All our friends at the dinner party were couples. I watched as they exchanged kisses, teased each other, laughed with each other, etc. I can't deny that I felt a little envious.

discuss this tomorrow, since we had both had too much rum cocktail.

Did you learn anything new about Jessica? Lately, I feel like her mood can sway at any given moment. I know she's stressed from her headaches—and my uncertainty is not helping—but her moods are draining me.

I FELT THE SAME ABOUT HIS MOODS! —JW

Did you learn anything new about yourself? She made a comment at dinner, jokingly saying I'm "controlling." I know I was a jerk in the cab, but now I'm controlling? It didn't make me feel so good.

How do you feel about this relationship/project right now? Not good. She seems very affected by this project. She wants more from me, and I feel pressured about it.

Is there anything that you want to do differently? Everything.

Additional comments? All I could think about was that line from The Real World, "When people stop being polite and start getting real." Yup, here we go.

Jessica Walsh

Did you see Timothy today? Yes.

What did y'all do together? We went to Easter brunch on the Upper East Side with Tim's old teacher Sara from the School of Visual Arts. I was impressed by how sharp she is for an eighty-five-year-old lady. We talked about everything from the latest museum shows, to the TV show *Girls*, to politics.

Timothy Goodman

Did you see Jessica today? Yessir.

What did y'all do together? We made plans to have Easter brunch with Sara, who's a former typography teacher of mine. Sara is in her mid-eighties, and she's always been really great to me. She's as smart as a whip, and I appreciate her wisdom and knowledge. She was shocked when I told her that I'd be bringing

Did anything interesting happen? Spending time with Sara reminded me of my grandfather who passed away years ago. Easter was one of his favorite holidays, and I couldn't help but become nostalgic at brunch. I remembered how he'd give me a chocolate bunny every year. I'd only eat the ears.

One Saturday over five years ago, my grandfather was rushed to the hospital with heart problems. I spent the day with him, and when visiting hours were almost over, I couldn't muster the courage to tell him how much I loved him. The next morning I missed the 8:05 train from Grand Central Station to Harrison, New York, by a matter of minutes. When I finally arrived, I knew from the look in my mom's eyes that he was gone. He passed only ten minutes before I got there. I was devastated that I never got to tell him how much I loved him. My mom suggested that I handwrite him a letter. However, Poppy was proud that he learned to email just a few weeks earlier, so I emailed him my letter instead.

YOU CAN READ THE LETTER ON THE WEBSITE. —JW

Jessica along. It's the first time I've ever introduced a girl to Sara.

Did anything interesting happen? After what happened last night, I figured Jessie wouldn't come to brunch. However, she called me early in the AM to say that she still wanted to come. I was happy about that, but I was also a bit nervous. No need to bring our drama around someone over eighty.

When I picked Jessie up in a cab, I gave her one of those chocolate Easter eggs. I was trying to be funny and make light of what happened last night.

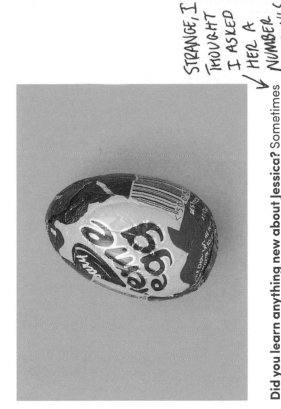

STRANGE, I THOUGHT I ASKED HER A NUMBER OF THINGS. —JW

Did you learn anything new about Jessica? Sometimes Jessie doesn't like to talk a lot. Sara was very excited to meet her, and she asked Jessie a lot of questions about her work. I know Jessie was super exhausted from the night before, and of course her headaches are horrible, but I don't think she asked one question the whole time. But hey, the apple crumble was amazing.

dear poppy

Poppy spoiled my grandma with love, attention, and so much food! He did everything for her. My mom

Did you learn anything new about yourself? I brought Sara flowers. I think it's important to be sweet and respectful to my elders, since I've always had a very close relationship with my grandparents. They're both creative people, and their personal lives and their relationship have always been a big inspiration to me. They love to travel, and my grandmother still sends me postcards. The one on the left is from last September. She sent me the one on the right when I was eight years old.

always told us that we should never settle unless a guy treated us like this. I looked for this in relationships when I was younger, but I always felt that it's unattractive when a guy holds me too highly on a pedestal. When Poppy passed, my grandma didn't know how to take care of herself. I think it's good to find the right balance of mutual support, with the occasional spoiling on both ends, but I don't want to ever depend on a guy.

Did you learn anything new about Timothy? Tim interacted with Sara with patience and kindness, which was nice to see! He told me about his own grandparents, and how close he is to them. It's nice to hear that family is important to him, too.

Did you learn anything new about yourself? Poppy imparted so much wisdom to my family over the years. He was full of what my family would call "Poppyisms," which were sayings that he'd repeat to us over and over and over.

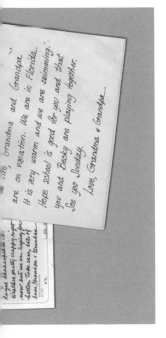

..., Grandma and Grandpa
are on vacation. We are in Florida.
It is very warm and we are swimming.
Hope school is good for you and that
you and Becky are playing together.
See you Sunday.
Love, Grandma & Grandpa

How do you feel about this relationship/project right now? Like the last couple days, my headaches today were severe. I didn't feel up for going to brunch, but it sounded important to Tim that I meet Sara, so I dragged myself there. It's really hard to enjoy anything these days, I am in so much physical pain.

→ I REALLY HAD NO IDEA ABOUT

Is there anything that you want to do differently? Poppy always said that if you have your health, you have everything. I need to take care of this headache situation. Friday I have an appointment to go to a neu-rologist—maybe they will have better insight thar my regular doctor. So it goes.

JUST HOW MUCH PAIN SHE WAS IN. SHE DIDN'T TELL ME EVERYTHING, SO I WAS SCHOCKED TO READ THIS STUFF. —TG

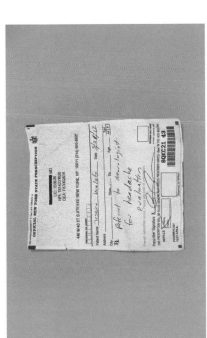

Additional comments? Tim was silent when Sara and I were discussing the most recent gallery and museum shows around New York. I'm only now realizing he doesn't enjoy the art world as much as I do.

How do you feel about this relationship/project right now? We didn't really talk about what happened last night, and that's fine by me. I feel like I'm walking on eggshells a bit. However, I gotta admit her Crazy is starting to turn me on.

Is there anything that you want to do differently? I can't stress out when Jessie stresses out. I can't let her mood swings bother me. We all have our problems, and I want to keep my cool no matter what happens.

Additional comments? Jessie looked cute at brunch. I like it when her hair is back.

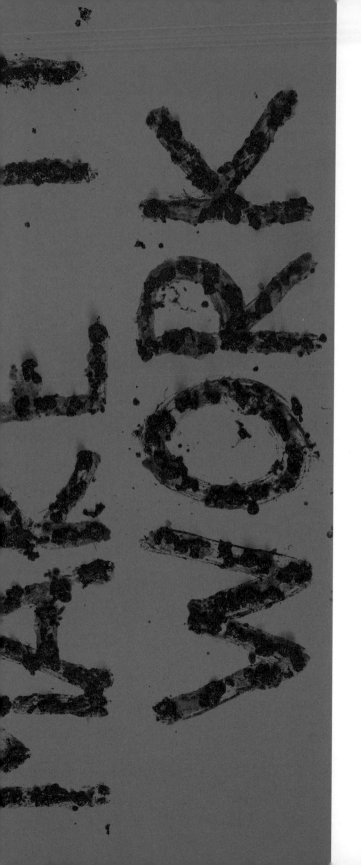

Jessica Walsh

Did you see Timothy today? Yes. Almost naked, too.

What did y'all do together? We went to the Aire spa in TriBeCa. I've been several times with friends, and I love the hot baths and steam rooms. Tim bought me tickets to the Knicks game last week, his happy place, so I thought I'd treat him to one of mine. I got us the two-hour pass that includes a one-hour massage.

Timothy Goodman

Did you see Jessica today? Yep.

What did y'all do together? Jessie got us spa time and massages at Aire Ancient Baths. It was "payback" for the Knicks game. I couldn't imagine a better payback!

Did anything interesting happen? While we were half-naked and sweating in saunas together, I brought up what happened Saturday night. She basically gave me an ultimatum: We either need to be just friends, or I have to tell her that I want more. Yes, I am interested in more, but it just feels too risky.

FUNNY, I THOUGHT I LOOKED LIKE A MESS. —JW

Did you learn anything new about Jessica? She looked all cute in her blue pants, beige sweater, and glasses. I feel like she wears black every day, so I was diggin' the changeup. Secondly, I saw her with no shoes in the spa (she's usually wearing heels) and I noticed that she walks pigeon-toed, which is super cute. Lastly, I like that Jessie can joke around about all this. I sent her an April Fool's email this morning.

Question for you □

Timothy Goodman
to Jessica ▶

Jessie,

We need to talk ASAP. I'm freaking out. I can't do this unless we have sex instantly and consistently.

Seriously. Otherwise, can I have permission to see someone else the rest of the 40 days?

Let me know your thoughts.

····

Re: Question for you □

Jessica Walsh
to Timothy ▶

Tim,

I'm freaking out, too. I can't do this unless you promise we'll be together forever.

Otherwise, I'm just going on Match.com to find a guy to marry.

Let me know what you think.

····

Did anything interesting happen? While we were in the steam room, Tim discussed why he didn't think a romantic relationship between us would ever work. This meant ten minutes of listening to him point cut all my quirks and weaknesses. If I didn't know him so well, I would have either written him off or gotten offended. I've known Tim for years, though, and I know this is his normal routine when he likes a girl.

As soon as he starts seeing a girl, especially a girl he really likes, he'll focus on bizarre things about her that bother him. These things are meaningless in terms of a relationship, but he claims they are deal breakers. A few months ago he dated a great girl who seemed to have it all, but he decided he should end things because he didn't like her shoes. Seriously. The next girl he said he liked hooked up with him too soon. The next girl he dated was amazing but she didn't like her career as much as he likes his. All of them are either too thin, too curvy, too quiet, too loud, not creative enough, not smart enough, have daddy issues, etc. The lists of these reasons go on and on.

IT'S TRUE. I'M TOTALLY SEINFELD. —TG

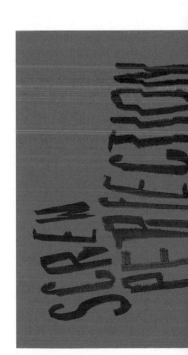

There is no such thing as a perfect relationship. People aren't perfect. No one likes perfection anyway, it's boring. Tim knows this. I think he uses these excuses to protect himself from getting too attached to a girl. I think the fears that if he gets too close he'll lose control of the situation and get hurt.

Did you learn anything new about Timothy? In the steam room I noticed he has a big tattoo sleeve on his upper arm. I don't know how I missed this before. We talked about the meanings behind his tattoos and when he got them. He told me that one of his ex-girlfriends got a tattoo of his name. She wanted him to have her name tattooed on him as well, but they broke up before he went through with it.

Did you learn anything new about yourself? In middle school and early on in high school, I had serious struggles with perfectionism. I was terrified of breaking rules, I never had the guts to stand up for myself, and I had a massive fear of failure. I became shy and withdrawn, as I feared I might say something wrong. I hated my appearance, and I pushed myself too far at times.

Many years and many hours in therapy later, I've come to realize that the more I tried to reach perfection, the further I would get from it. I happily learned to embrace my quirks and weaknesses, and focus my energy on my strong suits. I am far from perfect and I want to continue to learn and grow. However, I also want to be with someone who can accentuate my positives, not focus on my negatives.

How do you feel about this relationship/project right now? I have now admitted to Tim on a few occasions that I like him and I am curious to see if something

Did you learn anything new about yourself? Today I was chatting with one of Jessie's close friends. She wants me to stop the project because of Jessie's recent health issues. She said that Jessie "needs friends, not experiments." It made me feel badly, because I want what's best for Jessie, too! Jessie is a big girl, and if she wants out, then she'll quit. She then asked me why I'm doing this project, what's in it for me. I told her that I really believe it's testing my capacity for intimacy. I haven't emotionally let a woman in my life for a while, so opening up to Jessie and not having some kind of motive feels really nice.

How do you feel about this relationship/project right now? I'm concerned about our talk in the spa. What happens if we "go there" and then I don't want anything else after the forty days? Won't Jessie feel used? I'm not trying to "hit and quit it." I think a relationship with an expiration date is actually worse.

Is there anything that you want to do differently? Jessie was mildly talking about quitting the project or making it shorter. After the spa, I sent her a "BIG-ASS MESSAGE," but she didn't respond. I was just trying to be funny about the situation.

MY EX
ACTUALLY
WROTE ME
WHEN SHE
READ THIS.
–TG

ME YOT, JESSIE!

more could develop between us. We still have to see each other every day for the next twenty-seven days, so if there was ever a time to try this out, why not now? Needless to say, he's still confused and continues to send me mixed signals.

Is there anything that you want to do differently? I suppose I should listen to our therapist, who said I should be careful of how close I let myself get to Tim. He seems to be unable to admit to the idea that he likes me, so will he ever be ready for something more? Perhaps it is better we just stay friends.

Additional comments? My insomnia is now full-blown because of the headaches. I've been trying out various medications, and while they help me sleep, they make me extremely tired and foggy during the day. Thankfully my doctor's appointment is tomorrow.

Additional comments? Everyone was teasing me Saturday night after Jessie left the dinner party. They said that I'm getting all the bad parts of a relationship without any of the good parts. Dammit.

TO COMMI_ _SELF
YOU_ _SELF
IS TO R N

THE RI_K OF
BE_RAYAL

Jessica Walsh

Did you see Timothy today? Briefly.

What did y'all do together? We grabbed a coffee at the Grey Dog, a cafe in Chelsea.

Did anything interesting happen? I finally got the official diagnosis from my doctor:

Cluster headache

From Wikipedia, the free encyclopedia

Cluster headache is a condition that involves, as its most prominent feature, an immense degree of pain that is almost always on only one side of the head. Some doctors and scientists have described the pain resulting from cluster headaches as the most intense pain a human can endure — worse than giving birth, burns or broken bones. Cluster headaches often occur periodically: spontaneous remissions interrupt active periods of pain, though there are about 20% of sufferers whose cluster headaches never remit. Some people affected with cluster headache have committed suicide, leading to the nickname "suicide headaches."

Timothy Goodman

Did you see Jessica today? Awkwardly, yes.

What did y'all do together? We met at Grey Dog for breakfast. Funny enough, we tried to meet here right after we first met four years ago. Evidently, she thought I was hitting on her back then—which I was actually NOT doing. I really liked Jessie when I met her, and I respected her work. I just wanted to get to know her better.

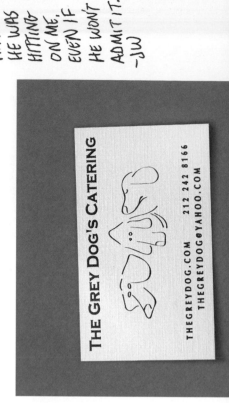

THE GREY DOG'S CATERING

THEGREYDOG.COM 212 242 8166
THEGREYDOG@YAHOO.COM

HA! HE WAS HITTING ON ME. EVEN IF HE WON'T ADMIT IT. —JW

Did anything interesting happen? We talked about our "relationship," but everything about our conversation felt so heavy. It was full of innuendos and cryptic bullshit. I felt like we just needed to be more honest with each other. I took out my notebook, ripped out a couple sheets of paper, and suggested that we write "pros" and "cons" about this project/relationship. It's always easier to be honest on paper, but I don't think this really changed anything.

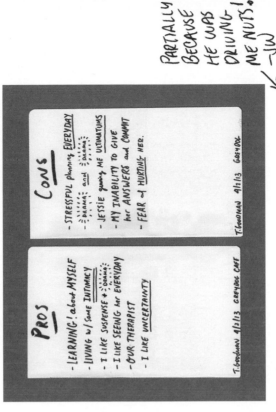

PARTIALLY BECAUSE HE WAS DRIVING ME NUTS. —JW

Did you learn anything new about Jessica? She's always too busy, too stressed, and ultimately too serious these days. I know the headaches are getting worse, and now she has insomnia, too. I feel really bad for her—and on top of it all, she's under a lot of pressure at work. When I worked at Apple, I would rush home to do freelance work until 2:00 AM every night. I was always putting pressure on myself. Jessie

Lovely, right? I did feel somewhat relieved that the description at least touches on the absolute hell I've been experiencing the past few weeks.

I tried to talk to Tim about how this project is becoming an additional layer of stress in my life. I just can't handle this while I'm experiencing my recent health issues. I asked him if we could just call the project "14 Days of Dating" and end it. He sort of laughed off my suggestions, pulled out his Moleskine, and had me fill out a PROS and CONS list about whether or not we should continue the project.

WOW. AGAIN, I HAD NO IDEA IT WAS THIS SERIOUS. —TG

Did you learn anything new about Timothy? I didn't realize until today how different our work situations are. He works for himself, and at the moment, his schedule is relaxed. I work with a team of people in a studio environment with a more consistent work flow. It's very difficult for me to make time to see him every day.

Did you learn anything new about yourself? Tim and I talked about my "all or nothing" outlook on life and in relationships. I like to do things 100 percent or not at all. However, I know life isn't always black and white, and whether I like it or not, this relationship is forcing me to accept shades of gray.

How do you feel about this relationship/project right now? I'm already overwhelmed and this relationship isn't helping. Around lunchtime, we were chatting on instant messenger. I became busy with a client call, and I had to get some art files out to the printer. Our chat window became buried behind layers of documents, and I didn't check it for a couple hours. When I did, I was greeted with this:

does the same thing. She'll do whatever it takes to be in control, and she certainly doesn't like it when someone worries about her. She reminds me of my mother that way. My mom would lie to us about her health if it meant no one would worry about her.

Did you learn anything new about yourself? I feel a lot of pressure from Jessie. I like a bit of uncertainty, and I like living in the questions. I don't like having to live up to some idea or to fulfill some expectation, though. I don't think she even realizes she's doing it. The whole situation is making me feel very unsettled, and she wonders why I'm being so wishy-washy.

How do you feel about this relationship/project right now? After two weeks, I feel much closer to her, much more intimate, and I'm attracted to her. On many levels, I am enjoying this. However, because of what's going on with her, I do feel vulnerable. When I got back to the studio, I saw this movie trailer with a voice-over that said, "To commit yourself is to run the risk of betrayal, the risk of failure." Seriously, Universe?

Is there anything that you want to do differently? I just want us to find some sort of normalcy. We've been overanalyzing everything and getting way too serious about stuff lately. The parameters of this experiment seem to be backlashing on us. If this is what it's going to be until the end, then kill me right now.

Additional comments? It never struck me until today, but Jessie sorta has an Eddie Murphy laugh! (In a cute girl-way, of course.)

ADMITTEDLY, SLOW DIGITAL CORRESPON-DENCE IS A PET PEEVE OF MINE. —TG

HA, I DO. IT'S PRETTY BAD. :^)

To: Timothy Goodman

Did you finish that animated typographic piece you were working on? Can I see it or do I have to wait?

Did you get new medication at the doctor?

What do you want to do tommorow?

Something different like go to a jazz club? That could be fun?

But I'm also down to just do somethign chill like go to a movie, do you know what is playing?

Jessie I see you on your studio web camera. I know you are sitting at your computer.

Can you just respond to me please?

So now you are not talking to me now?

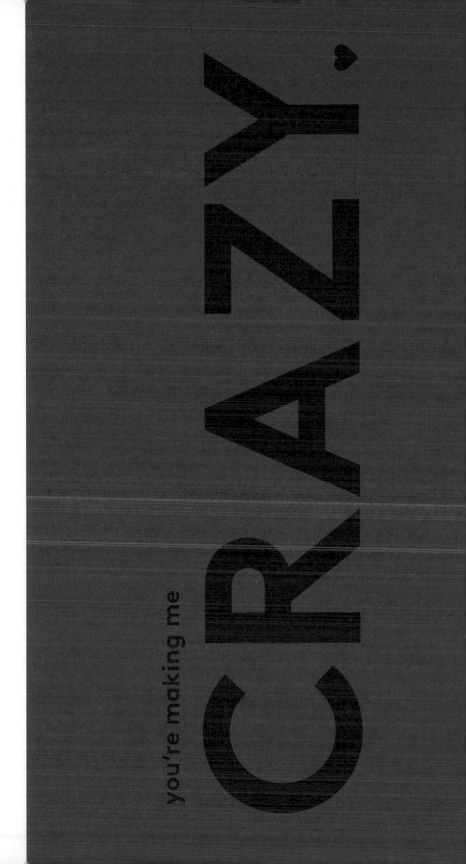

AIM & Jabber
Away

Is there anything that you want to do differently? I've read scientific studies that say if I pretend I'm in a good mood, or if I fake a smile, I can actually trick my brain into making me feel better. Well I tried it today, and I am sad to say that it does not work.

Additional comments? No, not today.

you're making me CRAZY.

Jessica Walsh

Did you see Timothy today? No.

What did y'all do together? We spoke on the phone.

Did anything interesting happen? I had dinner last night at Roberta's Pizza with a few girlfriends. Afterward, I shared a cab ride home with one of my closest friends. We talked about this project and my health. I broke down crying. I told her how overwhelming everything has become with my headaches and insomnia. I've been researching treatment solutions for the headaches, and the options are not good. The pills they've given me are extremely addictive and they cause rebound headaches. Surgery or anesthetics could be a possibility, but sound risky. The idea of living a lifetime in this pain is depressing.

My friend told me that she asked Tim several days ago to end the project because she was so worried about me. The more time I spend with Tim, the more I really care about him. Learning this made me wonder if Tim might care more about this project than he does about my well-being.

Did you learn anything new about Timothy? One of the girls I was at dinner with admitted to sleeping with Tim many years ago. This is the third time this week that I've learned he's been with someone I know.

Did you learn anything new about yourself? Growing up, my parents put a huge emphasis on perseverance.

Timothy Goodman

Did you see Jessica today? No.

What did y'all do together? We didn't see each other today because I woke up this morning to a text message at 3:48 AM:

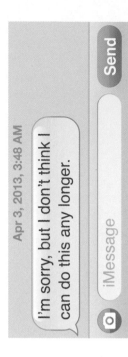

Did anything interesting happen? Jessie went out with a bunch of girlfriends last night. Now, from what I gathered (without sounding too gossipy), this is how it went down:

This project came up in conversation during the course of the night, and it sounds like she was slightly ridiculed for doing a project like this with me. I feel like I was made out to be some sort of heartless Lothario. One girl who was there (whom I still consider a friend) is someone that I slept with over five years ago. I guess that fact came up, too. Obviously, Jessie has already been struggling with her health, and the project, so I think this just solidified her decision to walk away.

It's hard not to be disappointed, but I'm not going to fight her about it. She has to do what's best for herself,

SHE + I HAD A NICE CONVERSATION ABOUT THIS RECENTLY. —TG

One of my most vivid memories was when I desperately wanted to quit Tae Kwon Do training after receiving a yellow belt. I just had way too much going on with school and other sports. They convinced me to stick with it, and I was grateful. Receiving that black belt felt unbelievably rewarding.

Since then, I've always tried to work through bumps and failures in all aspects of my life. This means relationships, too. I don't give up easily, and I will try to work through all the issues before resorting to breaking up. However, this perseverance strategy seems to only prolong the demise of a doomed relationship. My mom always says that when you meet the right person, it all just clicks. Everything feels easy, and you just "know." I guess in the context of dating, perseverance is not necessarily the best solution.

How do you feel about this relationship/project right now? After I got home from dinner last night, I couldn't sleep. I contemplated continuing this experiment. I hate the idea of giving up on a project that I was excited about, and I don't want to let down someone who I care about so much. On the other hand, I am in serious fucking pain and this project is making me a little crazy. Sometimes life shits on you and there doesn't seem to be a right way forward.

Is there anything that you want to do differently? After much consideration, I've decided it's best to end the project. While I hate to quit, my friends are right: I am too ill and have too much on my plate. I need to focus on my health and get rid of any unnecessary stress in my life.

Additional comments? Sorry, Tim.

and it seems like this project has become too much of a burden for her considering her health issues. I just wish we could have had a conversation about it.

Did you learn anything new about Jessica? I'm learning that she can be very easily swayed. I wish she had stood up for herself, and I wish she had stood up for me. While I understand that her friends are only looking out for her, she knows me better than any of them. That's what bothers me. Sometimes friends can very easily make it an "Us vs. Them" situation.

Did you learn anything new about yourself? Our past will always come back in some form, and we have to be ready to deal with it. When I was younger, I gave guilt trips to some of my girlfriends about their past relationships. Thankfully, I don't do that anymore, and this is a reminder of how much it sucks to be judged for my past.

How do you feel about this relationship/project right now? This relationship is ruining our relationship. The main point of this project is for Jessie and me to work on our past issues with sincerity. I'm trying to support her through these headaches, and I've deliberately tried to not let anything sexual happen with Jessie for fear of screwing things up. Yet, I feel like my past is still being used as a way to divide us.

Is there anything that you want to do differently? Everything. How can I purchase a time machine?

Additional comments? We talked a couple times during the day. Honestly, I don't know what to say.

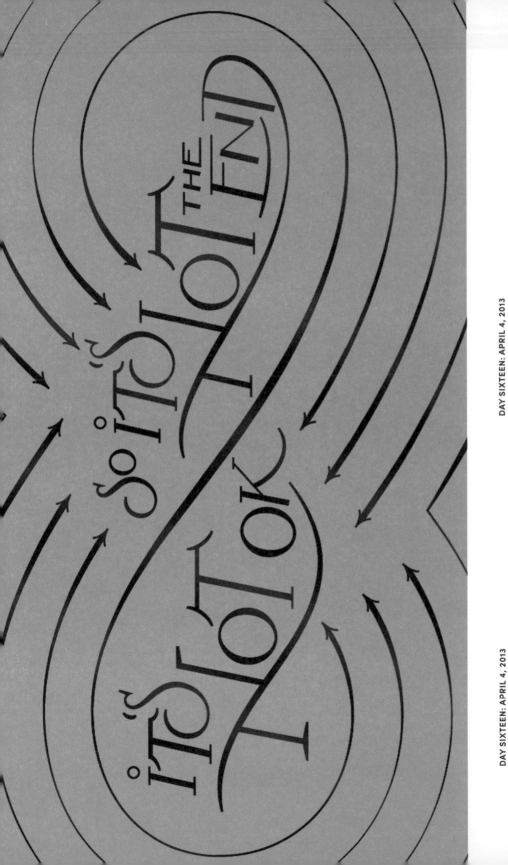

DAY SIXTEEN: APRIL 4, 2013

Jessica Walsh

Did you see Timothy today? No.

What did y'all do together? We tried to meet up to discuss the end of the project. However, I had another

DAY SIXTEEN: APRIL 4, 2013

Timothy Goodman

Did you see Jessica today? Nope.

What did y'all do together? Jessie called me last night and asked me if I still wanted to do the project.

WE'RE BOTH CRAZY! —TL

doctor's appointment and had to work very late on client work at the studio. We talked on the phone a few times throughout the day instead.

Did anything interesting happen? Tim sounded extremely sad and disappointed that I wanted to end the project. At times in the conversation he sounded vulnerable and insecure. He doesn't want to let go, he really wants us to make it through the full forty days. As the conversation progressed, the guilt of quitting on him started to eat away at me.

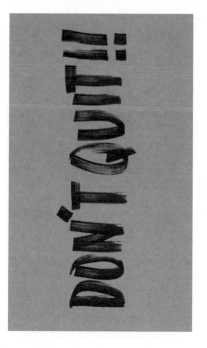

I also couldn't help but remind myself that his fear of abandonment is very real, and this is just adding to the guilt. Even if this isn't a romantic relationship, I don't want to abandon him. I gave him my word, and I want to honor my commitment. But things are not okay, and we both need to figure it out. It reminds me of this saying: "In the end, everything will be okay. If it's not okay, it's not yet the end."

I called him late tonight to let him know I was willing to push through and continue with the project if he was, too. He said he was.

I told her I was obviously still up for it, but she needs to be sure.

Did anything interesting happen? We agreed to just focus on each other. We tried to hang, but she was working late, and I had a dinner with my studio manager. Which is fine. I think it's good to let the emotions simmer down before we start up again.

Did you learn anything new about Jessica? I really think she's crazy. And I really think it's turning me on.

Did you learn anything new about yourself? Sometimes it's hard for me to let things go. All day I was thinking about what Jessie's friends said yesterday. I

Did you learn anything new about Timothy? Tim continues to be wishy-washy around the romantic possibilities between us. He continues to show signs of interest through flirtation, but when I try to reciprocate, he pulls back. It's confusing.

Did you learn anything new about yourself? His ambiguity stirs up some insecurities on my end, too. If I like a guy and he's interested, then that's great! If not, I move on. I don't need to chase him. It's not possible to move on in the context of this bizarre experiment, though. I have to see him for another twenty-four days, so my mind just wanders in circles. He says he wants to change and settle down, and he says he's interested in me, so then what is the hold up? Is he really that afraid? Is he looking for something that I don't have? Why do I care so much?

How do you feel about this relationship/project right now? I'm now 100 percent committed to finishing the experiment with Tim.

Is there anything that you want to do differently? I need to become more comfortable with ambiguity. And I need to let go of the hopes that this could turn into something more.

Additional comments? The doctor gave me a new medication to try. I want to stay positive about it all. Like other shitty things in life, I am confident this too shall pass.

have to live with the consequences of my actions, but hearing this brings new perspective. I'm thankful for it.

How do you feel about this relationship/project right now? Jessie and me against the world!

Is there anything that you want to do differently? I have to give her more certainty and intimacy, and I hope she can get some help with her headaches and insomnia. We need to find some sort of balance or we'll never make it.

Additional comments? I told my buddy Greg that the project was back on. We're both super paranoid about going bald, so this gave me a much needed laugh.

Jessica Walsh

Did you see Timothy today? Yes.

What did y'all do together? We had our weekly therapy session with Jocelyn.

Did anything interesting happen? I talked to my personal therapist about Tim's fear of trying this with me, despite his obvious interest. My therapist reminded me how insecurity is at the core of the fear of commitment. He suggested that I could try being completely open with the reasons that I like him, which might make him

Timothy Goodman

Did you see Jessica today? I did.

What did y'all do together? Therapist appointment.

Did anything interesting happen? We talked about Jessie quitting the experiment and what happened a couple days ago. Jocelyn talked about how vulnerable we are to our friends' opinions. Ultimately, some of the things our friends are saying are a mirror of what we're actually feeling. That's why we don't like hearing them. We also discussed the idea of taking our relationship

feel more secure. He quickly followed this statement by warning me that this plan very well might backfire!

I used our couples therapy with Jocelyn as the time to try this. I put it all out there: I think he is good-looking. He is fun to hang out with, and we always have a great time together. He's as spontaneous and silly as I am. He's as crazy as me, but in different ways. He's honest, open, and kind. He makes me laugh! I respect him and his work. He is interested in self-growth. He's sensitive and smart. He understands my passion for design, but we don't need to talk about it all the time. Last but not least, we work great together creatively. It's very important to me that I find someone I can collaborate with, formulate ideas with, and just make shit with. I also know how rare it is to find this.

After I told him all this, Tim seemed genuinely confused and taken aback. He asked me how I could possibly like him considering everything that has happened, considering his past, considering his reputation, considering that he has blond hair and that he's not my usual "type." I told him that besides his serious commitment issues and all the shit that goes with it, I think we could be a pretty good fit.

Did you learn anything new about Timothy? He said he is concerned about what people will think of him if the relationship becomes intimate. He's worried about falling back into his old habits and hurting me. Jocelyn reminded him that all relationships are a risk. I reminded him that I understood the risks, and thought that we were both over thinking things. Lets just try this out.

Did you learn anything new about yourself? After all the discussion today about commitment-phobia, I read a few articles on the topic. Tim definitely meets most

further and what that could mean. Although nothing has become physical yet, she said we're both doing what we always do in relationships: Jessie wants more and more, and I pull away more and more. Now, it's up to us to tackle this. Are we going to fall into the same habits or are we going to switch up?

Did you learn anything new about Jessica? Jessie got rest! She's upbeat, positive, and full of life. She's like a completely different person. I love this. Also, lately she's had her glasses on and her hair up, which I'm a sucker for. Who doesn't like the sexy librarian look?

Did you learn anything new about yourself? We discussed what her quitting means to me. Jocelyn brought up an interesting point: How often do you ever get to hear what people really think about you? Everyone has a reputation in one way or the other, but do you ever get to hear about yours unsolicited? **How do you feel about this relationship/project right now?** Jessie was very open today about being

interested in me. I feel bad that I'm confused about what I want, but after what happened the other night, I'm even more defensive about it. I feel like we're just going in circles with this. If she could just ease up on the gas a bit, then I'd be more willing to come around.

Is there anything that you want to do differently? We need to get back on track and take it slowly.

Additional comments? I had dinner with a good buddy of mine tonight. He's in a serious relationship, and during our conversation, something dawned on me: All my friends who are in serious relationships think being single is just NONSTOP fun. I guess they believe this because (1) it's been so long that they forgot what it's like, and (2) they're only hearing the highlights. For example, if I can use the "Baseball Metaphor" in a different way: Watching baseball is long and boring and the excitement spreads over nine innings, but if you catch the highlights on ESPN then you get to see all the action jammed into a two-minute span. My friends only hear the highlights once a month, but they don't hear about all those long, tireless innings full of eating bad food and drinking beer alone in the stands. If Jessie and I were using a scorecard for the first seventeen days of this project within the "Baseball Metaphor" rules, it would be wildly uneventful. Remember: First Base is kissing; Second Base is hands under dress; Third Base is hands in the pants; Home Plate is sex. This is how my scorecard would look.

	1	2	3	4	5	6	7
Walsh						WP	
Goodman						G	

of the criteria for being a commitment-phobe. And I definitely relate to that last line!

THE SIGNS of a PHOBE COMMITMENT

LONG HISTORY of BRIEF RELATIONSHIPS

OFTEN MOODY AND *hates* PLANNING

CHOOSES JOBS THAT ARE ⇒ *flexible* ⇐

DOESNT WANT YOU TO MEET FAMILY & FRIENDS 🏠

YOU HAVENT SEEN HIS HOME 🏠

🕐 LAST MINUTE PLANNER

LOOSES INTEREST WHEN THINGS GET SERIOUS 🐎

ATTENTIVE AND *charming* WHEN YOU'RE TOGETHER

HE MAKES YOU FEEL *crazy*

8	9	10	11	12	13	14	15	16	17
				K		K		I	
			FO	WP					

1B - SINGLE BB - WALK K - STRIKEOUT FO - FLYOUT
2B - DOUBLE HR - HOME RUN I - INTERFERENCE FO - FOUL OUT
3B - TRIPLE SB - S. BASE G - GROUND OUT WP - WILD PITCH

How do you feel about this relationship/project right now? He knows all my feelings about him now, so the ball is really in his court. I am interested to see how this will unfold.

Is there anything that you want to do differently? I want to have fun with this all, no matter what happens.

Additional comments? While I am still not feeling well, I'm realizing how much a positive outlook can help. I feel optimistic today.

Jessica Walsh

Did you see Timothy today? Yes.

What did y'all do together? My design/business partner Stefan and his fiancée, Veza, left a letter on my desk at work. It said "40 days." One evening for Romance. Much love." Inside were two tickets –o go see Leonard Cohen at Radio City Music Hall. So lovely and thoughtful, as they always are!

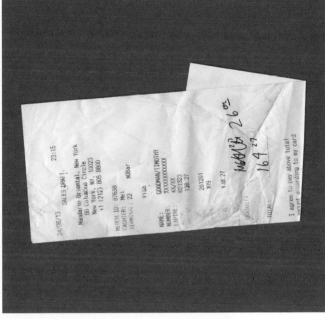

I FOUND
THE TICKETS
A FEW DAYS
LATER IN
MY DRAWER.
—JW

An hour before the show I couldn't find the tickets anywhere. I tore up my apartment trying to find them but they were nowhere to be found. I was extremely embarrassed and angry at myself. I'm normally more responsible, but the last few weeks have been

Timothy Goodman

Did you see Jessica today? Yes.

What did y'all do together? Her partner Stefan gave us tickets to see Leonard Cohen at Radio City Music Hall. However, an hour before the show started, Jessie couldn't find the tickets! We still tried to get in, unsuccessfully. Since we were already in Midtown, I suggested that we go to one of my favorite hideaways, MObar at the Mandarin Hotel.

NY MEN :
TAKE A
CROW YOU
LIKE HERE
IF YOU'RE
IN THE
AREA!
—TG

Did anything interesting happen? A couple hours later, we were holding hands. It felt like a big relief. We left around 11:00 PM, started making out in the cab, and we went right to her apartment. I feel close to her, but I'm also worried about what will happen after hooking up now. I hope I don't get a thousand questions.

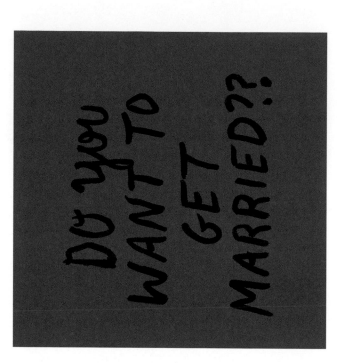

DO you WANT TO GET MARRIED??

Did you learn anything new about Jessica? She felt horrible about losing the tickets. She tends to dwell on that energy and criticize herself even more.

Did you learn anything new about yourself? I have powers that I didn't know were possible. She wanted me to stay over, but I left her apartment around 1:00 AM. We didn't have sex, and I feel good about that decision.

overwhelming and I feel frazzled. I couldn't believe my stupidity, and it bothered me the entire night.

Tim thinks I need to go a little easier on myself. Tim suggested we head over to MObar at the Mandarin Oriental Hotel. We had a few ginger mojitos and talked about life. Everything from past relationships and experiences to work, goals for the future, and the universe. At one point in the conversation he grabbed my hand and held it. Finally! His touch was welcomed, and it felt very nice. We continued to touch and hold hands throughout the night.

Did anything interesting happen? On the way out of the bar we ran into Laura, my old advisor from high school. I hadn't seen her in over ten years! She helped me through a rough patch, which I opened up to Tim about on the cab ride home. After I told him the story, he grabbed and kissed me. We kissed the entire cab ride. I invited him up to my apartment. We opened a bottle of red wine, and we continued to kiss on the couch. I could have kissed him all night, but he didn't want to rush things, and he left early.

Did you learn anything new about Timothy? I don't think Tim likes to dance. Late last night we were texting about possibly hanging out. When I told him I was going out dancing, he stopped responding.

Did you learn anything new about yourself? I was always a terrible dancer. In college, I was nicknamed "the finger dancer," as I was too shy and self-conscious to dance. I'd move my fingers back and forth at parties.

NOPE. I LOVE TO DANCE. –TG

My younger sister Lauren has the exact opposite personality of me. She's naturally extremely outgoing, confident, and she couldn't care less what anyone thinks of her. Over the years, I've learned to adopt a bit of her fearlessness toward life, and I'm much more outgoing and open now. Every once in a while I get this urge to let loose and dance. I've been working long nights, and my headaches feel better today, so I was ready for a night out last night. My sister is really into the electronic music scene, so we went out with a friend to a place called Output. I know I'm just as awkward at dancing as I always was, but I can enjoy it now! I must say it's extremely liberating when you stop caring what people think.

How do you feel about this relationship/project right now? Good! The intimacy with Tim was nice. I'm excited to see where things might go from here.

Is there anything that you want to do differently? I guess I should go a little easier on myself—I am only human. I'd like to be more fearless. And I should definitely keep a closer eye on $300 concert tickets.

Additional comments? That's all.

How do you feel about this relationship/project right now? A lot better. I feel like part of what happened this past week was built-up sexual frustration. Her bad headaches and my uncertainty have been a deadly match, so hopefully we'll fly through clearer skies now. It's like what my friends were saying, "all the bad parts of a relationship with none of the good parts."

Is there anything that you want to do differently? Not really. It's been a tiring week, and we still have plenty of time to make mistakes!

Additional comments? Jessie hung out with her ex-boyfriend last night. Is she breaking the rules? I'll give her a pass since they're friends. Anyway, she texted me while they were out, and asked me if I wanted to join them.

Okay, first, a little backstory. Apparently, he doesn't like me so much—which I didn't know until after they broke up. I guess he accused her of flirting with me in front of him. It's a shame, because I actually enjoyed hanging out with him. Apparently he won't speak to her about this experiment now, and he's not too fond of me. So why would I want to hang out with them? I didn't want to get into any of this, so I stopped responding to her texts.

Apr 6, 2013, 12:48 AM

Hey! You still out? We are at Output in Williamsburg.

iMessage Send

A FRIEND?
IT WAS
HER EX.
—TG

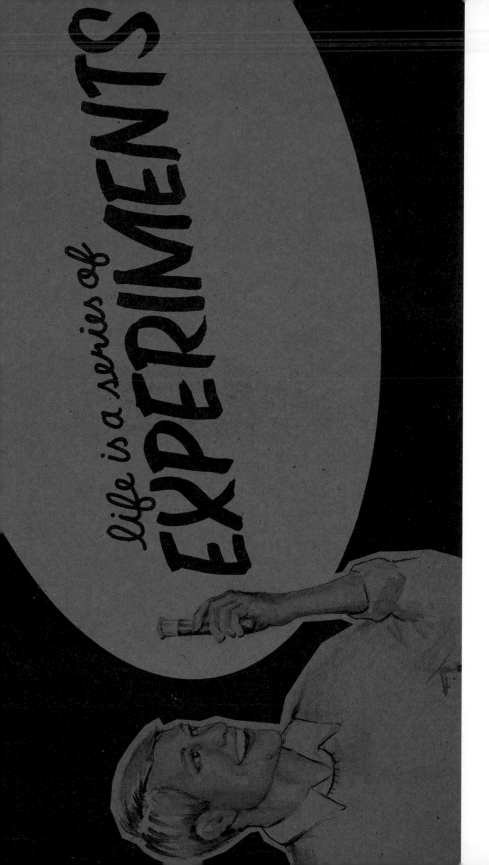

Jessica Walsh

Did you see Timothy today? Yes.

What did y'all do together? We did a "Rapid–Fire Truth Test" experiment today!

Timothy Goodman

Did you see Jessica today? Oh yes.

What did y'all do together? Therapy experiment we're calling a "Rapid–Fire Truth Test."

WATCH IT ON OUR "40 DAYS OF DATING" VIMEO PAGE! —JW

Did anything interesting happen? We had our "friend Dan Blackman ask us a series of questions about our past and about this relationship.

Did you learn anything new about Timothy? Tim was very defensive with his answers relating to past relationships and dating. Even after the experiment was over, he seemed to feel the need to justify his past actions to us. It makes me think Tim is not completely comfortable with himself or at peace with his past.

Did you learn anything new about yourself? I know I can be overly candid. I know this straightforwardness is a turnoff for some guys, and it's definitely no—Tim's style. Tim likes to flirt. Tim likes the excitement of the pursuit. He likes to play games. He loves the drama. I hate games. I like to cut to the chase and be real.

How do you feel about this relationship/project right now? Good, I love experiments! Life is a series of experiments. I am constantly testing out new ways to work, live, learn, sleep, act, and react. I am always trying to figure out how to be as productive and happy as I can.

Is there anything that you want to do differently? The experiment today reminded me how gut instincts

Did anything interesting happen? I felt really defensive and incredibly uncomfortable at first. Dan asked questions about topics that aren't easy to talk about—particularly with a camera on me! Also, everything he asked me had to do with sex, which felt like a setup for failure on my part. I also felt like it was weird timing to do this since we got physical for the first time last night. As the questions rolled on, I did feel more comfortable, but it still wasn't easy.

Did you learn anything new about Jessica? Even though Jessie can be quiet and reserved, she's definitely fearless when it comes to confronting her issues. I admire that.

Did you learn anything new about yourself? It was like looking through a window into my past—everything felt so vivid. It felt weird talking about this s*uff, all the emotions left in those sheets, the disappointment I've felt, and the disappointment I've caused.

How do you feel about this relationship/project right now? While it's socially sensationalized and acceptable for men to be promiscuous, I still feel written off as some sort of "womanizer" by today's questions and from what happened this past week. Just because

are often the most honest and interesting. I find this with my creative work, too. While I believe it's important to exhaust numerous concepts and possibilities, I often come back to my initial ideas. I should stop overthinking things.

I'm having fun and I like dating women? I know that I don't handle every situation in the best way, but I'm usually candid with my intentions. I guess I'm just feeling defensive once again.

Is there anything that you want to do differently?

Jessie said that I'm controlling. I don't know if I'm really controlling or if she's just a bit submissive. I want to stay aware of it, though.

Additional comments? After the Truth Test, Dan and I got some food and watched the Knicks game. He told me about this girl he knew. He thinks she and I would hit it off. We're practically halfway through right now, and for the first time, I thought about what will happen to Jessie and me when this experiment ends.

Additional comments? Tim looked at me at one point today, with a cute smile, and said, "We're so crazy." We really, really are.

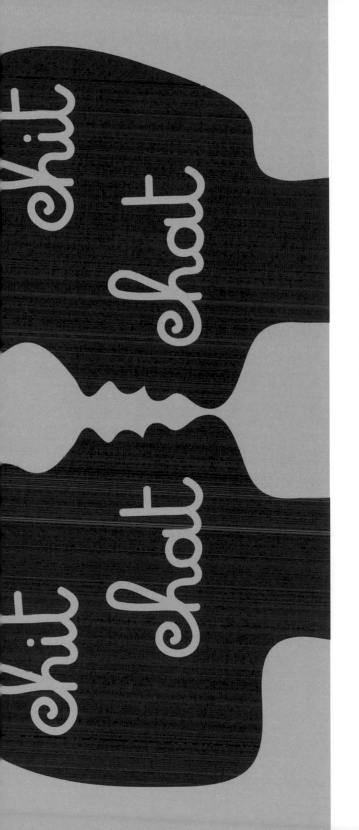

Jessica Walsh

Did you see Timothy today? Oui.

What did y'all do together? We met up at City Eakery in the morning for breakfast.

Did anything interesting happen? I ordered a green juice and a latte, Tim ordered a muffin and a tea. We had small talk at a cute Parisian-style cafe table.

Did you learn anything new about Timothy? Tim loves to constantly talk. I, on the other hand, hate small talk. I

Timothy Goodman

Did you see Jessica today? Yep.

What did y'all do together? Breakfast at City Bakery. We met close to her work, because I'm trying to be accommodating like a good boyfriend.

Did anything interesting happen? No, not really. She had coffee and a juice, and I had an English Breakfast tea. I quit coffee three years ago, since it wasn't on good terms with my stomach. We had some small chitchat about nothing really. It reminds me of a fun

song that I like by this French singer, Soko. In it, she sings about having pointless chitchat with a guy she likes, along with some other relevant things I'm concerned about.

UNTIL YOU REGRET LIKING SOMEONE LIKE

am totally comfortable enjoying silence with the person I am dating, especially if there's nothing interesting or relevant to talk about. I think my silence drives him nuts.

Did you learn anything new about yourself? I am seriously in love with coffee. I drink three to five cups of coffee per day. I love the ritual, the taste, the boost of energy, the reason to take a break. I love it in all its forms: a shot of espresso, a cup of black iced coffee, a creamy latte. I'll even eat coffee beans straight.

SORRY!
—TG →

Tim does not drink coffee or espresso. It's definitely trivial, but I wish we shared the mutual love!

How do you feel about this relationship/project right now? I wonder if we'll continue to be physical after we hooked up Saturday night.

Is there anything that you want to do differently? It's going to be a crazy week of work, and the headaches continue to come and go. No matter what happens, I want to stay calm and stay positive.

Did you learn anything new about Jessica? Jessie is ← I love to FLIRT, I JUST DON'T UNDERSTAND HIS FLIRTING STYLE. —JW

kind of bad at flirting. When I like a girl, I like to flirt and play on email/text/messenger during the day. Nothing major or time-consuming, just little things that give energy toward the relationship. It makes me even more excited about the relationship. I keep trying with her, but she's just so pensive and takes things so literally. I have to accept that it's just not her thing.

Did you learn anything new about yourself? I ask a lot of questions. Jessie is more on the quiet side, and

I tend to talk more when someone is quiet. I'm sure this is annoying for her.

How do you feel about this relationship/project right now? I feel good about it! Jessie happy = Timmy happy.

Is there anything that you want to do differently? City Bakery was our second breakfast date recently. It's a good way to quickly see each other, but it also feels like a cop-out. We should spice it up a bit.

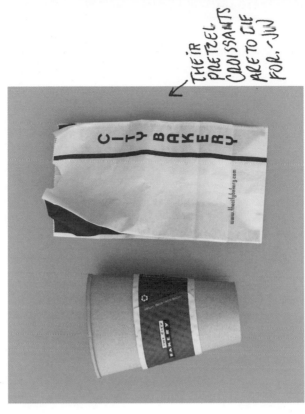

THEIR PRETZEL CROISSANTS ARE TO DIE FOR. ~JW

www.thecitybakery.com

THE CITY BAKERY

CITY BAKERY

Additional comments? I get this impression that she thinks I'm avoiding talking about what happened on Saturday night. It's a two-way street here. She hasn't brought it up either. I'm sure she's writing about how I'm the one who's avoiding this whole thing . . .

Additional comments? I adore giving and receiving handwritten notes. I've kept every note that's ever been given to me in a leather suitcase. While texting and emails take over our lives, a handwritten note feels so much more special and romantic.

M

At the end of breakfast, Tim handed me an envelope. Inside was the sweetest little twenty-day anniversary card. All smiles over here. It's amazing how much the little things can be so huge in a relationship.

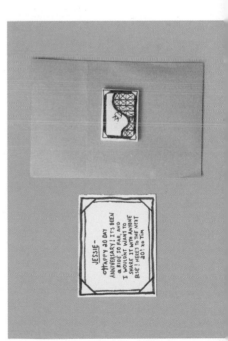

JESSIE —
HAPPY 20 DAY
ANNIVERSARY! IT'S BEEN
A RIDE SO FAR, AND
I WOULDN'T WANT TO
SHARE IT WITH ANYONE
ELSE! HERE'S TO THE NEXT
20! xo TIM

Jessica Walsh

Did you see Timothy today? Yes.

What did y'all do together? My day was packed with tight deadlines, and I knew I'd be working late, so we met up for lunch by my office at a restaurant called

Timothy Goodman

Did you see Jessica today? Yes.

What did y'all do together? We met for a quick lunch. I came over by her work, and we ended up going to this funny place called Trailer Park that's decorated

Trailer Park. I used to come here once a week with my friend Michael to talk about life. There is something about the combination of their comfort food and potent margaritas that makes you really honest.

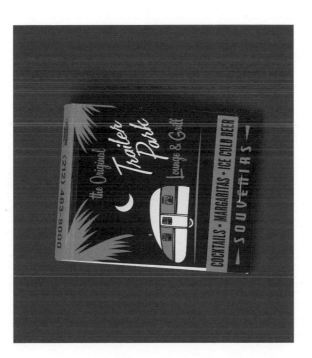

Did anything interesting happen? Tim was in a great mood. He was laid back, didn't have a lot of work, and was enjoying a book in the sunny 80° weather. The book Tim was reading is about archetypes of men and women. Tim thinks I fall within the "good girl" role and that I should channel my masculine energy more.

Did you learn anything new about Timothy? He's bothered by the fact that I go out of my way to accommodate the people I care about. He thinks I am too forgiving and empathetic, and that I've let friends or past lovers take advantage of this. I like to make people

like . . . a trailer park. We split a BLT and an order of Tater Tots. Very healthy. Anyway, I was really excited about those Tots, and they did not let me down.

Did anything interesting happen? I was explaining to Jessie about a book I'm reading. I was excited to share it with her. She really didn't seem interested in discussing it, though—and again, we sat there stuck in a rut, not really talking. I got annoyed about this.

I didn't learn until later in the lunch that she was having really bad headaches again. Why doesn't she tell me this stuff? It would be nice to know so I don't interpret it differently. Instead, I have to delicately wheedle information out of her in order to find out what the hell is really going on. Then, of course, I felt bad for being annoyed with her. I wish I could just help her out with these damn headaches!

Did you learn anything new about Jessica? While Jessie is a powerhouse professionally, I think she lacks an ability to take control of her romantic relationships. It's hard for her to confront major relationship issues, since she hates conflict. When she's in love, she sometimes puts her man before herself, a trait I personally do not find attractive. She can fall in love so hard, and so fast, that I think she is occasionally blinded by shortcomings the relationship or the guy might have.

Some women wait their whole lives to find a "soul mate," and then they just settle for a guy who's got a good job, or a guy with a nice apartment, or a guy who will simply stay with them. Jessie is definitely still looking for her soul mate, and I worry about this. I once hung out with a single Jessie one week, then went on a work trip, only to come back the next week and find her totally "in love." And when it didn't work out she was devastated.

THIS CAN BE TRUE BUT IT'S SITUATIONAL. I'VE BEEN IN MANY RELATION- SHIPS WHERE I WAS MORE IN CONTROL. —JW

that I'm close to feel comfortable and happy. I prefer to let the little things go in any relationship. I don't like unnecessary conflict or drama. When I give in to him, he says I have no backbone and that I should stand up for myself. But he's bothered when I stand up for myself and ask for what I want. He definitely likes to be the one in control of a relationship. Lately I feel like no matter what I do or say, I can't win with Tim.

Did you learn anything new about yourself? Tim's book about male and female archetypes reminded me of my psychology classes in college. I was fascinated by Carl Jung's theories of archetypes and the collective unconscious. Jung defined twelve primary types that each have their own set of values. His book *Psychological Types* was eventually put to practical use through the Myers–Briggs Type Indicator, which is a questionnaire designed to measure how people perceive the world. I just took the test, and I am the INFJ (Introverted Intuition with Extraverted Feeling) type.

YOU CAN TAKE THIS TEST ONLINE AT MYERS BRIGGS.ORG —JW

I read a lot about mythology, and part of the book I'm reading explains how women and men have both male and female sides/energies inside of them. For instance, a female with a healthy balance of male energy doesn't worry about being the "good girl" or doing what's "right." But if your feminine side is too developed, then there's no direction in your life. On the other hand, if your male side is too developed, then there's no meaning behind your direction and you can feel entirely lost. Many old fairy tales touch on this dichotomy and the importance of having a balance of both. I was thinking about this on my way to meet Jessie. In some ways, I think she suffers from this energy imbalance in relationships.

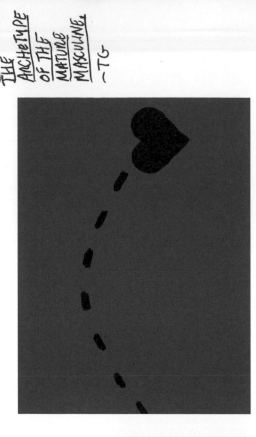

THE BOOK IS CALLED KING, WARRIOR, MAGICIAN, LOVER: REDISCOVERING THE ARCHETYPE OF THE MATURE MASCULINE —TG

Did you learn anything new about yourself? It's easy for me to compartmentalize things in my life, and not let my "worlds collide" like that old *Seinfeld* episode. Mainly, my creative work is the focal point, and everything else in my life fits around that without much

MYERS BRIGGS *Type* INDICATOR

ENFJ	INFJ	INTJ	ENTJ
ENFP	INFP	INTP	ENTP
ESFP	ISFP	ISTP	ESTP
ESFJ	ISFJ	ISTJ	ESTJ

How do you feel about this relationship/project right now? I discovered extensive writing about these various

leakage. I know it's very selfish, but lately I tend to let everything else fall by the wayside. I can already see how I'm just putting Jessie in a little box, not letting her touch the rest of my life. I know this isn't healthy. I'd like to change it, but I'm not sure how to really do that right now.

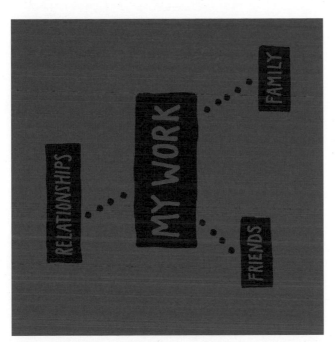

How do you feel about this relationship/project right now? During lunch, she mentioned that she feels awkward about hooking up on Saturday. I guess because I haven't shown her any intimacy since then, and we haven't talked about it. I don't feel so weird, and I was open to talking about how she was feeling. I know she's having these headaches, but she was sulking. There's no sulking around Tater Tots!

archetypes and how we approach love and relationships. They even tell you which psychological types are a good love match. Here are my results. Apparently, I would be best suited with an ENTP or an ENFP. Tim is an ENJF. Apparently INFJ's and ENFJ's are better as friends than as lovers.

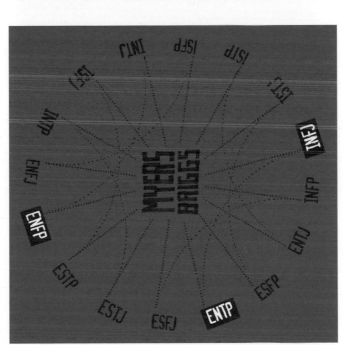

Is there anything that you want to do differently? My results say that INFJs seek intense and meaningful relationships which are long-term. I wonder, is part of our approach to love embedded in our personalities? How much can we really change? Do I even want to change? What is so wrong about seeking a healthy, committed relationship?

Additional comments? I was quiet at lunch because I had another headache attack. I felt bad that I couldn't engage more with Tim. I usually try my best to avoid telling Tim about the headaches. He was annoyed with me for being aloof, so I had to tell him. I don't like to complain or to put negative energy onto others. Just because I am in pain doesn't mean I need to be one.

Is there anything that you want to do differently? I'm so relaxed about everything, while Jessie thinks about everything so much. I want to be more considerate about how she's feeling.

Additional comments? A couple nights ago, Jessie and I were talking about our place in the universe, and the idea of "nothingness." We're both curious about what brings real meaning to our lives. It's shocking how many girls I can date, how long I can date them, and how rarely I ever have a conversation like this with any of them. It was nice.

MEN DON'T SETTLE DOWN, THEY SURRENDER

Jessica Walsh

Did you see Timothy today? Yes.

What did y'all do together? We both teach class from 6:00 to 9:00 PM at the School of Visual Arts. After class, Tim and I usually meet our friend Michael for drinks and hummus at the Bluebell Cafe. My class went a little later, so I met them at the restaurant, where they were already eating and drinking.

Did anything interesting happen? I was in a particularly good and energetic mood. My students did great work for our class, and I slept well last night. It was the first night in a month that I was able to sleep without sleeping pills, so I was feeling pretty awesome. Tim kept talking about how great my mood was, how lively I seemed, and how this made him feel closer to me.

He also said he really liked my outfit. I was wearing bright blue pants, tan boots, and a loose sheer white tee. Usually, I just wear black or gray. When we were outside waiting for a cab, I tried to be flirctious with him, but he seemed distant, and we parted ways.

Did you learn anything new about Timothy? Tim can be sensitive and flustered. We explained the Truth Test experiment that we did to Michael. Tim became worked up about it—he is concerned about coming off as the "bad guy." I often feel as if I am walking on eggshells around him, which can be stressful.

Did you learn anything new about yourself? I'm happy I've stayed in touch with almost all my ex-boyfriends. While we didn't work out romantically, there was a

Timothy Goodman

Did you see Jessica today? Another day, another dollar.

What did y'all do together? We hung out with our good friend Michael tonight. We all teach at SVA on Wednesday nights, and we usually meet up at a nearby restaurant after class. The place is pretty mediocre, but they do have really good hummus. We call ourselves the "Hummus Club."

Did anything interesting happen? Jessie called me "sensitive" about five times during the dinner. This really annoyed me. If she was me, I think she'd be "sensitive," too. Because of her headaches and insomnia, every single day I feel like it's a different mood, a different attitude, a different problem, a different

ISN'T THAT JUST LIFE? EVERYONE HAS UPS AND DOWNS —JW

THAT TRUTH TEST WAS PRETTY HARSH. —TG

reason I had a connection with each of them. After our "exes" project on day five, Tim and I asked them to write us letters about the relationships we shared. Here's what I received:

surprise. It's become especially hard after she quit the project last week. I'm constantly on guard about everything I do now.

Did you learn anything new about Jessica? Jessie was in tip-top shape tonight. She was full of life, talkative, energetic, and she looked good. Yesterday she was a zombie, but today she looked healthier and more positive than I've seen in a while. I love seeing her like this.

Did you learn anything new about yourself? Last night, I was on my way to meeting some friends downtown when I randomly ran into a girl I once went on a couple dates with. This was the second time I recently ran into her, so I invited her to join us for a quick beer. She's a smart girl, she looked beautiful, and I found myself wondering "what if." I couldn't help but text her today. However, I felt guilty about texting her and I stopped the conversation.

Apr 10, 2013, 12:20 PM

Nice to see you last night! Thanks for grabbing a quick one. So how about you stop stalking me and just see me on purpose next time?

iMessage Send

I ACTUALLY RAN INTO HER AGAIN! WEIRD. —TG

The story of how I met her probably represents one of the greatest assists by a wingman in the history of modern dating: I was having a beer with my friend

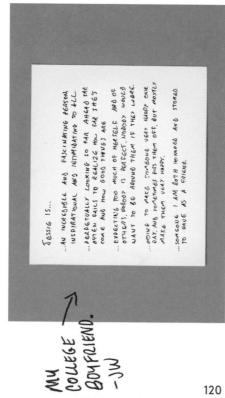

JESSIE IS...

...AN INCREDIBLE AND FASCINATING PERSON, INSPIRATIONAL AND INTIMIDATING TO ALL

...PERPETUALLY LOOKING SO FAR AHEAD SHE OFTEN FAILS TO REALIZE HOW FAR SHE'S COME AND HOW GOOD THINGS ARE

...EXPECTING TOO MUCH OF HERSELF AND OF OTHERS. NOBODY IS PERFECT. NOBODY WOULD WANT TO BE AROUND THEM IF THEY WERE.

...GOING TO MAKE SOMEONE VERY HAPPY ONE DAY. AND SOMETIMES PISS THEM OFF. BUT MOSTLY MAKE THEM VERY HAPPY.

...SOMEONE I AM BOTH HONORED AND STOKED TO HAVE AS A FRIEND.

MY COLLEGE BOYFRIEND. —JW

John at a French spot after work one night. She and her friend were sitting at the bar, too. I noticed her right when I got there. She had dark Persian features, and the two of them were having a lively conversation. I never made an attempt to talk to her, though. She was at the other end of the bar.

After a drink, John had to get home to his family. I decided to stay for one more. As he was putting on his jacket to leave, he goes up to her, gently sets his hand on her shoulder, and says, "I just want to tell you that you have beautiful eyebrows." He continues quickly, "And the only reason I can even tell you something like that is because I'm leaving right now and you won't think I'm hitting on you."

Before she could even say "thank you" he promptly exits, leaving her unexpectedly blushing, smiling, and laughing. What a move. I mean, who compliments eyebrows? (They are nice eyebrows!) And here I am, by myself, while they slide down to ask me who the hell my crazy friend was. An hour later, after a great conversation, I left with her phone number. Two days later we went on our first date. Later that night he texted me saying, "You're welcome."

How do you feel about this relationship/project right now? If I'm thinking about other women, then something must be wrong. I've been in four serious relationships in my life, I've lived with women, and I've been fully committed and in love. I was never tempted. The last couple years, however, I've let all that go. Is temptation a result of this, or could it be related to my incompatibility with Jessie? Are all men like this as they get older? And if so, is wondering about other women healthy or is it only detrimental? It reminds me of an old Chris Rock joke where he says, "Men don't settle down, they surrender."

Is there anything that you want to do differently?

Jessie and I asked some of our exes to write a hand-written note about the relationship we experienced with them. Well, I wrote eight girls and ALL of them denied me! Gah! I don't have the heart to write any more. I wish this wasn't the case.

WE DID GRAB COFFEE IN NYC. HI, JULIA! —TG

Re: Hello ▢

Julia
to Timothy ▶

Hi Tim,

Good to hear from you. London is great, I'm living in Islington which is fun. I hope you are well too.

Listen I don't think this hand note thing is a good idea. I don't know what you will do with it, nor do I feel like I owe it to you. I think you're a good person, but I didn't hear from you for years. Then you sent me that random email one day and now this random email?? Sorry.

Maybe we can grab a coffee when I'm back in the fall.

Julia

⋯

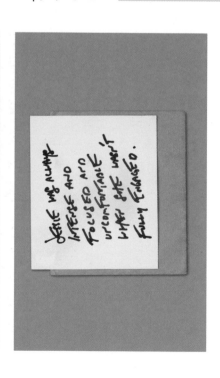

How do you feel about this relationship/project right now?
I'm feeling pretty great about everything today!

Is there anything that you want to do differently?
I've suffered from insomnia, on and off, since I was twelve years old. My doctor prescribed Zaleplon and Ativan to help. However, my mood is significantly better when I get natural sleep. I'd like to find a way to cut out the medication.

Additional comments? Not today.

Additional comments? Hi, mom!

Jessica Walsh

Did you see Timothy today? Unfortunately.

What did y'all do together? We had therapy in the morning. It had to be the most disastrous "date" in dating history.

Did anything interesting happen? Tim started out by expressing his frustration, then declared that he wanted to quit the project. This came as a shock con-sidering his comments about feeling very close to me the night before. He has been the one pushing me to not quit the experiment, and now that I'm 100 percent committed, the tables have turned.

Tim talked to the therapist about being afraid after hooking up on Saturday night. He's still afraid of hurting

Timothy Goodman

Did you see Jessica today? Yes.

What did y'all do together? Therapy session from hell.

Did anything interesting happen? Maybe it's because we're in the dog days of this experiment, but I've never felt more like a mouse in a cage being tested against my will. I feel very uncomfortable. I feel grimy. I feel emotional. For the first time, I thought about quitting the experiment last night. My blasé attitude and un-willingness to commit versus Jessie's mood swings from her headaches and her resistance to living with uncertainty makes me wonder if this is really worth it. I went into therapy looking for a way out. In the one-hour session, we both threatened to quit the project.

me since he is unsure of his intentions. His indecisiveness is getting old, and the therapist said she thought he was being cowardly.

Tim seemed overwhelmed by the pressure, and he began to pick me apart again. He said some of the most hurtful things anyone has ever said to me. I have not done anything to deserve this, and have no reason to put up with it. The therapy session ended with me in tears trying to walk away from this experiment once again.

I was in a negative mood about this whole thing. I said some hurtful stuff, she got very upset, and she started crying. I know I was being unfair, but she's also very sensitive about certain topics. It's a deadly combination sometimes.

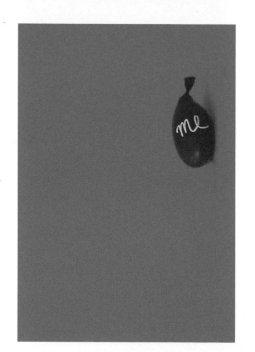

I don't know how she did it, but Jocelyn somehow managed to calm me down and convince me to stick with it. She pointed out that we shouldn't be shocked that we were playing out the roles we set out for ourselves in the beginning: I was being overly empathetic and interested in more, and Tim was trying to push me away out of fear of commitment. Big surprise.

Did you learn anything new about Timothy? After the therapy session ended, Tim and I had an intense talk

The therapist reminded us that people in relationships say hurtful stuff to each other. I apologized to Jessie for what I said. I didn't mean it, I know I was only trying to push her away. Jocelyn said "fight, not flight!" By the end of therapy we were kissing on the street.

Did you learn anything new about Jessica? I didn't know she was so sensitive about certain family affairs. She's very open about a lot of things, but in many ways she'll shut down on you. It's just bad energy.

JOCELYN SAW US TALKING AS SHE LEFT THE BUILDING. SHE GAVE ME A SMILE + I FELT BETTER. —TG

Did you learn anything new about yourself? I didn't know I was so insecure about my family's situation in comparison to hers. I just feel like we have completely different values and ways of looking at things. I know I shouldn't take this out on her, though. I feel bad for that.

How do you feel about this relationship/project right now? After therapy, Jessie and I talked outside. She told me that I need to figure out what I want. Honestly, I don't think this is about me being a commitment-phobe. I'm just not sure I want to be in a relationship with her. But after what just happened today, I think I've had enough. I owe it to both of us. I think it's time I really try this with her.

Is there anything that you want to do differently? Jessie wrote me a nice note today.

Hi 🗆

Jessica Walsh
to Timothy ▾

Tim,

How are you feeling?

Obviously, we've both been through a lot in the past, and this experiment has brought up a lot of uncomfortable emotions and insecurities for both of us. It's not going to be all easy and fun, when we're putting ourselves through this. But let's not forget all the good times we've had too. No matter what, let's try to be understanding and supportive of each other.

Hope you're having a nice day. :)

xo

on Jocelyn's doorstep. I told him that I've only been understanding and patient, and I wouldn't stand for this. He apologized for everything he said. He said it was a defense mechanism stemming from his fears about a possible relationship with me. He said he knew I deserved better, and he'd understand if I wanted to walk away. It's really hard not to be forgiving when I know so much about his past and where all this is coming from. I told him he just needs to figure out what he wants, and stop picking everything apart as a way to avoid it. We hugged. He kissed me. We parted ways.

Did you learn anything new about yourself? I've learned a lot about myself from this experiment, but it has been emotionally turbulent and extremely stressful.

How do you feel about this relationship/project right now? I feel deflated right now. While I am usually very good at dealing with criticism, it is hurtful to hear someone you care about say such hurtful things, even if I know he didn't really mean it. I'll forgive and forget this time, but I will not let him pick me apart like this again. I want to surround myself with positive energy. I am tired of this.

I NEVER RESPONDED. —TC

Additional comments? It's 2:30 AM right now. I can't sleep and I'm still feeling neurotic from what happened today. On top of it all, I just got a text from a girl who I occasionally saw before the experiment. I feel tempted to write her back. But if I'm going to try this with Jessie, then I have to let it go! I can't give in to late-night temptation. The sexter made me think of a Bukowski line that I've always liked.

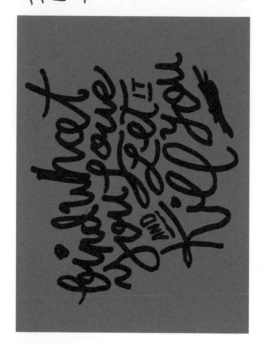

find what you love and let it kill you

FOR NEGATIVE this BULLSHIT.

Is there anything that you want to do differently? I need to let go.

Additional comments? I need to lower my expectations.

126

Jessica Walsh

Did you see Timothy today? Yes.

What did y'all do together? Tim emailed me early in the morning with a drawing that he made for me. It had four hands, designed for me to choose one of four period-specific dates. I wish I could tell you how adorable and romantic this gesture was, but I happen to know that he's used this same exact illustration game on another girl he dated a few months ago! Had any other guy done this for me, I would be swooning. Still, I played along with his game and I chose the "1920s" hand.

After yesterday's horrible therapy session, I was craving bourbon. I figured the "1920s" option would likely involve a cocktail bar. I was right! He emailed back with a "congrats" drawing and we met at Middle Branch at 8:00 PM.

Timothy Goodman

Did you see Jessica today? Yes.

What did y'all do together? Earlier in the morning, I sent Jessie an email with a drawing attached. The drawing asked her to "pick a hand" that had four date-themed options.

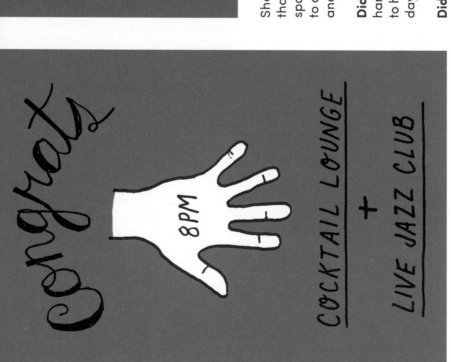

Did anything interesting happen? We smoothed everything over that happened yesterday, and we were able to enjoy a lovely night out together. We had a drink at the cocktail bar, and then headed over to the jazz club. We listened to the music and shared a plate of mac and cheese with a side of greens. The food was delicious, the music was great, and things felt right.

She picked "1920s" and I tailored the date around that. First, I took her to one of my favorite cocktail spots, Middle Branch. Then we went down the street to a great jazz club to see the drummer Eric Harland and his band.

Did anything interesting happen? We were holding hands at the show. After the jazz club, we went back to her place. What follows *technically* happened on day twenty-five, so I will wait to write about it then...

Did you learn anything new about Jessica? Jessie was checking her email during the show! I'm a big jazz fan, so this was sacrilegious to me. I got over it, but this can't happen again. No, no, not at a jazz show.

Did you learn anything new about yourself? When I was a teenager, I decided I wanted to learn more about jazz. At first, I thought it was a cool thing to tell girls. While I knew there was a real value to be discovered in the music, I just didn't have the capacity for it at the time. I would, however, draw instruments for fun.

WE'RE ALSO BIG FANS OF THEIR SISTER BAR, CALLED LITTLE BRANCH. —JW

At one point during the show he took my hand into his. After the jazz show finished, we meandered toward my place, holding hands, laughing about silly things, with plenty of kissing in between. Once we got to my apartment building, I invited him up to my place.

Did you learn anything new about Timothy? He loves jazz music and he knows quite a bit about it. His face lit up as he explained the history of jazz to me. It was very endearing!

Did you learn anything new about yourself? We lay in bed and discussed life, the universe, and religion. I told him I think we're too young as a species to fully comprehend our place in the universe. So while I don't subscribe to a religion or believe in a deity, I like to stay open-minded to the infinite possibilities of it all. I think we're probably just a bunch of lucky stardust, in the right place at the right time, winners of a cosmic lottery. I find beauty in the potential meaninglessness of it all. He said he thinks my views are pessimistic. I never thought of myself as pessimistic, just realistic. I still find everything about this world beautiful, and I approach each day and experience with curiosity. There is so much I want to do in my short time on this earth.

Not until later did I really appreciate the music and understand how jazz played an important role in the fabric of American history. Writer Gerald Early told Ken Burns that "when they study our civilization two thousand years from now, there will only be three things that Americans will be known for: the Constitution, baseball, and jazz music. They're the three most beautiful things Americans have ever created."

I'm fascinated by stories of triumph, particularly those of the African American community, and how a people overcome adversity. When I was a child, I grew up in both black and white neighborhoods, so I have an affinity for the culture. Jazz grew out of the Civil War in New Orleans, and by the early 1900s it was linking white middle and upper classes to black entertainers. Anyway, let's just say that I'm slightly obsessed. Jazz represents improvisation. Jazz represents expression. Jazz represents democracy. Now,

HMM. THE WAY I REMEMBER IT IS I ASKED HER TO COME TO MY PLACE. SHE SAID "NO" AND HAILED A CAB TO HER PLACE. —TG

How do you feel about this relationship/project right now? We had sex. I feel like there was a lot of built-up sexual tension between us these past few weeks, so it was a relief. I enjoyed it, and we had a lot of fun! He didn't stay over, though, since I have an early flight to catch in the morning for a work trip.

Is there anything that you want to do differently? Less of the stress, more of the sex.

Additional comments? While Tim has opened up to me in many ways, I still feel like he keeps many parts of his life guarded from me. The best physical connections I've experienced were in part a deep trust and an emotional intimacy. I wonder if he'll begin to let me in more now that we've become physically intimate. My gut tells me that I will find out very soon.

let's get psychological and draw the parallels to my lifestyle decisions!

How do you feel about this relationship/project right now? Yesterday I said I was going to give this a go, and today was the start. There's a Thelonious Monk track called "Straight, No Chaser." That's how I'm feeling about this right now. Straight to the head, no chasers, no buffers, no apologies.

Is there anything that you want to do differently? When we met for cocktails, we immediately started talking about our therapy session yesterday. I don't want to always harbor this stuff.

Additional comments? Apparently, she knows I've done this "pick a hand" game with other girls I've dated. Not very smooth, Tim.

YES, THAT TACTIC HAS BEEN OFFICIALLY RETIRED. —TG

Jessica Walsh

Did you see Timothy today? Technically. But not really.

What did y'all do together? Since Tim was over past midnight last night, we counted that as our day of seeing each other.

Did anything interesting happen? I had an early flight in the morning for a lecture I was giving. I woke up at 5:00 AM with the most excruciating headache imaginable. It was the worst attack I've experienced so far. Despite the pain, I somehow rolled out of bed and hobbled out the door to catch a cab. When I am having these headache attacks, I become extremely sensitive to light or noise. As I was waiting outside for a cab, I felt nauseated. Next thing I knew, I had collapsed on the sidewalk. It wasn't the first time this had happened, but it's always scary.

I went back up to my apartment to rest for a moment, and I tried to figure out what to do. There was no way I could get on that airplane. I felt horrible that I had to cancel. I hate backing out on anything.

Timothy Goodman

Did you see Jessica today? Technically I did. I didn't see her during the day, but I left her apartment around 12:30 this morning.

What did y'all do together? After the jazz club last night, we went back to her place. I found out that she took an Ativan late at night to help her sleep. This upset me, and we were arguing about it a little. I know medication is very common, and it was prescribed for her, but I get sensitive about this stuff when I care for someone. Jessie has everything, yet her health seems to be a constant issue. I'm worried by how many meds she's on.

Did anything interesting happen? We had sex. I didn't have any condoms on me, so I had no choice but to use one of her Sagmeister & Walsh company condoms. Ha!

Did you learn anything new about Jessica? She's great in bed. All day I've been thinking about the intensity between us, how she tasted, the way she felt, and the way she made me feel like she needs me.

Did you learn anything new about yourself? All along, I've been trying to not let this happen. I can't do that anymore, I have to let it happen.

How do you feel about this relationship/project right now? We had a great time last night on our date. I like this.

Is there anything that you want to do differently? I need some sleep.

Additional comments? I've been thinking a lot about this movie I saw last week called *The Place Beyond the Pines*. At its core, the movie is about the consequences a father has to face and what it means to leave a legacy behind to your children. I've never met my biological father, and I grew up with two different stepfathers. Luckily I've had a slew of mentors who have helped me through the years. In hindsight, I see the resentment I carried around when I was

THIS IS A GREAT MOVIE. —JW

Did you learn anything new about Timothy? He doesn't carry condoms on him.

Did you learn anything new about yourself? Health-wise, I am an absolute mess. The headaches have been occurring for a month now, and it's been the fastest downward spiral I've ever experienced. The headaches make it difficult to work, so I take Fioricet to make it through the day. The caffeine in the medication has aggravated my insomnia, so I take Sonata or Ativan to get a few hours of sleep when I can. Those medications make me foggy and lower my ability to concentrate, so I drink massive amounts of coffee to stay awake. All of this has caused me to fall behind at work, which is stressful. The stress causes severe back pain, which has intensified the tendonitis in my arm. The stress also causes me to grind my teeth at night, and now I have temporomandibular joint dysfunction. It's a vicious cycle.

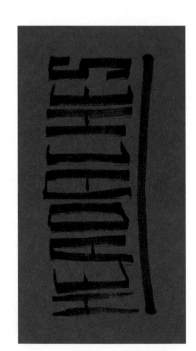

How do you feel about this relationship/project right now? My physical ailments have caused me to become anxious and depressed. I can't continue like this any longer. While I've mostly hidden this from Tim, I know

younger—acting out just to prove my existence to someone. Without a real fatherly influence, it's easy to walk blindfolded, sometimes touching on brilliance, other times tripping over a mirage of male egotism.

Anyway, I went to the Knicks game with a couple friends the other day, and it dawned on me that none of us have our fathers around. They both have young children now, and I wonder how that will affect the way they raise them. How it will affect the way I will raise my children? What kind of legacy will my friends and I leave? And how will our kids cope with the pathology of fathers who miss their fathers?

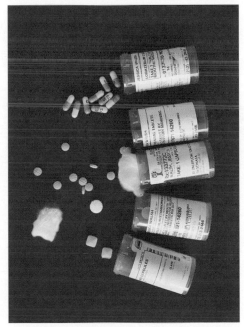

he can sense when I am tired or down, no matter how hard I try to mask it. I can't care for someone else until I take care of myself first. I need to radically change my lifestyle before I can think about maintaining a healthy relationship.

Is there anything that you want to do differently? The doctors now have me on a scary combination of six different prescription medications, and this doesn't count the three over-the-counter medications they've recommended. The medications I've tried so far just seem to cause new issues, and the doctors keep prescribing new medications with each new problem.

Tim suggested I try working out to get healthier. My mom keeps telling me to eat better. My dad, a fellow insomniac, suggests I cut out caffeine and alcohol. From the research I've done online, I learned that the headaches can often be cured by cutting out gluten and/or dairy, and eating mostly plant-based foods

and lean proteins. As of tomorrow, I am going to start exercising daily, cut back on my caffeine and alcohol intake, and try to completely change my diet. I need to commit to my well-being. When nothing goes right, go left.

Additional comments? On a lighter note, I knew having condoms as business cards would come in handy one day. I woke up with an empty package under my pillow.

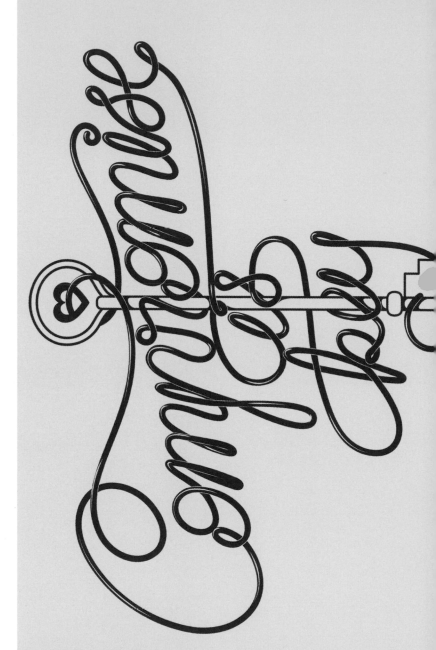

Jessica Walsh

Did you see Timothy today? Yes.

What did y'all do together? He came over to my work studio today.

Did anything interesting happen? We discussed where we might want to go for our weekend trip. Tim really wants to do a road trip. He suggested camping upstate. While I like the idea of going upstate, I don't think this is the right time for it. We are coming off a long winter, and I really want to get some sun.

In therapy, we've discussed how Tim likes to be in control, and how I can be more passive. I spend all day making choices and decisions at the office, so the little decisions—where to go on a date, what bar to go to—seem trivial. I give input and ideas, but I don't have the energy to debate him on what to do. I often just go with the flow. This drives Tim nuts, and he wishes I'd have more of an opinion about it. Sometimes I think Tim would be happy spending an hour disputing what appetizer we should order!

Making a decision on where to go for a weekend trip seemed like a good time to step up. I told him I'd like to go somewhere warm where we could relax and focus on each other. We went back and forth for an hour, but we couldn't find a solution. A few hours later I went home to do some more work. I turned on my email and I found the most perfect suggestion from Tim. We're going to Disney World! It seems like a perfect getaway to end this crazy roller coaster of a journey.

FUNNY!
CAMPING?
NO, I
DON'T GO
CAMPING!
—TG

Timothy Goodman

Did you see Jessica today? Yep.

What did y'all do together? We met at Jessie's studio on a beautiful Sunday afternoon.

Did anything interesting happen? Not particularly. We talked about where we should go for our weekend trip, since we only have two weeks left. Personally, I want to drive upstate, stay at a cute bed-and-breakfast on the Hudson River, and take in the fresh air. That's my idea of a great weekend trip. Not Jessie. Jessie wants to go to Mexico and chill out on the beach. Which is great when you're worn out and just need a vacation. I'm just too active for that right now. I want an adventure. I want a bonding experience. I want to listen to a vacation mix!

Jessie's resistance to my idea reminded me of an old *Sex and the City* episode. In the episode, Carrie is forced to go upstate to her boyfriend's country house, where she freaks out about nature. (Yes, I know about this. And YES, Aidan was the best.) That's Jessie—a Manhattan girl through and through. You can't hike in high heels, Jessie!

Did you learn anything new about Jessica? She gets dismissive sometimes. She gives me a hard time, but she can get wishy-washy if she doesn't 100 percent like something. Neither of us should have to compromise on a weekend trip, though. We both should be excited about this. When I got home, I had this random idea.

NATURE
IS SO
OVERRATED.
☺ —JW

Considering all the ups and downs, it only seemed fitting that we do something crazy wonderful. Disney World, holla!

Let's go to

Timothy Goodman
to Jessica ▶

... DISNEY WORLD!

Re: Let's go to

Jessica Walsh
to Timothy ▶

YES!!!!

Re: Let's go to

Timothy Goodman
to Jessica ▶

Are you serious?? This will be so fun, I am down if you are. Do you even like rides Jessie?? I went once when I was 7 or 8 and I cried the whole time because it was too hot and sticky. I'll probably do it again.

Re: Let's go to

Jessica Walsh
to Timothy ▶

Of course I am serious! I went when I was 5 and I got pneumonia. My parents didn't believe me that I

WHAT HAPPENED

Did you learn anything new about Timothy? Today I realized that besides our creative work, Tim and I don't have much in common. Tim likes the woods. I like the beach. Tim likes to debate. I like to compromise. Tim likes to date around. I like meaningful relationships. Tim is great at saving money. I suck at it. Tim is excitable. I am calm. Tim reads about current events and politics. I read about psychology and art. Tim likes to watch basketball and stand-up comedy. I like to watch indie and foreign films. Tim likes jazz and hip hop. I like alternative and electronic. Tim loves drama. I hate drama. The list goes on!

They say opposites attract, and I can see why, especially in the beginning of a relationship. When I date someone with different interests or a different outlook, I inevitably experience new things and see new perspectives. These kinds of relationships can be challenging, but they can also be interesting and rewarding. But do opposites really work out?

COUPLES WHO ARE MORE SIMILAR + SHARE MUTUAL INTERESTS HAVE LONGER HAPPIER RELATIONSHIPS —JW →

Re: Let's go to

Timothy Goodman
to Jessica

That's hilarious. When you have time, can you look into packages... I know you're like the queen of planning things, right?

Re: Let's go to

Jessica Walsh
to Timothy

Yes I love planning trips. Just not to the woods.

I don't think it's necessary to share all interests, nor is it necessary to do everything together. I've always valued my alone time. Yet, from what I've noticed in my friends' relationships, if they have nothing in common (or if they don't develop shared interests), then these relationships eventually fall apart. While there are articles that support the opposites-attract theory, I have found many more by psychologists that support what is called similarity theory or balance theory.

Did you learn anything new about yourself? I instantly fell in love with the idea of Disney World. I have to admit that I'm still a kid at heart.

How do you feel about this relationship/project right now? Considering Tim suggested Disney World, he's just a kid at heart, too. So I guess we have that in common!

Is there anything that you want to do differently? I am glad we settled on a trip that we are both happy with. I guess relationships are all about the compromise and letting go of the small differences.

Additional comments? Day one of healthy living!

Did you learn anything new about yourself? I already knew this, but I really do love the unexpected.

How do you feel about this relationship/project right now? I'm worried that she could be overthinking the sex the other night. I hope she's not, I'm having a good time with everything.

Is there anything that you want to do differently? No, not today.

Additional comments? Jessie is having dinner tonight with our friend who wanted me to stop the project a couple weeks ago. I'm a bit worried.

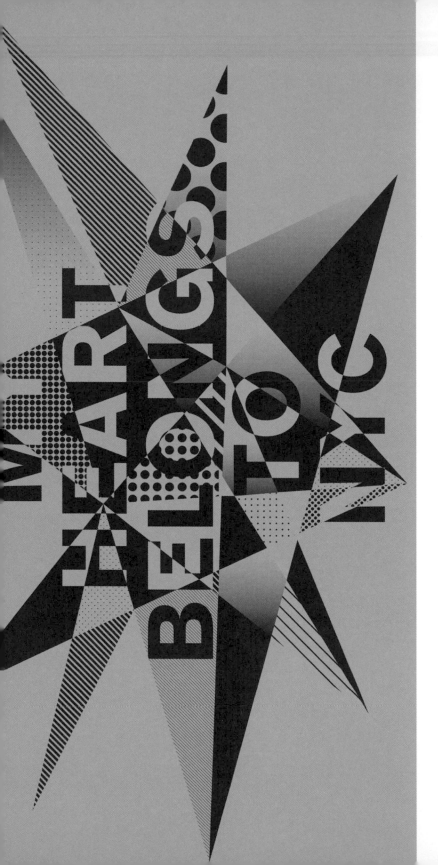

Jessica Walsh

Did you see Timothy today? Yes.

What did y'all do together? After work I went to the gym for my new "get healthy" regimen. As part of this plan I want to start cooking healthier meals. I used to love cooking, but for the past year and a half I've ordered in almost every single meal, including breakfast.

Timothy Goodman

Did you see Jessica today? Yessir.

What did y'all do together? Jessie cooked for us! It seems this modern NYC gal has some domestic qualities. It was super cute. She wanted us to spend a night in, since we tend to always go out. After dinner, we took it up to the roof. She has an amazing view.

YOU LOSE ALL THE VITAMINS WHEN VEGETABLES ARE OVER-COOKED. —TG

LOVE TO CLEVELAND! —TC

Did anything interesting happen? She overcooked the asparagus.

Did you learn anything new about Jessica? Some of Jessie's friends refuse to speak to her about this experiment. They don't approve, which obviously bothers her. I talk to my good friends about Jessie every day, so I'd be pretty disappointed if I couldn't speak to them about it.

Did you learn anything new about yourself? I feel so "American" compared to Jessie. It really hit me tonight. At my core, I'm just an Ohio boy who loves basketball, books, beer, babes, and barbecue. I dig American history, current events, and pop culture; things that make this country tick. I read the *New York Times* the moment I wake up. I can't talk to Jessie about this kind of stuff—it's just not her thing. Jessie likes mysterious foreign guys who wear all black, talk about Gothic architecture, and contemplate human existence.

It's just so tempting to get all your meals delivered when you are single in NYC. It's fast, convenient, and often cheaper than cooking for yourself. While I was in the market, I called Tim to find out what his thoughts were for dinner. He was not excited about this. He worried that it would become an ordeal, and he was already hungry. He tried to convince me to order from a healthy restaurant near me. Perhaps he was afraid my cooking would be a disaster? After several minutes of back and forth, I finally convinced him to let me cook. I made salmon topped with a mango salsa, with asparagus on the side.

After our meal, we went to my rooftop for a drink. I sipped on champagne, Tim had a beer. It started to get chilly up on the roof, so Tim put his arms around me to warm me up. The embrace was calming and comforting. After twenty minutes, we headed back downstairs for dessert, and Tim surprised me with chocolate

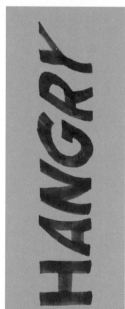

peanut butter ice cream! I'm trying to cut out dairy, so I savored just one spoonful. This was my favorite flavor growing up! In middle school, my dad would take me to Baskin-Robbins to get a scoop of classic Peanut Butter N' Chocolate ice cream every day after soccer practice. So many happy memories. Tim put on some jazz and we danced around my apartment for a while.

Did anything interesting happen? By now I know how quickly a "hungry Tim" can turn into "hangry" Tim! I can get this way, too. In fact, I'm pretty sure one of my earlier relationships deteriorated in part to my low blood sugar issues. I made Tim some bean dip crostinis to hold him over while I cooked. He seemed to enjoy them.

Did you learn anything new about Timothy? I learned that Tim does not like avocado, so I left it out of my usual mango-salsa recipe. Who doesn't like avocado?! I am not sure how it's going to work out long-term between us if he doesn't learn to appreciate the awe-someness of avocados.

Did you learn anything new about yourself? I think my heart belongs to New York City. The views from my rooftop never cease to astonish me. Some nights I go to the roof with a glass of wine and soak in how incredible

140

I ACTUALLY DO LIKE AVOCADOS! THEY JUST HURT MY STOMACH. :(- TG

How do you feel about this relationship/project right now? I had a really nice time tonight. We were kissing on the roof. We were kissing in her apartment. It was romantic. It felt right.

Is there anything that you want to do differently? Keep it going!

Additional comments? Jessie's been going to the gym. She seems way more upbeat because of it. I really, really like this. All hail her gym!

WORKING OUT AND EATING RIGHT IS THE BEST CURE I'VE FOUND FOR INSOMNIA AND MY HEADACHES. —JW

and unique this place is. So much life, so much energy, so many interesting people walking around and living their different stories. It's filled with endless places I want to go, art I want to see, good food to eat, and great people I want to meet.

I love to travel, and I'm grateful my job allows me to do this often. But no matter how wonderful a trip is, I always eagerly await the moment I catch a glimpse of the skyline on my way back from the airport. I fall in love with the city all over again.

How do you feel about this relationship/project right now? Everything felt romantic tonight, and I didn't want the night to end. However, I had to get up at 5:30 AM for work, so I asked him to leave early.

Is there anything that you want to do differently? I used to cook elaborate meals for my ex-boyfriend when we lived together a few years ago, but my skills are rusty now. I want to start cooking more often. There's a great local organic market near me, and it's much easier to be healthy when I handpick the ingredients.

Additional comments? I overcooked the asparagus, but we still ate it!

Jessica Walsh

Did you see Timothy today? Yep!

What did y'all do together? Tim met me near my office for a quick coffee at a place called Ports. I have a day packed with meetings, and I really appreciate how accommodating he is being with my schedule.

Did anything interesting happen? Tim is reading a manuscript for a book jacket design he is working on. The topic is creative duos, and why creativity works best in pairs rather than as a single person or in large groups. I have always loved to read, so I appreciate that Tim does as well. After coffee, Tim walked me back to my studio. He kissed me goodbye when he dropped me off at my office.

Timothy Goodman

Did you see Jessica today? Sí.

What did y'all do together? We met for coffee around 3:00 PM by her studio.

Did anything interesting happen? Not particularly. It was, however, the first time we kissed in public. As we had coffee, I could sense that she wanted me to be affectionate with her. While I've had commitment issues the last couple years, I've never been scared of PDA. I will hold hands and kiss any girl I'm dating in public. I can actually go too far at times, turning my PDA into TMI.

THE BOOK IS CALLED POWERS OF TWO.

SADLY MY COVER WAS KILLED. —TG

Did you learn anything new about Timothy? Tim brought up how "American" he felt compared to me, and how I seem much more European. I never thought about this before, since I am not so interested in these kinds of labels. Personally, what I think defines some- one is their character, not where they are born or their religion. It's how they treat people, their passions and interests, their goals and ambitions. Tim has great character. He is passionate, motivated, interested, and he has a big heart. Sure, he has his problems and issues, but at least he can call himself out on his own bullshit and laugh about it. I think the only people to laugh at are those who can't laugh at themselves.

Did you learn anything new about yourself? Tim called me an "enigma" today for the third time! I've been called this by family members and past boyfriends be- fore. Even my own therapist has called me an enigma. The Myers–Briggs personality indicator called me an enigma! Why do people think I am so complicated when

But this is different. This is Jessie. This is not the same. Usually, you don't know these kinds of things when you're getting to know somebody. But because I already know her so well, I know how much every- thing means to her. That's what's undermining me. I'm still nervous about leading her on too much right now.

Did you learn anything new about Jessica? She told me that she's been grinding her teeth. I used to do that years ago, and I'd wake up with massive head- aches. It was awful. I sent her an article about it today.

Did you learn anything new about yourself? We ran into my friend Wyatt while we were sitting in front of the coffee shop. Have you ever felt like someone knew you were up to something, even if you really weren't? Like, I knew that he knew that I knew that he knew something was going on. It was hilarious.

How do you feel about this relationship/project right now? I'm designing a book cover for a book on creativity and pairs. Essentially it explains how the "lone genius" is a myth, and that two people working

together is better than an individual or three people. It goes on to explain how pairs can challenge and support each other because they can only really lean on each other; there are no shortcuts. A three-legged table will hold up just fine, but two legs can run.

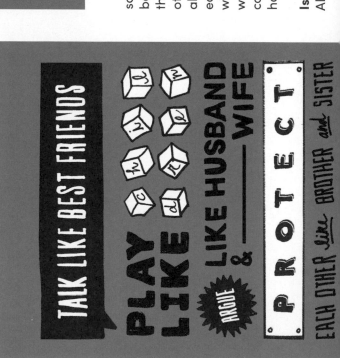

I feel so simple? I talked about this with a friend of mine. She told me to not take it personally, that being an enigma is basically the definition of being a woman. Perhaps it's not a bad thing to not be so easily defined.

How do you feel about this relationship/project right now? Someone once said that the best kind of relationship is one where you "talk like best friends, play like children, argue like husband and wife, and protect each other like brother and sister." Whether or not Tim and I work out romantically, I feel lucky to have this with Tim. Today we talked about how no matter what happens, we'll be forever linked through this crazy experiment.

It also explains that two people who co-create something will forever be linked. Studies that have been performed indicate that it takes twenty-five to thirty hours for people to really get to "see" one another for the people they are. It makes me wonder about Jessie and me, and how much we really "see" each other after twenty-eight days. I feel a real bond with her right now. We've been through a lot. No matter what happens in the next twelve days, I know we'll be connected forever because of this experience. I'm very happy, she's my best friend right now.

Is there anything that you want to do differently? Although I can be resistant about things, I really feel

144

Is there anything that you want to do differently? Not today. Things are good.

Additional comments? I drank decaf coffee today, but it just wasn't the same. I bought a croissant, but realized it was wheat, so I resisted eating it. This is rough. However, it's day three of healthy living and still no headaches! #tradeoffs

I CAN'T BELIEVE I WROTE IN HASHTAGS. →

#EMBARRASSING

-JW

like I'm going with the flow. I'm giving this a chance. I'm not freaking out or feeling a need to run away.

Additional comments? I talked to my grandmother tonight. My grandparents have been together for fifty-six years. If there's ever been hope for me to make a relationship work, it's the standard that those two have set. Grams told me that a relationship is about pushing through, not looking for a way out. Then she asked me if it'll be hard after I no longer have to see Jessica every day. It felt like a hit in my gut. I couldn't answer her.

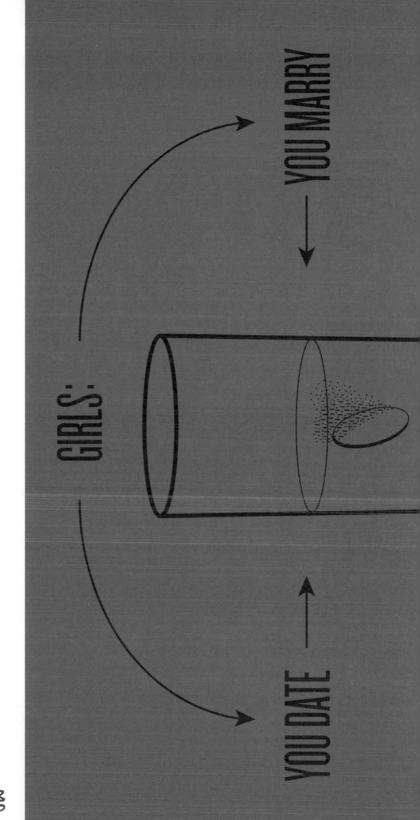

GIRLS:

YOU DATE →

YOU MARRY

Jessica Walsh

Did you see Timothy today? Yes.

What did y'all do together? Tim and I both taught our last class of the semester at SVA.

Did anything interesting happen? We each passed out cards in our respective classes. The cards asked whether the student was single or in a relationship and why. We collected the cards and were touched by their awesome and uninhibited responses.

There were a few like this that made me laugh:

☒ I'm single because...
☐ I'm in a relationship because...

BEING IN A RELATIONSHIP KEEPS ME FROM BEING FUCKING AWESOME.

Are your parents still together? Y☐ N☒

Timothy Goodman

Did you see Jessica today? Yes.

What did y'all do together? Our weekly after-class "hummus club" meeting with our buddy Michael. My students rocked it out tonight. However, it was our last class this year, so no more hummus until September. Over the weekend we made a set of cards that we passed out to our design students tonight. The cards asked them to select an option about being single or being in a relationship. We got some amazing responses back. I always tell them that there are no "rules" to this thing, that it's important for them to play and work with the truth in their work. College students are usually not afraid to express themselves, and I wasn't let down. Here are a few of them:

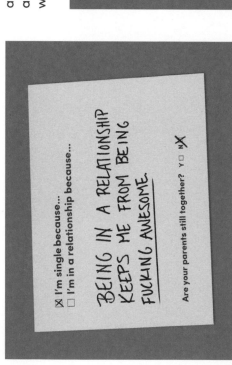

☒ I'm single because...
☐ I'm in a relationship because...

I pose shirtless on my myspace page.

Are your parents still together? Y☐ N☒

LOOK AT THEM ON OUR 40 DAYS FLICKR PAGE!

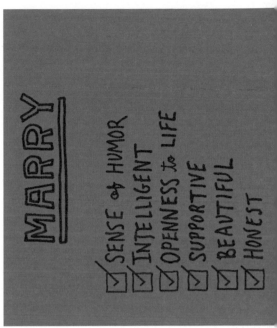

Did anything interesting happen? Not really. I feel like we're in that funny moment when we're no really sure if we should kiss when we see each other. It's probably my fault.

And there were a few like this that made me yearn for love:

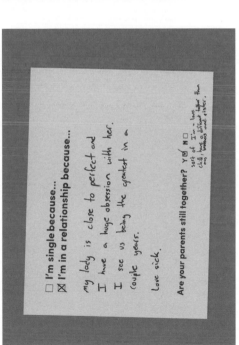

What I love about art/design students is that the realities of working in the "real world" haven't diluted their ideas and imaginations yet. They are young, but they're so much more open and honest than many other people. I think age is just an illusion. Some of the youngest people I know are the oldest at heart, and some of the oldest have been the youngest.

Did you learn anything new about Timothy? Through-out our friendship, Tim has always enjoyed expressing his dating escapades to me. I've always poked fun at him, comparing him to a little kid in a candy shop. He gets so excited about all the possibilities of differ-ent women, he can't focus long enough to figure out what he wants. Tonight, Tim was boasting about a few girls he dated before the experiment who have been messaging him recently. He also told me about

HA! I WASN'T "BOASTING." I WAS JUST BEING OPEN. —TG

OBVIOUSLY,
I'M JOKING
ABOUT THE
iPHONE
NOT
ABOUT
THE UGGS,
THOUGH!
—TG ←

- ☑ SPONTANEOUS
- ☑ CONFIDENT
- ☑ SENSUAL
- ☑ LOVES HER JOB
- ☑ EASYGOING
- ☑ WANTS KIDS
- ☑ PHYSICALLY ACTIVE
- ☑ AFFECTIONATE
- ☑ CURIOUS
- ☑ LET'S ME WATCH BASKETBALL
- ☑ DOESN'T WEAR UGGS
- ☑ OWNS an iPHONE
- ☑ DOESN'T USE AOL EMAIL
- ☑ NOT RACIST

Did you learn anything new about Jessica? There are girls you date, and there are girls you marry. Jessie is definitely a girl you marry. I think Jessie won't date a guy she feels is a waste of her time. There needs to be a real possibility for something more. I am much more open to dating someone who I know I don't want to marry. I have no qualms about dating a girl who only checks some of my boxes, as long as there are a couple that are definitive. But we all have that infamous internal wish list! I did a little online research and found this funny article from the *Huffington Post*,

a beautiful girl he ran into on the street who wanted to meet up with him. For the first time, all this bragging bothered me.

In therapy, we talked about how this desire for attention can stem from insecurity or low self-esteem. Constant attention provides constant reassurance that we are wanted or loved. I think deep down, no matter how confident we appear, we're all a little insecure. We want to feel accepted and understood on some level. Some of us seek this through romance, others through family or friendships, and others with work status and merits.

Did you learn anything new about yourself? One of my main goals is to find a way to help or touch people through my work. I've been unsure whether or not I want to teach next year since it's so time consuming. And I was a little insecure about whether I was making a difference. However, after my class, many of the students gave me gifts or came up to thank me for the semester. It gave me the encouragement to stick with it. Even if I only help out a few students a year, I think it's worth it!

How do you feel about this relationship/project right now? After class, my sister came over to my place for a glass of wine. I asked her to fill out one of our cards for the project. She wrote "I'm honestly too cool for any guy to handle." I had to laugh.

Is there anything that you want to do differently? Throughout my childhood, my sister and I would fight like cats and dogs. We'd argue over everything: attention from my parents, who was better at this or that, and her constant theft of my clothes. We were complete opposites in almost every way. My mom would always

MY SISTER
HAS BEEN
SINGLE FOR
YEARS AND
HAS NO
INTEREST
IN DATING
AT ALL...
HOW DID
WE TURN
OUT SO
DIFFERENT! →
—JW

148

say that one day we'd move past it all, and we'd share one of the most meaningful relationships of our lives. I thought this was my mom being overly sentimental.

A few years ago Lauren moved a few blocks from me, and we've grown incredibly close. I've finally understood the depth of this "sisterly bond" I've always heard so much about. While we have different personalities and different ways of expressing ourselves, I've come to realize that we're similar in so many ways. She's there for me anytime I need her. She is one of my biggest supporters and closest friends. We grew up together, so she understands me in ways that no one else can. While she continues to use my closet as her own personal cost-free department store, I've come to realize how meaningless a few pieces of clothing are in the bigger picture.

Additional comments? This makes me think about my relationship with Tim. While we're opposites in almost every way, I think deep down there are many similarities. However differently we may approach something, I think we want the best for each other.

entitled "10 Types of Women That Men Do Not Want to Marry." So true.

Did you learn anything new about yourself? If Jessie really is "marriage material," can I handle that realization? Am I really ready for a girl like that? What do I do if I start getting nervous about this relationship? Wait, am I nervous now? How do I manage that and still be sincere with her? What if I screw it all up? Maybe it's actually meant to be screwed up? What's going to happen next? Why am I overthinking this so much? Does she know I'm overthinking this? Am I possibly falling for her?

How do you feel about this relationship/project right now? I was once friends with an older gentleman named Jim. I could write a book on this guy. Anyway, he always had all these phrases he'd repeat over and over. This situation is reminding me of something he used to always say to me: "A man chases a woman until she catches him." However, I haven't been chasing Jessie, so why do I still feel "caught"?

Is there anything that you want to do differently? She gave me some attitude tonight because I didn't remember her entire work schedule. Sorry, Jessie, but I have a busy work schedule, too. What I loved about our friendship is that we never talked about design or our work. It was very refreshing to me. Now, inevitably, we talk about it a lot.

Additional comments? Big thanks to all the SVA students who contributed, along with our friends Julia Hoffmann, Luke Hayman, John Fulbrook, and Michael Freimuth for letting us pass these out in your classes!

HE'S TALKED ABOUT THIS BEFORE —JW

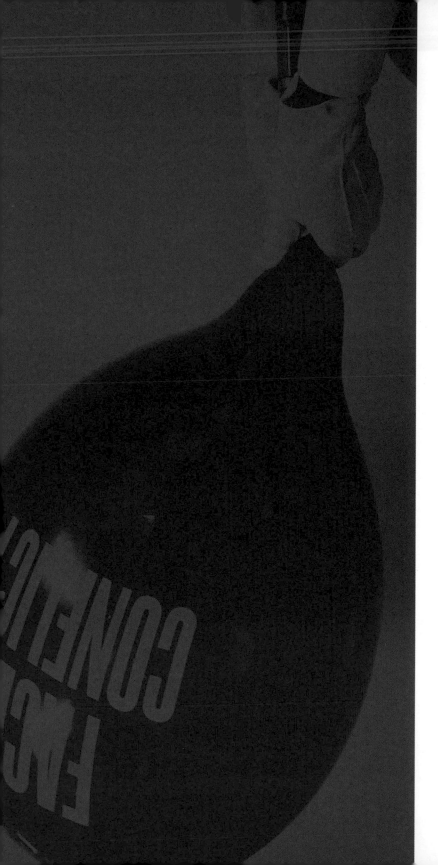

Jessica Walsh

Did you see Timothy today? Yes.

What did y'all do together? Another therapy session.

Did anything interesting happen? Jocelyn asked us what we thought would happen after the experiment ended. I don't think it will work out unless Tim is ready to

Timothy Goodman

Did you see Jessica today? Yep.

What did y'all do together? We met for our weekly therapy session.

Did anything interesting happen? Jocelyn was grilling us as usual. We talked about the sex. We talked

change, unless he's interested in dating me exclusively. I know his past relationship patterns too well. I know he likes to date around, and I know he likes the idea of new girls. I want more than that.

Did you learn anything new about Timothy? Jocelyn asked Tim what he thought would happen once the experiment was over, and if he would like to continue to date me. Tim said he hadn't thought about it yet. How can this have not yet crossed his mind? *Men.*

That being said, I am not worried or stressed about what might happen. I am definitely becoming more relaxed and tolerant of all this uncertainty. No sense in worrying—it's not going to help anything. What will be will be.

Did you learn anything new about yourself? Tim said he was worried about the idea of dating me after the forty days are over, since I have a pretty intense amount of work-related travel coming up. He said he's tried the long-distance thing before and it didn't work out. I talked to Jocelyn about my intense work/travel/teaching/lecture schedule coming up in the next month, and how that might impact a relationship. She suggested that perhaps it's not the best time for

about the fact that we've been more intimate recently. We talked about what all this means going forward. Jocelyn challenged us to start thinking about what's going to happen when this project ends in ten days. Do we want to continue dating or do we want to stop?

Honestly, I have no clue. Jessie said that she is preparing for things to be over between us. She thinks I'm going to call it off after the forty days are over. I don't necessarily agree with that. I do feel resistant to promising anything too definitive, though. I just want to go with the flow, keep it light, have a Coke and a smile and enjoy what's going on here. Is that so bad? Is that me just being a coward?

Did you learn anything new about Jessica? Jocelyn told Jessie that she's nonconfrontational to a fault. She said that she doesn't fight back and stand up for things in a relationship. She said that Jessie interprets remarks about her as the truth, rather than as an opinion. Jessie is a very smart, resilient, confident woman, and she should fight back!

Jocelyn also mentioned that it's not a good time for Jessie to be in a relationship because of her health issues and her work schedule. She said that Jessie should handle this stuff first. Lord knows I have my issues, so I'm okay with mystery and uncertainty, while Jessie isn't so much. But she has been much better this last week!

Did you learn anything new about yourself? Jocelyn said I'm going to have to eventually let a woman in, that I can't keep my life on only my terms all the time. This may sound obvious or ridiculous to you—but right now, it feels like such a foreign concept. Over the last couple years I have absolutely loved my freedom, my job, and the fact that I can do whatever I want,

YOU KNOW, THE COCA-COLA AD FROM THE EARLY 80s! —TG

whenever I want, with whomever I want. It has become increasingly addictive. And yet, deep down, I know Jocelyn is right. I'm going to have to share my life at some point. And I will when I meet the right person. When I used to paint homes for a living in my early twenties, our foreman would always yell, "I have a wife, not a life!" It always scared the hell out of me, even if I knew it was all malarkey.

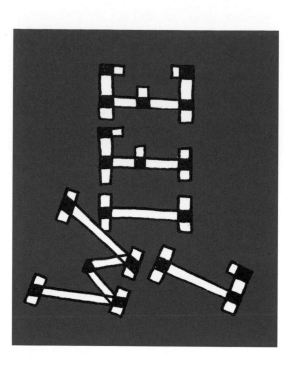

me to be in a relationship. It reminded me of an email from my ex who broke my heart.

I'm sorry □

Parsa
to Jessica ▸

I completely adore you, I just don't think you have room for me (in a healthy way). I think you are a remarkable woman who has too much on her plate but one of the biggest hearts of anyone I have ever seen. I will forever be there for you in whatever capacity you want me to be, I just don't think you have room for a boyfriend right now.

How do you feel about this relationship/project right now? Like many other New Yorkers, I've fallen into the busy trap. I've put my work before my relationships, my personal needs, and even my health. I believe my workaholic tendencies can be attributed largely to a genuine love and passion for what I do. It's truly the most interesting thing in my life right now. But maybe there's more to it than that.

Is there anything that you want to do differently? I discussed in therapy how I don't want to be that girl who is always "too busy." I want to set aside more time for my friends, my family, a relationship, and myself. This experiment has forced me to take time away from work each day, and while it can be stressful, I think it's been good. I want to continue to make time for all the relationships in my life.

I also want to face conflict more often. Jocelyn said she left the last therapy session feeling angry about how Tim spoke to me. She said I should fight back

How do you feel about this relationship/project right now? I feel really good! It's been a fun, solid week for Jessie and me.

Is there anything that you want to do differently? Not today.

Additional comments? Without knowing, we both wore blue pants today.

BONOBOS! —TG

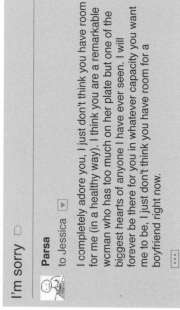

THERE IS A GREAT ARTICLE ABOUT THIS ON NYT.COM CALLED "THE BUSY TRAP." —JW

WOW TIM HAS HUGE FEET! —JW

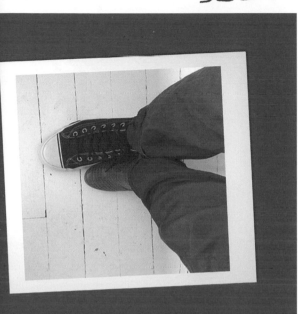

instead of internalizing negative comments. We discussed how my aversion to conflict and my desire to please people I care about affects my relationships. I used to stand up for myself more, but lately I've been avoiding conflict. She asked me to think back on past relationships.

I think this can be partially traced back to a relationship I had last year. Jocelyn said that perhaps I am now scared to confront conflict out of fear of losing people close to me. She said this conflict-free strategy does not help myself or others. She reminded us that a relationship that can't stand up to conflict is not worth staying in at all.

Additional comments? At the end of therapy, Tim said "as long as Jessie's happy, I am happy." That was sweet. He hailed a cab for me, we gave each other a hug and kiss, and I headed back to the office.

Jessica Walsh

Did you see Timothy today? Yep.

What did y'all do together? We went to the AIGA Bright Lights gala. Tim is on the benefit committee, and my design partner, Stefan Sagmeister, was being awarded the AIGA medal. It was nice to be there to show them both support. It was a wonderful evening full of food, friends, drinks, and more food.

Timothy Goodman

Did you see Jessica today? Oh yes.

What did y'all do together? We went to the AIGA design gala. I was on the benefit committee, so I happily dragged her along with me. Also, her partner, Stefan, was being honored with a medal. We sat with him and his fiancée, Veza.

Did anything interesting happen? At least four of our friends asked us to kiss during the course of the night. They wanted us to prove that we're doing this experiment together, like it was some sort of a contest. It was ridiculous. My friend Esteban practically made us make out in front of him. And everyone asked if we're going to keep dating after the forty days. I felt tired from it all. Stefan's fiancée was antagonizing me a lot. At one point she came up to me and said, "You're hot, but you're a coward."

Did you learn anything new about Jessica? I love that Jessie lets me be me. I never feel like I have to conform

WE WERE POINTING AT JULIA'S STOMACH BECAUSE SHE WAS PREGNANT. YAY, BABY ZOE! -TG

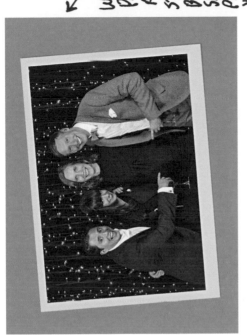

Did anything interesting happen? I have sensed that Tim is not comfortable with public displays of affection. He has always kept the girls he dates private and separate from his friends or work relationships. In the four years I've known him, I've only met one or two of the girls he's dated. Tim and I have been intimate for the past few weeks, but he avoids showing affection in front of anyone we know. At the gala, a few of our friends wanted us to kiss to prove we were really dating. Tim became extremely uncomfortable from the pressure to kiss me in public. Is this just how he always is? Or is it just me? I'll try not to take it personally, but it's nice to be with someone who is proud to have me by their side.

Did you learn anything new about Timothy? His face turns bright tomato red when he is embarrassed or feels pressured. I must admit I've always found this insanely adorable.

Did you learn anything new about yourself? After the gala we took a cab from Chelsea to the Lower East Side to meet up with a couple friends of ours. It was raining out and the restaurant steps were very slippery. I was in five-inch heels and a long dress. On the way down the stairs, my dress got caught under my heel, and I completely wiped out and tumbled down the entire staircase!

The entire restaurant stopped eating and stared at me. Tim made so much fun of me for it. In the past, this sort of thing would have been so mortifying that it would have completely ruined my night. But more and more I don't take myself too seriously. So I picked myself up and laughed it off and forgot about it almost immediately. I was able to enjoy the rest of the night without worry.

for her, nor do I worry about her in social settings. We both had a lot of friends and people we knew there. I can be very sociable at parties, and even though she's a bit more reserved, she's always fun and up for whatever. I really appreciate this.

Did you learn anything new about yourself? Is Veza right—am I really a coward? Perhaps. As I've said, something is holding me back. And it's not just about having commitment issues. Yes, I do think the fear of commitment and the fear of monogamy are natural states for a lot of men. I salute those who are never tempted, because it's damn hard to stay focused in NYC. I think I'll know when it's right, though.

25

NUMBER of TIMES A DAY A GUY THINKS ABOUT SEX. WOMEN THINK of IT.

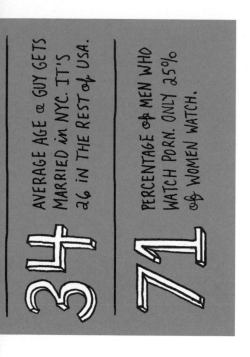

34 AVERAGE AGE a GUY GETS MARRIED in NYC. IT'S 26 IN THE REST of USA.

71 PERCENTAGE of MEN WHO WATCH PORN. ONLY 25% of WOMEN WATCH.

How do you feel about this relationship/project right now? People who have heard about the experiment joke about how this would make an awesome wedding story. I recently read a psychology piece on attachment theory. It said that if two people are just physically proximate for enough time then they can fall in love, regardless of how different they are, or how they treat each other. Tim has really started to open up to me this past week, we've been having a great week, and we've grown closer. But I keep reminding myself of Tim's dating history. Only a few days ago he was bragging about other women! I want to keep my guard up and prevent myself from getting too close too fast. That's what I've done in the past.

Is there anything that you want to do differently? In the words of one of my favorite artists, Jenny Holzer:

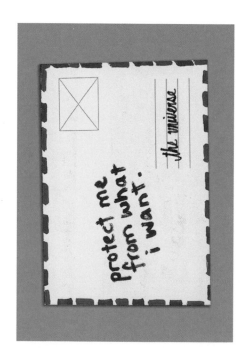

protect me from what i want. ——— the universe

Additional comments? We enjoyed a few cocktails with our friends. It was a wonderful night. On our way out of the restaurant, we were all a little tipsy. I

How do you feel about this relationship/project right now? Things have been really great the past week. But after all the questions during the gala, I'm starting to feel pressured again. I hate that I feel like I need to decide something in the next nine days. Honestly, I wish we didn't have to talk about it.

Is there anything that you want to do differently? When it comes to the pressure, I need more patience. I've gotten a lot better, especially after living in San Francisco for a year and a half, but my patience isn't the best.

Additional comments? After the gala, we met up with some friends for a drink at a spot in NoHo. As we were leaving, Jessie and I stole some oatmeal from this place. It was hilarious! She and I had a fun time and a good laugh.

TIM FARTED RIGHT AFTER WE TOOK THIS PHOTO. —JW

told Tim how hungry I was, and next thing I knew he swiped a bag of granola off the shelf.

I was such a klepto as a teenager. By the time I was thirteen, I practically had a baseball card racket going. My friends and I would wear tighty-whities, and stuff an entire box of baseball cards down our pants successfully. I still have my Ken Griffey Jr. rookie card. When I was fourteen, we'd steal CDs from the used CD shop. I still have the entire Led Zeppelin and Pink Floyd discographies because of it. When I was fifteen, we would steal Mad Dog 20/20, and then get drunk at the movies. When I was sixteen, I was stealing cigarettes from the gas station. And finally, when I was seventeen, we had enough of the small-time stuff. We convinced our friend to work at CVS pharmacy, so we could literally hijack the joint. We'd come home with a garbage bag full of cigarettes, cigars, beer, wine, rolling papers, candy bars, candles, anything we could party with. I was such a little dust-kicker. Anyway, even though those days are long gone, I love that Jessie can still bring a part of my youth out (even when it involves breaking the law). We had a good night.

SORRY FOR THE RANT ABOUT MY HIGH SCHOOL DELINQUENCY! —TG ←

We laughed about it, but I did feel pretty guilty about it. I insisted on going back and returning it. Tim reassured me that we'd go back for brunch together and leave an extra large tip instead. The four of us wandered up and down the cobblestone streets of SoHo trying to find a cab. We passed the time by devouring the granola, making jokes, and splashing each other with the rain. We finally gave up on finding a taxi and hailed a gypsy cab. We held each other and kissed the entire cab ride back to my place.

HA, WE NEVER WENT BACK. —TG →

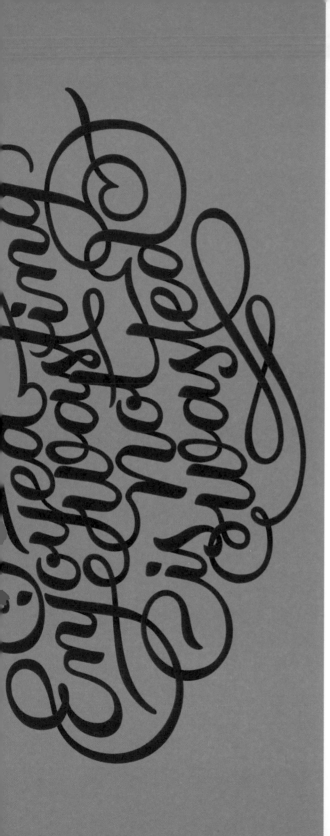

Jessica Walsh

Did you see Timothy today? For a moment.

What did y'all do together? Our friend Julia was having a going-away party, and we planned to go together. However, after a long morning at the gym, I was extremely tired. I strained a muscle after running five miles, and I just wanted to lie in bed and watch a movie. I asked Tim if he would mind if I stayed at home. He seemed kind of annoyed, but said he'd stop by instead. I felt really bad about it, but I can't remember the last time I took a day off from work. Sometimes time enjoyed wasting is not wasted!

Timothy Goodman

Did you see Jessica today? For a fast second.

What did y'all do together? My friends Julia and Esteban are moving to Berlin, so we were going to go see them tonight in Brooklyn. I was damaged from all the whiskey I had last night at the gala. Jessie decided to stay at home, so I left early to go watch the Knicks game with Esteban. I stopped by Jessie's before going.

Did anything interesting happen? I brought her a rose. She was lying in bed watching *Silver Linings Playbook*. We talked about tomorrow's plans and we kissed a lot.

Knicks won! 85-79. —TG

Did anything interesting happen? He arrived at my door with a single red rose.

Did you learn anything new about Timothy? The flower was incredibly sweet and romantic. Little gestures like this are very meaningful to me in any relationship. We hugged and kissed and talked about our plans for tomorrow.

Did you learn anything new about yourself? This experiment has been crazy, and the self-reflection in therapy has not been easy. In combination with the headaches, it sent me over the edge last week. It's unbelievable, but since changing my lifestyle last week, I feel almost entirely better. I run and do yoga every morning now. I am sleeping better, and the headaches are gone, which makes me feel calmer. I am starting to feel like my normal self again, and I think it's having a positive impact on Tim and me as well. I went into

Did you learn anything new about Jessica? I was certain that she did not watch movies! Who knew.

Did you learn anything new about yourself? I still feel the pressure from our friends last night at the gala. Everyone seems to have these expectations about me and this project, and I feel burdened by that.

How do you feel about this relationship/project right now? Seeing each other every day isn't easy. I'm feeling a bit claustrophobic. Honestly, I was hoping that she wouldn't want to come with me to the going-away party tonight. It's nothing personal, I just needed some space. We were texting earlier, and I tried to be coy about it.

I LOVE WATCHING MOVIES, I JUST DONT OFTEN HAVE THE TIME. —JW

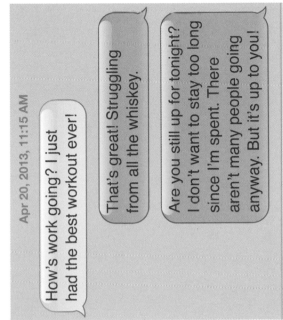

Apr 20, 2013, 11:15 AM

How's work going? I just had the best workout ever!

That's great! Struggling from all the whiskey.

Are you still up for tonight? I don't want to stay too long since I'm spent. There aren't many people going anyway. But it's up to you!

iMessage Send

this experiment hoping to learn about relationships, but we've really learned and grown so much on a personal level as well.

How do you feel about this relationship/project right now? Tim's rose reminded me of my all-time favorite book, *Le Petit Prince*. I have several copies, but my favorite is this old vintage edition I found last year, which I now keep by my bedside. I reread it today.

The story is about an adventurous prince who loves a little rose. The rose is naïve, proud, and doesn't know how to admit her love back to the prince. Because of this, she accidentally drives him away. When she informs the prince of her love, it is too late. The prince's heart is already set on traveling the world. During his travels, he meets many adults of various professions. He comes to realize that most adults are narrow-minded and pragmatic. He realizes they are too preoccupied with wealth and power and other

Is there anything that you want to do differently? A couple days ago, Jocelyn said that we're playing the roles we've been cast in from the beginning: Jessie wants more and I pull away. I suppose everyone is playing out their own reactions, roles, myths, and characters in relationships. How does one really change their habits in a relationship, anyway? Is that even possible? When you meet someone, you usually don't meet the real person. You meet their sponsor or their agent. It takes a while to really know someone, and it takes a while to let go of our baggage. It's a tough current to swim against. No wonder people find themselves making the same mistakes over and over again.

Additional comments? Jocelyn's words reminded me of something a wiser, older friend said to me many years ago. I had just graduated college, and I was feeling

I'M ALSO SO THANKFUL THAT I WENT THROUGH ALL THAT. CHANGED MY LIFE. —TG

"serious matters," and they miss the important things in life: beauty, friendship, self-discovery, imagination, open-mindedness, and love.

The prince watches as adults rush from one place to the next, never able to appreciate the small wonders of the world right in front of them. Through his journey he begins to greatly miss his flower and realizes the deep extent of his appreciation for her. While there are many roses out there, it's his love for her that makes her so special and unique.

There are so many life lessons embedded within this beautiful story. St. Exupéry suggests that the key to happiness is to stay inquisitive about life and to explore the unknown, with an acceptance that many of life's questions will remain a mystery. The story emphasizes the responsibilities of our romantic relationships, and how they teach us about our greater responsibility to the world.

Is there anything that you want to do differently?
The story emphasizes that words are the source of misunderstandings, and that the truths in life defy explanation. Only our hearts can see them correctly. It makes me think about Tim, and how many misunderstandings we've had. We do deeply care for each other, but our opposing styles of communication cause unintentional stress between us. I started reading about these communication styles, which are outlined in this book. I have an "affiliative style" and Tim has a "competitive style" of communication. This all makes me wonder. Do I really comprehend his true intentions and feelings, and does he understand mine? I should listen more to my heart. Does this feel right?

Additional comments? A few favorite lines from *Le Petit Prince* to end the day...

extremely unstable about my future. At the same time, I had recently gone through a rough breakup—a relationship that I had pretty much single-handedly ruined. I was depressed, heartbroken, and I wasn't handling anything well. I have to laugh at what a mess I was then. Isn't it extraordinary to look back at something that felt so profound at the time, only to see how trivial it feels now? Anyway, my friend gave me some very meaningful words, something that I'll never forget.

Re: (no subject)

Kenton
to Timothy ▶

It is a hard one. I have been very blessed to have had a very successful professional life, but I feel empty because there has not been a real relationship for some time. Success means nada if you have no one to share it with, believe me on that one. But it's very important to get with a woman who shares your values, who you have compatibility with in the areas that really matter to you. And I have to be physically, spiritually, and intellectually attracted to a woman. It must be all 3, or I won't even consider going out with her, let alone being in a relationship with her. So I think you have to ask yourself about what you want and need, what would you be willing to compromise on, and what is absolutely non-negotiable. A lot of folks do not really think these things through, so our relationships become a series of reactions. Although I've never been married, I have lived with three women, been with all kinds of women, and my God the mistakes I've made and the harsh lessons I've learned. It takes a while to become a more self-realized adult, but it will happen if that is what you really want. And the right partner will be there waiting for you.

Timothy Goodman

Did you see Jessica today? Handz yes!

What did y'all do together? We met early on a beautiful Sunday AM. As an experiment, our plan was to explore a common relationship cliché: holding hands.

Jessica Walsh

Did you see Timothy today? Yes.

What did y'all do together? We challenged each other to hold hands for eight hours straight. Hand-holding is the quintessential public demonstration by couples.

THIS GUY'S NAME IS VLADIMIR —TG

CHECK OUT THE VIDEOS ON OUR VIMEO PAGE! —JW

And we met some interesting people along the way:

Did anything interesting happen? We held hands for eight hours straight without once letting go! We went shopping, we ate brunch, we bowled, we played pool, we went on the train, we held hands with strangers, we got annoyed with each other, we peed together, we did head stands. It was a ton of fun.

Did you learn anything new about Jessica? Today just reaffirmed how awesome Jessie is. There aren't many people I could share stuff like this with so comfortably—even when it's uncomfortable! There's a reason why we're on this crazy ride together. Also, Jessie's hand sweats.

Did you learn anything new about yourself? I can't pee when there is an audience listening to and recording me. I also forgot that I'm a bad bowler.

How do you feel about this relationship/project right now? I feel good about it all. However, I'm becoming increasingly concerned about what I'm secretly calling "40DoD-Day." At the end of the day today, my friend asked me what's going to happen when the forty days are up. I didn't know how to answer him. This

Did anything interesting happen? I told my sister what we were going to do. She thought it was impossible that we'd make through the entire day. Impossible just means it hasn't been done before! It wasn't that difficult. Surprisingly, I adjusted easily to having only one hand.

We met at my studio. Tim looked super cute today, I liked his striped shirt. We rode the subway together. We tried on shoes. We went to the bathroom. We played pool. We bowled. We ate brunch. We took cabs. We used a Starbucks restroom. We did handstands in the park. We attempted to do yoga, then we gave up and fell asleep in the grass. Some people were perplexed. Some whispered. Some rolled their eyes. A few people joined in and held hands with us. Most just laughed or smiled. It was a beautiful day.

Did you learn anything new about Timothy? I learned that Tim is extremely pee shy! He also pees for an exceptionally long time. I wasn't sure it would end. It was endearing.

Did you learn anything new about yourself? I know I can be super quirky. Looking back, I was always like this, even as a child. Twelve years ago wher my family watched a love story about a shy and peculiar French

girl named Amelie, they practically tried to change my birth name. They've always thought our personality similarities were uncanny, and we both had a suicidal goldfish as a childhood best friend. I guess the bangs match up, too. All I need now is a gnome.

TIM CONVINCED ME TO TAKE THIS PHOTO. NOW I'M EMBARRASSED. —JW →

I've always been looking for a boy who can match my level of weirdness. Tim isn't quite as strange, but I do love that he can be playful, and we can laugh at ourselves and each other. Running around the city today reminded me of the *Amelie* ending. We had so much fun. Could Tim be my Nino? I've been trying to keep my guard up to protect myself, but maybe I should listen to Mr. Dufayel and let myself be vulnerable before it's too late.

How do you feel about this relationship/project right now? I think this experiment brought us closer together. There is actually biological science to all this. Holding hands and hugging decreases the stress hormones in the brain, lowers blood pressure, and releases oxytocin (the cuddle hormone). It promotes the feeling of trust, and, let's face it, it makes you feel all warm and fuzzy inside. In many ways it's more serious than kissing!

makes me curious, because I always know if I want to at least pursue something. Jessie and I seem to be fundamentally different on many levels—I wonder if there's some cosmic roadblock. If Jessie and I were supposed to be more than great friends, wouldn't I know by now?

Is there anything that you want to do differently? I need to forget everything I just wrote and stop worrying about "40DoD-Day." Also, my hand feels odd right now, like it broke out of some plastic mold. Truth be told, my hand misses Jessie's hand right now.

Additional comments? This experiment was so fun today. I'm reading a book on writing and myths that a previous boss gave me years ago. When I worked for him, we used archetype cards to help with our brand stories and positioning. Archetypes are ancient, universal patterns of behavior that highlight an original example, ideal, or epitome. According to this idea, all people fall into various types, including the Trickster, who manipulates others through duplicity; the Martyr, who transcends service to oneself or a cause; the Fool, who helps people laugh at absurdity and hypocrisy; the Artist, who inspires others to see life symbolically; and the Gambler, who follows intuition even when others don't.

These helped us to know who a particular company was, what they stood for, and where they were positioned in culture—which sometimes informed our entire creative process. While myths and archetypes are created around our favorite brands, I find it's much more important to be in the story, rather than the one who's telling it. Living the experience is what matters, not what kind of archetype you're labeled as.

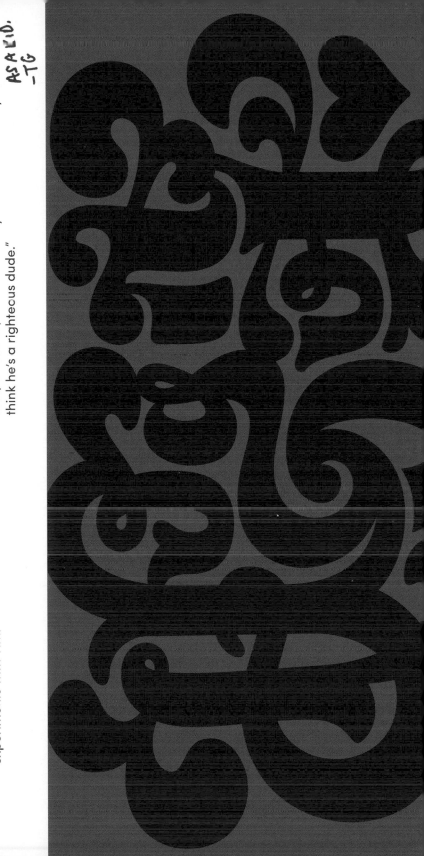

Is there anything that you want to do differently?
We started out the day by passing a street musician named Vladimir who I walk by on my way to work every morning. He plays the guitar and sings for tips. Today we saw him in the subway, away from his usual spot outside the Chelsea Hotel. He said this was the first time he has seen me smile. That is crazy! I should smile more often. Then he mentioned that he thought Tim looked like he worked in porno.

Additional comments? I want to do more crazy weird experiments with Tim!

All of this makes me think about *Ferris Bueller's Day Off* when Mr. Edward Rooney's secretary, Grace, speaks about Ferris: "Oh, he's very popular, Ed. The sportos, the motorheads, geeks, sluts, bloods, waste-oids, dweebies, dickheads—they all adore him. They think he's a righteous dude."

Ferris was my hero as a kid. —TG

Jessica Walsh

Did you see Timothy today? Yes.

What did y'all do together? After work I had a dinner planned with my friend Veza at Pure Food and Wine. Tim had a work meeting. He texted me around 9:30 to meet in my building's lobby. Right as I got the text, I was getting out of a cab. I saw him standing in line at the market below my apartment building. I snuck into the market, ran up behind him and surprised him with a big hug and kiss. I also gave him a card that I made him. I bought him a chocolate sundae as a takeaway treat from my dinner. He was very excited about this and scarfed down his pasta and the ice cream within minutes of walking into my apartment.

FUNNY, I DON'T RECALL ANY HUG OR KISS! —TG

166

Timothy Goodman

Did you see Jessica today? Yes.

What did y'all do together? I went to her place around 9:30 PM. The plan was for me to sleep over. I emailed her during the day to tell her that I was coming over. I was excited about it!

Did anything interesting happen? We began arguing the first minute I saw her. She brought me some ice cream, and then she told me about a guy she knows who had just started dating a girl I was once mildly talking to. When I say mild, I mean mild. I never even kissed this girl. We hung out a couple times, had some laughs, and that was it. I asked Jessie what exactly she told this guy, but her answers seemed suspicious to me. I continued to ask her about it, and she started to contradict herself. I felt like she was lying.

Outside of all that, this whole thing really just bothers me. I can't speak for all men, but if I was in his position and had just started dating a girl I was excited about, the LAST thing I'd want is for someone to tell me gossip about her. Why go there? Jessie doesn't seem to have a filter sometimes.

And more importantly, I never even dated this girl! So on top of Jessie blurting this stuff out to him, what she told him was something that wasn't even true. This creates a couple of problems:

(1) If the girl hears this, she might think I was lying about what actually happened between us—which

Did anything interesting happen? After he ate, Tim talked about going to a work-related party on Thursday night at a gallery. Only an hour before, a guy friend of mine told me he was going to this party with his new girlfriend, someone who I thought Tim had dated last year. I thought I should give Tim the heads-up that this girl might also be at the party, to avoid any awkwardness. Tim started grilling me intensely to find out more information. He was upset that I thought he had dated her. I was under this impression since he took me to a party at Miami Art Basel once just so he could meet up with her. When we were flying back from Miami, we were talking about girls that he was seeing at the time, and he named her. I remember the entire trip vividly.

was nothing. (2) The next time I see this dude, he might be weird with me because he thinks I dated his girl—which I didn't. (And I know he cares, because when Jessie told him, he texted his girlfriend to ask if she and I had ever dated.) It's a recipe for awkwardness for everyone, and it could have all been avoided if Jessie didn't say something.

THE COUPLE READ THIS AFTER AND LAUGHED ABOUT IT. —JW

Anyway, we argued about this for a good hour. Admittedly, it was the stupidest argument ever. But I couldn't let it go. I felt like she lied to me and I just wanted her to ADMIT that she lied to me. I'm like the police: I can have all the evidence, but I want a confession! Ha! Really, I just wanted her to take some responsibility for what happened. But Jessie can be stubborn sometimes, refusing to see things my way. Then, of course, she felt attacked because she hates confrontation. Then it turned around on me. Things got heated. I threatened to leave. She said sorry. I said sorry. I ate some ice cream. We talked. We hugged. We made out. We had sex. We went to bed.

Did you learn anything new about Jessica? Jessie famously brushes any conflict off by simply dismissing me as "sensitive." Her new line is, "It's not a big deal,"

boat trip!

Tim," in this condescending tone. Nothing drives me up a wall more than this stuff. Sometimes I feel like we're two aliens, from different planets with different languages, trying to communicate via Skype without electricity. Sigh.

Did you learn anything new about yourself? I can't believe I haven't figured this out until now, but Jessie is totally a "tricky girl"! I'm literally having an epiphany right now! Jessie has all the characteristics of a tricky girl: pretty, quiet, complicated, talented, and mysterious. She's completely unaware, yet willing to make her mind up at the drop of a hat. She is Annie Hall, Felicity Porter, Clementine Kruczynski, and Patricia Franchini all rolled into one.

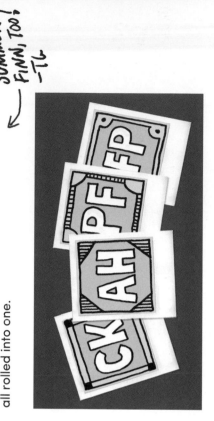

SUMMER FINN, TOO! —TG

The tricky girl thing is totally my Achilles' heel. I'm at this kind of girl's mercy. You can NEVER tell what's on a tricky girl's mind. The tricky girl will unknowingly rip your heart out, cut it into little pieces, and then ask you, politely, if she can feed you. I've fallen hard for girls like this in the past. I guess I've always known this about her, but now that we're in this relationship, I'm seeing it in a whole different light. Everything that

Tim wanted to know exactly what I told my friend about this girl. I couldn't remember the exact wording of the conversation, which upset him. He was pressuring me to remember the conversation verbatim, and it became more and more heated. As he got angrier, I started to withdraw and shut down. This only aggravated him more. I was beginning to feel defeated. I mixed up some small irrelevant detail, and next thing I knew he was calling me a liar. Honesty is one of the most important things to me. I just never lie. Even if I wanted to lie, I'm one of those people who just can't. You can read it all over my face.

I tried to step outside of the situation and analyze what was really going on. I think Tim was experiencing anxiety about his past. It was once again coming back to haunt him, and he's very worried about his reputation now. It's a defense mechanism. He began displacing the conversation and projecting the "bad guy" feelings onto me.

Did you learn anything new about Timothy? I know how these stupid misunderstandings can ruin relationships. I've had fights with exes, woken up the next morning and couldn't even remember what the disagreement was about. I expressed my interest in dropping the subject. I started to rub his neck, and gave him a big hug. Personally, when I am sad or upset, this "hug it out" strategy always seems to work. And it did! We started hugging and kissing and the mood lightened back up within one minute.

Did you learn anything new about yourself? I have gotten much better in my life about stepping back from miscommunication and drama in order to see the bigger picture. This wasn't always the case. In earlier relationships, I could get lost in an argument

and I wouldn't drop it. I'd let it consume me. I don't feel the need to win arguments or feel right or wrong anymore, I am more interested in keeping the peace. I feel good about this.

How do you feel about this relationship/project right now? The makeup sex that followed was great! Who doesn't love makeup sex? Also, apparently Tim hasn't masturbated the entire thirty-five days. No wonder he was so tense before!

Is there anything that you want to do differently? I watched a documentary the other day that explained how the human brain can only store so much information. There is so much data going on around us at every moment, it's impossible to process everything. As humans we are constantly making unconscious decisions about what is relevant. I already feel overwhelmed with all the knowledge and interesting ideas I want to absorb. I have no interest in wasting valuable brain space on "he-said-she-said" gossip drama. I hate that Tim and I wasted an hour fighting about it.

Additional comments? Veza sent me one of Eleanor Roosevelt's quotes. It's a nice reminder of where to keep the focus.

happened tonight was a classic tricky girl situation. I've dated girls like this before, and it always drove me nearly mad. And the funny thing is that one man's tricky girl doesn't necessarily make her another man's. Someone else might date Jessie and not see ANY of this. A tricky girl is situational and circumstantial. It depends on all parties involved. I'm not built for a tricky girl. Oh dear.

How do you feel about this relationship/project right now? I hate to make her a trope, because she's clearly an amazing three-dimensional person. But this is blowing my mind right now. We have some fundamental differences we need to work through. I guess that's what relationships are about, right?

Is there anything that you want to do differently? I don't want to attack her. And I don't want her to feel attacked by me when we have disagreements. I think a lot of this stems from us having to seeing each other every day. It's hard, y'all.

Additional comments? She gave me a really sweet note in the beginning of the night. She knows I geek on Winnie-the-Pooh, so I could care less about this fight we had. Besides, we'll be in Disney World.

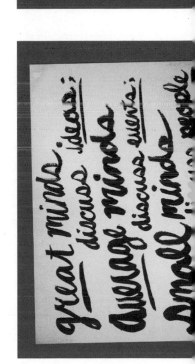

169

I am not
two-dimensional

DAY THIRTY-FIVE: APRIL 23, 2013

Jessica Walsh

Did you see Timothy today? Technically!

DAY THIRTY-FIVE: APRIL 23, 2013

Timothy Goodman

Did you see Jessica today? Technically, yes.

I FELT
BAD FOR
PUSHING
OUT. –TG

What did y'all do together? He slept over from Monday night.

Did anything interesting happen? I slept like a rock. As per usual, I gravitated toward the middle of the bed in a fetal position, hugging my Tempur-Pedic pillow. Sadly, Tim did not sleep as well—he was disturbed by the noises of garbage trucks outside my apartment. I've lived in my apartment for five years with insomnia, and I somehow failed to notice the garbage trucks until now. Now that he's brought it to my attention, the noise seems constant! It's like when you learn a new word and suddenly you see and hear it everywhere. It was an interesting reminder how much we see and hear what we want to.

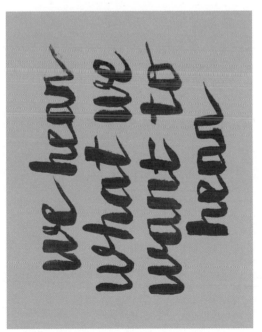

Around 2:00 AM, Tim woke me up in the middle of my REM-cycle dream. I was dreaming that Tim and I were with my sister by the ocean. The world

What did y'all do together? I slept over at her place last night. I rushed out of her apartment quickly because I was running late for a breakfast with my friend. I love meeting for breakfast in NYC.

Did anything interesting happen? Jessie is an insomniac, and I usually sleep very well. But ironically, I had the worst night's sleep ever. I was up all night tossing and turning. This NEVER happens with me. I can sleep through a tornado. Anyway, it was nice to stay over at her place.

Did you learn anything new about Jessica? Jessie slept directly in the middle of the bed the entire night. I literally don't think she moved one time. She was a rock. I even tried to push her over, albeit unsuccessfully. It was horrible.

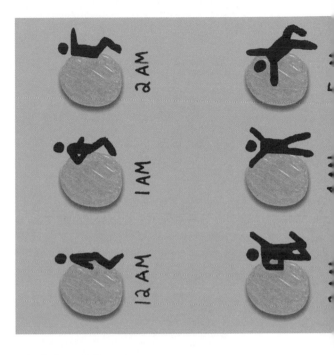

12 AM 1 AM 2 AM

171

HA, THIS IS SO TRUE. —JW

was going to end, and while I was aware of this, I didn't want to tell them. I knew there was nothing that we could do to stop it, and I wanted them to enjoy their last moments on earth. I've never been afraid of death, and the dream seemed strangely peaceful.

Did you learn anything new about Timothy? I like him naked. In the morning he took a shower, gave me a kiss goodbye, made a snide comment about my fancy toothpaste, and left for an early breakfast.

Did you learn anything new about yourself? When I fell back to sleep, I began lucid-dreaming. When this happens, I'm aware that I'm dreaming and I can manipulate what happens. This is one of my favorite experiences in life. I am fascinated by dream psychology, and how we can use dreams to make sense of our lives. As humans we often define what happens in our day-to-day life in the waking world as what is "real." However, I find that anything that is conceived in the mind (consciously or unconsciously) can be real.

Did you learn anything new about yourself? This never happens when I sleep at a woman's house. Is this a bad omen? I mean, everything was bothering me last night: the city lights were coming in through the window shades, there was a loud garbage truck outside, the pillows felt hard, and her place felt unusually warm.

How do you feel about this relationship/project right now? I feel better about our little fight last night. If there's one thing Jessie and I are good about, it's getting over things quickly.

Is there anything that you want to do differently? Get some sleep tonight.

Additional comments? I've been reading a book about the great baseball player Pete Rose. He was sort of this mythical character when he played in Cincinnati. He was a throwback to earlier times, when ball players were iconic enough to make a difference in their own community. In many ways, he was a great man. Forever gracious and considerate to his community,

6 AM 7 AM 8 AM

particularly with blue-collar folks. He was always giving to charity and he'd make sure he signed every piece of memorabilia for fans after games. He was the epitome of baseball for a long time.

He did, however, have three major shortcomings: He was an alleged addictive gambler, womanizer, and a compulsive perfectionist at work. He was a tragic character, who possessed a lot of good qualities—and a lot of destructive ones that tainted his life, his reputation, and his good standing with the baseball community.

There are usually two reactions when it comes to Pete Rose. He's good or he's bad. He's right or he's wrong. He's a nice guy or he's an asshole. It's natural to make these snap judgements, but why do we so easily dismiss someone as a two-dimensional character? We all carry a dichotomy, with gray areas in between. I suppose I'm trying to justify my own actions

Dreams and the musings of the imagination are more interesting than any day-to-day reality, as they are not bound by the constraints of waking life. Combining reality with the dream world makes things awesome. You can do whatever (or whomever!) you like! I taught myself how to lucid-dream last year.

How do you feel about this relationship/project right now? Feeling good!

Is there anything that you want to do differently? I still haven't been to Tim's apartment, which made me think back to the commitment-phobia signs. I texted him, asking when I'd get to stay over at his place. I knew he was writing something after seeing the classic iPhone "..." but he never sent a response. #sigh.

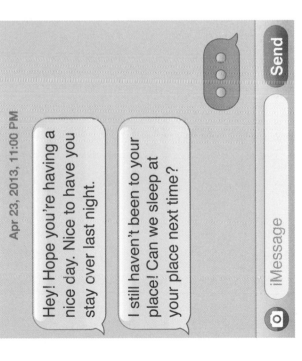

Apr 23, 2013, 11:00 PM

Hey! Hope you're having a nice day. Nice to have you stay over last night.

I still haven't been to your place! Can we sleep at your place next time?

iMessage Send

FUNNY,
BECAUSE I
DID INVITE
HER OVER
AFTER
JAZZ
ON DAY
24. —TG

Additional comments? I thought I moved to the right side of the bed, but apparently Tim remembers it otherwise. He sent me an illustrated diagram of his sleeping positions throughout the night. Such a weirdo! I like that.

here, but this experiment has made me confront so many things that I've tried to sweep under the rug. We shouldn't judge someone based on one snapshot of their life, we should measure someone by the totality of their existence.

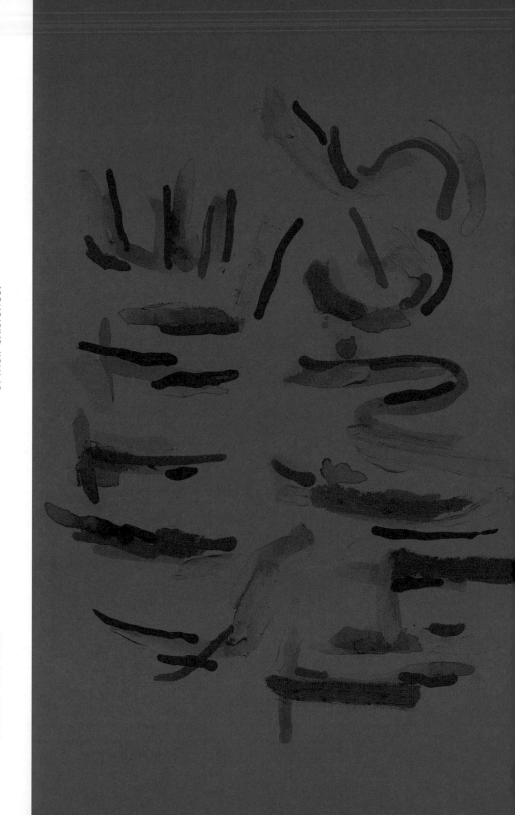

Jessica Walsh

Did you see Timothy today? Yes.

What did y'all do together? We met at a hotel in Midtown, where we were evaluating portfolios for junior-year design and advertising students. We grade their portfolios and help determine which students should get honors classes or receive scholarships. It was sad to close out the semester. I've grown attached to a few of my students. But every ending is a new beginning, and I am excited to see where the students go.

Did anything interesting happen? Tim's friend John is a funny character. He's been to Disney World three times in the past few years with his kids, and he had some pretty awesome tips. He told us that the most romantic ride is Haunted Mansion. He and his wife went without the kids last year just for that ride! So sweet. It sounds like they are very much in love. It made me think about other successful marriages I know of and wonder what makes a relationship last long-term.

JOHN WAS EXCITED ABOUT GOING ON DOUBLE DATES. —TG

Timothy Goodman

Did you see Jessica today? You know it.

What did y'all do together? Since we both teach juniors at SVA, we had to go to the mandatory portfolio review this morning. Essentially, a group of design teachers together in one room grading students' portfolios. When I got there, Jessie was already talking to a good friend of mine (and fellow teacher). I liked seeing her in my "world" today.

Did anything interesting happen? For the first time, I could really sense that she likes me. I hadn't felt that energy from her the way I did this morning. These little smiles and gestures and courtesies. I felt like we were "together," especially when we were explaining our Disney trip to some friends. I've always liked the word "together." I have no idea about its origin, and I obviously love the thrill of the chase, but I like to think it comes from merging these three wonderful words: to-get-her.

Did you learn anything new about Timothy? I am excited about Disney World, but I think Tim is starting to freak out. He keeps mentioning how much pressure it will be to spend three days together there. He said a weekend trip with a girl is something he has rarely done. It is very serious for him. We've been on trips together before, but perhaps he feels pressure now that we are more of an item?

Did you learn anything new about yourself? I have no issue spending a weekend with a guy who I like. Truthfully, when I find something I like, I want it all the time. I know I can have a slightly obsessive personality. This can apply to a song, a restaurant, a piece of clothing, a type of makeup, or a kind of food. For example, when I discovered this restaurant Dogmatic, I became obsessed and ate a gourmet sausage dog every day for lunch for two years straight. Or when I found this amazing pair of fleece-lined tights I loved, I bought fifty pairs of them so I'd never run out. I've listened to this James Blake song on repeat all month. And I like to go to the same coffee shops and order the same coffee every day.

Did you learn anything new about Jessica? I realized it was 12:30 PM, and I had a lunch in Brooklyn at one o'clock. Jessie was in a conversation, so I just waved goodbye and gave her a gesture that I had to go. Didn't seem like a big deal, but she has this way of making me feel like I'm doing something wrong. I've always felt this.

Did you learn anything new about yourself? I don't know if my way of leaving today bothered her, but I realized it might have been weird. If I need to be somewhere fast, I just like to go without a fuss.

How do you feel about this relationship/project right now? I feel okay on the surface level, but everyone is asking me what happens on day forty-one. That is not making me feel okay. I really think it's important to finish this project first. Then we should take a couple days off from seeing each other, gain some perspective, and keep seeing each other before we make any decisions. I'm not interested in dating other women. I'm interested in seeing if there is a healthy relationship between us beyond the project.

Is there anything that you want to do differently? Things are really good. I took one of the SVA reviews with me, filled one out for Jessie, and emailed it to her later in the day. Strong! Smart! Sexy!

176

FABULOUS BOOK! Your work
is strong, smart + sexy. I
see a bright future. :)

I can be the same with relationships. If I am really into a guy, I am totally cool to hang out as much as possible. Weekend trips, family events, work parties, bring it on! I have to accept that Tim will never be that way. He likes variety and constant change. He loves having plenty of personal space and doesn't like when his girl interferes with other parts of his life.

How do you feel about this relationship/project right now? Pretty good! Things seem to being going well between us.

Is there anything that you want to do differently? After the portfolio review, I met my parents at the Chelsea Market. They have been to Disney World too, and had some tips of their own. It made me think again about what makes a relationship work. They've been together almost thirty years. And both of their own parents have stayed happily married their entire lives. Anyway, they started listing off some great relationship advice, so I asked them to write it down.

THE WAY
JESSIE SAYS
"BRING IT
ON" IS
KINDA
SCARY,
NO? —TG

Additional comments? I love teaching because it makes me articulate a process that isn't easy to define. Creativity is not predictable. And since I enjoy working on a diverse range of work, the process is constantly in flux for me. (I suppose this runs parallel with my dating history, too!) As I continue to get better at my craft, it's important for me to remember why I loved it in the first place. So many of us set this aside and simply do what others suggest, never finding our own voice, and forgetting why we set out on this journey in the first place.

I always tell my students that they should approach design as a practice rather than a profession. We can't forget the place we started from, and we should always be looking for new ways to connect with people through our work. I recently re-watched *It Might Get Loud*, a documentary that I love. Jack White talks extensively about the reduction process in music and art, and how hard it is to find the truth in its simplest form—something I'm always trying to work at. He goes on to say, "Technology is a big destroyer of emotion and truth. Opportunity doesn't do anything for creativity. Yeah, it makes it easier, and you can get home sooner, but it doesn't make you a more creative person. That's the disease we have to fight in any creative field: ease of use." He also wrote one of my favorites, a fifty-second song entitled "Little Room." It consists of nothing more than vocals and drums. For me, the lyrics tally up one of the critical difficulties in the creative process.

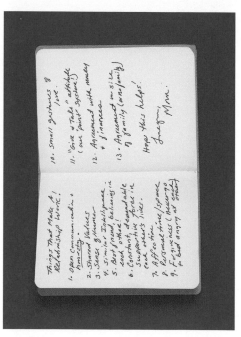

Additional comments? Tim loves cheese danishes. He ate three of them. Three!

not the
DESTINATION

I LOVE THIS
PIECE! THANKS
MIKEY! —JW

DAY THIRTY-SEVEN: APRIL 25, 2013

Jessica Walsh

Did you see Timothy today? Yes.

What did y'all do together? It was our final therapy session together. While often difficult, I do love the therapy sessions. I think anyone can benefit from therapy, no matter what the reasons or goals. Go with your lover, go with your husband, go with your boyfriend, go with your best friend. Take your pet! It's amazing to shed light onto your day-to-day insights, if only to bring more awareness to your actions and choices.

DAY THIRTY-SEVEN: APRIL 25, 2013

Timothy Goodman

Did you see Jessica today? Yep.

What did y'all do together? Weekly therapy session. Last call!

Did anything interesting happen? Jocelyn reinforced that I'm the "dominant" one in this relationship. I seem to be the one who's in control, because I've been on the fence, while Jessie has been willing to dive in head first. I guess by default I am in control, but I don't understand why Jessie can't take some control. I'm not holding us for ransom, nor do I want to. I remember reading something a while ago about how relationships don't fail because of little differences. They fail because of arguments about who is in charge and who is not in charge and the stress that comes along with that.

We talked a lot about what Jessie and I have learned from the last thirty-seven days. We talked about what we're going to do after Sunday. Admittedly, I've been trying to avoid thinking about this. Jocelyn asked me if I want to go back to dating other women. I have no interest in seeing other girls on day forty-one or thereafter, and I don't want to stop seeing Jessie. I just want to see

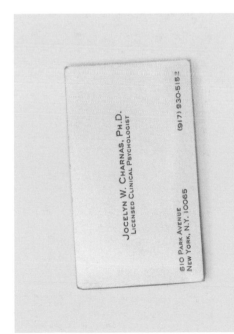

JOCELYN W. CHARNAS, PH.D.
LICENSED CLINICAL PSYCHOLOGIST

810 PARK AVENUE
New York, N.Y. 10065

(917) 930-5152

Did anything interesting happen? Jocelyn asked us what we wanted to do now that the project was ending. Tim said he really does want to date me exclusively, he just couldn't give any marriage commitments yet. Wait, what? Marriage?! Where did that thought even come from? Still, I agreed that I'd also like to try dating him outside the context of the project.

Jocelyn brought up how Tim was "in control" during the entire experiment. She asked me to analyze why I became so submissive around him. In previous relationships things were much more balanced, or I often had more control. Throughout this experiment and relationship, everything has felt like it is on Tim's terms. Part of me always feels on guard around him too, as he can be sensitive and I am afraid something I might say might set him off. It's interesting how we can be (or become) such different people depending on whom we're with, or on the situation we find ourselves in. No wonder relationships are so difficult. It's not easy to entirely understand yourself, let alone the person you are with. We are all constantly growing and evolving.

She also challenged me to think about why it was so difficult for me to feel so out of control during the experiment. My own personal therapist has told me that I have major control issues. He says I like to highly control, organize, and curate every aspect of my life as a way to cope with a painful situation from my past that I had no control over. It's part of why I like things in order, part of why I try to make things appear perfect, and part of why I have avoided meaningless relationships that might leave me vulnerable. He has challenged me numerous times to face this fear by completely letting go and relinquishing all control. I didn't understand what that meant or how to go about it.

what happens when we're outside of the parameters of this experiment. This hasn't been "real" dating, and nothing about this experience has necessarily felt natural. While pressure can create diamonds, sometimes pressure can blow out from the bottom. I'm interested in seeing what could happen when we're "unchained."

It makes me think of Dave, a former boss of mine I had right after high school. He eventually became an important mentor and a great friend. He has all these phrases he goes by, stuff like "Dress for the job you want, not the job you have," and "Never put your hands in your pockets; it's a sign of laziness." Anyway, one phrase he says that particularly rings a bell in this case is, "Never say 'I can't.'" When will I stop saying "I can't" when it comes to relationships?

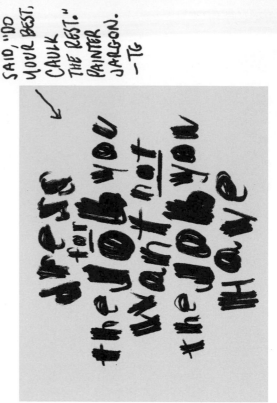

DAVE ALSO SAID, "DO YOUR BEST, CAULK THE REST." PAINTER JARGON. —TG

Did you learn anything new about Jessica? Jocelyn brought up how hard it is for me when Jessie gets down about things. That can have a major effect

on your significant other, and it's truly affected me throughout this experience. Jocelyn asked me to describe to Jessie what that feels like to me. Then Jocelyn mentioned to Jessie how valuable it is to hear something like this without the heat of an argument. She said it's a significant piece of information for Jessie to know as she goes forth.

Did you learn anything new about yourself? Jocelyn said I abandon women before they abandon me as a reaction to my missing father. This isn't news to me, obviously, but when someone tells you that to your face it's like a punch in the gut. I know it is a defense mechanism, a way to "get" them before they "get" me. I'm not proud of it.

How do you feel about this relationship/project right now? I feel good about it. I feel like Jessie has been consistently chill the last two weeks, and I've been consistently allowing her into my life. I don't feel the pressure from the gala anymore. I don't feel pressure from her. I love this.

Is there anything that you want to do differently? I want us to have the best possible time on our trip. I don't want to worry about what's happened in the past or what could happen in the future.

Additional comments? I love making playlists for friends, and I love making playlists for trips. There is a real pleasure in carefully and considerately selecting tracks that are appropriate for someone or something. (And I always need a reason to bust out Huey Lewis or a classic '90s alternative song!) Obviously, I had to make a 40DD playlist for this Disney Trip! Forty songs that highlight every moment, smile,

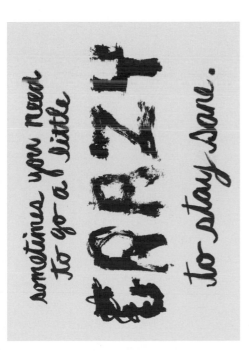

In some strange way, this experiment ended up being the answer to this. We also discussed the importance of me putting less pressure on myself and learning to say "no" more often. When I take on too much, I become miserable, and both my work and my relationships suffer. We discussed how much happier I feel and how much my outlook and mood have changed since I've started taking better care of myself.

Did you learn anything new about Timothy? Jocelyn discussed how Tim's cycle of abandoning women likely goes back to being abandoned by his father. Jocelyn discussed how men will repeat this pattern in a way to identify with or feel closer to the absent parent. Over time, this pattern only makes the person feel emptier, as they never develop meaningful relationships.

Did you learn anything new about yourself? We talked about how empowering it was for me to "let go" a few weeks ago and to stop trying to define the relationship.

In the past I have put too much pressure on myself to determine if the person I was dating was right long-term. If a guy didn't give himself to me wholeheartedly, I would give up on the relationship out of fear of failure. I couldn't enjoy dating in the moment.

How do you feel about this relationship/project right now? Tim mentioned how it would be a tremendous relief to date without the burden of recording everything every day. Amen!

Is there anything that you want to do differently? I am looking forward to dating Tim outside of the experiment, but I don't want to accidentally pressure him. There is no need to rush. I want to enjoy the journey, not get hung up on the destination.

Additional comments? Disney World! Tomorrow!

tear, or any other related experiences we've shared through this experiment.

Find the playlist on my Spotify! —TG

4ODD MIX

1. "For Once In My Life" – Stevie Wonder
2. "Talamak" – Toro y Moi
3. "Ex-Factor" – Lauryn Hill
4. "Tessellate" – Alt-J
5. "I Never Learnt to Share" – James Blake
6. "Hey Hey What Can I Do" – Led Zeppelin
7. "I'll Be Seeing You" – Billie Holiday
8. "Librarian" – My Morning Jacket
9. "You Can Call Me Al" – Paul Simon
10. "She Belongs to Me" – Bob Dylan
11. "I'd Rather Go Blind" – Etta James
12. "We Might Be Dead Tomorrow" – Soko
13. "I Wanna Hold Your Hand" – The Beatles
14. "Little Room" – The White Stripes
15. "You've Got A Friend" – Carole King
16. "I Get Around" – 2Pac
17. "Feel It All Around" – Washed Out
18. "Mo Better Blues" – Branford Marsalis
19. "Girls from Addis Ababa" – Mulatu Astatke
20. "Supercalifragilisticexpialidocious" – Julie Andrews
21. "FM" – Junior Boys
22. "Moon Dreams" – Miles Davis
23. "The Hypnotic" – The Roots
24. "If This Is It" – Huey Lewis
25. "That Girl" – Justin Timberlake
26. "Change" – Deftones
27. "Uptown Girl" – Billy Joel
28. "The Weight" – The Band
29. "Mind, Drips" – Neon Indian
30. "Werewolf" – Fiona Apple
31. "Back to Manhattan" – Norah Jones
32. "Patience" – Guns N' Roses
33. "Fist, Teeth, Money" – Poliça
34. "Seven Souls" – Material
35. "Time In A Bottle" – Jim Croce
36. "Miss You" – Trentemøller
37. "We Need A Resolution" – Aaliyah
38. "Low" – Cracker
39. "Airplanes" – Local Natives
40. "Winnie the Pooh" – Gordon Lorenz Orchestra

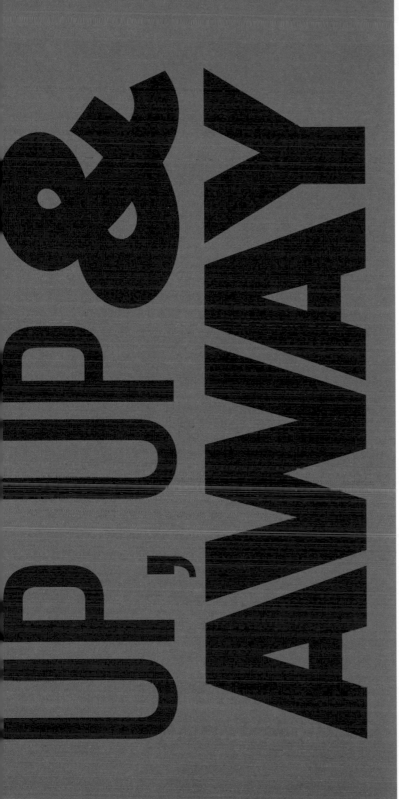

UP, UP & AWAY

Jessica Walsh

Did you see Timothy today? Bright and early!

What did y'all do together? I hailed a cab at 4:00 AM and picked up Tim at his apartment. We headed to JFK and arrived at Jet Blue's terminal for our 6:00 AM flight to Orlando. I was very tired because I was unable to sleep during the night. I was too excited

Timothy Goodman

Did you see Jessica today? Oh yes.

What did y'all do together? Disney World! Six AM flight JFK > ORL.

(handwritten note, top) I GOT SOME HEAT FOR THIS, BUT I THINK WE ALL HAVE OUR TASTES WHEN IT COMES TO THE OPPOSITE SEX. —TG

(boarding passes)

GATE 24 SEAT 5F
E-TICKET
1 279 7221931593 3
BOARDING PASS

JETBLUE AIRWAYS
NAME WALSH/JESSICA MS
26APR
FQTV
FLIGHT 79 NEW YORK JFK
ORLANDO INTL
E-TICKET
1 279 7221831592 2
GATE 24 SEAT 5E
BOARDING PASS

about the trip, and I stayed up making maps of the various rides we should go on.

(handwritten note, bottom left) JESSIE HAD ONE OF THOSE EYE BOOGERS THE WHOLE TIME. I DIDN'T THE HAVE HEART TO TELL HER! —TG

Did anything interesting happen? We boarded the plane and I fell fast asleep on Tim's shoulder. I woke up as the plane was touching down. We took the Magic Express train to our hotel room at the Contemporary. We unpacked, had sex, and got changed into our bathing suits. We went to the pool bar and ordered a few mango margaritas. Tim scarfed down a disgusting looking hot dog as we strategized the plan for the weekend. We decided to tackle Epcot today, Magic Kingdom on Saturday, and end with Animal Kingdom on Sunday.

I have a hard time sleeping on planes, but Jessie took a sleeping pill and passed out the entire time. When we got there we decided to do Epcot Center today. I remember crying the whole time I was there when I was kid. I thought it was so boring. Twenty years later, I don't feel much different. However, the rides "Soarin'" and "Mission: Space" were awesome. Jessie was screaming at the top of her lungs during "Mission: Space." I thought she was going to die.

Did anything interesting happen? Later in the day we were sitting beside the pool and we started talking about her weight. How in the world I found myself in that conversation I haven't a clue. But I know there's no way to get out alive! She can be self-conscious about her weight, even though by general standards she is a stick figure. I stupidly told her that I'd love to see her gain about ten more pounds. This did not go over so well, obviously. I also realize that it's not that easy for her to put on pounds. Again, I should have just shut my mouth!

Did you learn anything new about Jessica? I was convinced that she had no interest in any bit of pop

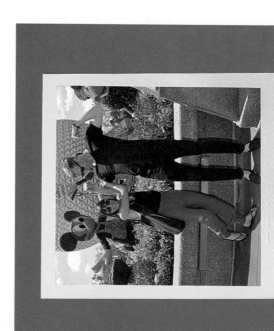

I FORGOT ALL MY HEELS! IT WAS ODD FOR ME.—W

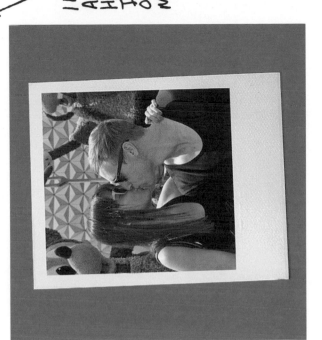

We headed over to Epcot and ran around the park getting into all sorts of trouble. We went on the first ride, which was called "Mission: Space." We were not prepared for it. Aren't these rides supposed to be for kids?! We both stumbled out of the ride feeling dizzy with motion sickness, laughing at the hilarity of it all. We wandered over to the "Soarin'" ride after, which was a simulation of hang gliding over California landscapes with a wraparound IMAX screen.

Tim became annoyed with me at several points in the day for various things, but I was able to brush it all off. There's no need to fight around the children! We ended the evening with dinner at the Grand Floridian. I had asparagus and risotto, and Tim had the tomato and mozzarella.

After that, we headed outside and watched the fireworks. I sat in his lap, and we sipped champagne. Things felt romantic. I realized how much I've let my guard down this past week. I am starting to admit to myself how much I care about him.

After the fireworks, we lay in the grass outside our hotel and looked up at the stars. We noticed how clear the stars in the sky were compared to New York. We talked about the possibilities of alien life, string theory, and space travel. While I've always thought that 2013 is a great time to be alive in the history of the universe, I do wish we lived in a time where space travel was affordable for civilians.

Lying under the stars reminded me of a friend who loves astrology and horoscopes. She recently suggested that we do a horoscope partner analysis together. I've never been a believer in the type of horoscopes you find in gossip magazines, but I have always been curious about them. I did some research, and I found a site with readings by a reputable astrologist whose work is based on Jungian psychology.

culture until today, when I found out that she LOVES Harry Potter. The things you learn about someone. Also, Jessie didn't bring ANY high heels. I'm dumbfounded by this, too. Are we in bizarro world? But it was nice to see her in flats.

Did you learn anything new about yourself? During dinner tonight we got into a conversation about her weight AGAIN. Damn, I really just need to shut the hell up. Here's the thing: I LOVE to eat. I have no qualms about it. Highbrow to lowbrow, I'm in. I'll eat sushi for lunch, and then I'll kill a hot dog at the basketball game. And I like women who enjoy eating with me, especially when we're on vacation or when we're at an event. Plus, I'm six-foot-three, so it takes more for me to keep the tank full. She knows I like to eat, and I feel

Did you learn anything new about Timothy? Tim was born on June 23 at 9:19 PM in Ohio. He falls under the Cancer zodiac sign. Here is his personality portrait, and his psychological portrait.

Did you learn anything new about yourself? I was born on October 30 at 10:05 AM in New York. I fall under the Scorpio zodiac sign. Here is my personality portrait, and my psychological portrait.

like she's pressuring herself to eat more around me. It's sweet, but I don't want her to feel pressured into doing something she doesn't feel comfortable with.

How do you feel about this relationship/project right now? After the pool, we were in the sauna together. Jessie wanted to talk about what happens after day forty. She told me that I don't need to feel pressured to date her after the forty days, which clearly means the exact opposite. The very mentioning of all this is indeed putting pressure on me. If we weren't talking about any of this, then there would be no pressure. She said she understands if this relationship is not what I want and she's cool if we just go back to being friends. Her mouth said it, but her eyes said the opposite.

This worries me, because I know that what she's saying isn't true. Jessie is so black and white, and I know she needs to KNOW what the plan is for day forty. Can't we just keep going and not talk about this stuff all the time? Everything has been so good lately. The questions and the pressure make me realize, yet again, that I don't know what I want. And if I don't know what I want yet, then maybe that's enough to know that this isn't right. I'm starting to feel a bit nervous.

Is there anything that you want to do differently? At the end of the night we were watching fireworks from the Grand Floridian. They were beautiful. Children were running around, people were laughing, and we were cuddling. Something inside, however, didn't feel right.

Additional comments? There are two questions every person has to ask with any conflict or problem they need to solve: "How?" and "Why?" My old boss, Brian Collins, would always say that "Why?" is a much more interesting question than "How?" As designers,

READ THE HOROSCOPES ON THE WEBSITE! —JW

we always want to solve problems—but instead, we should make problems by asking bigger questions of our clients and ourselves. Asking why encourages us to be provocative and memorable rather than simply making pretty things. As much as I strive to achieve that sentiment in my professional work, I think I understand what he means in a different context now.

I can "solve" things with Jessie either by dating her or by simply walking away from this situation. But asking why I'm doing what I'm doing is a much more unpleasant, yet important, road to potentially go down. Essentially that's what this entire experiment has been about: asking bigger questions and making a "problem" for ourselves when we could have just kept going with our regularly scheduled program. So am I willing to accept what may happen in the next two days? Am I brave enough to see what's in front of me? And, if so, can I actually do anything about that?

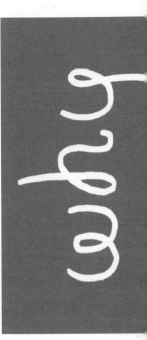

How do you feel about this relationship/project right now? After we did our individual psychological portraits, we tried a relationship portrait together.

Is there anything that you want to do differently? As I was reading these horoscopes, I became spooked by how the descriptions seemed to resemble our personalities, our issues, and even our pasts. Are these strategically written to make us all feel that we can relate? Do we just see what we want to in them? This makes me think of the idea of romantic fatalism. I often find myself looking for signs of fate in a relationship, like strange coincidences or similarities that make me think "it's meant to be." I can't deny that I attach meaning to the coincidence that Tim and I are both die-hard Winnie-the-Pooh fans, or that we share the same favorite childhood ice cream flavor. But when you look for these signs between any two people, there are bound to be overlaps. I have to remind myself that the only meaning behind certain things is what we choose to attach to them.

Additional comments? I had a good laugh at this part of the horoscope:

They are unlikely to air their feelings in public, regardless of how combustible things might be between them.

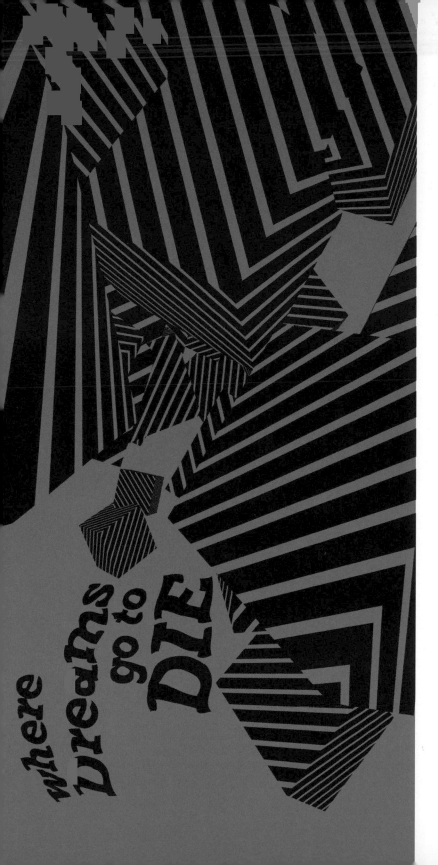

where Dreams go to DIE

Jessica Walsh

Did you see Timothy today? Yes.

What did y'all do together? It felt nice to wake up in Tim's arms. We were out the door by 8:30 AM, on to Magic Kingdom. Tim scarfed down a cheese danish, a chocolate croissant, a microwaved egg sandwich, and a tea. This boy can seriously eat. After Tomorrow–

Timothy Goodman

Did you see Jessica today? If I could play the guitar, I'd play the blues.

What did y'all do together? I was crabby in the AM because I was hungry, but Jessie was full of energy. I ate a horribly disgusting breakfast, and I felt better. We hit up Space Mountain, Splash Mountain, Haunted

WE HAD A GREAT SYSTEM: JESSIE WOULD ACT AS IF SHE COULDN'T FIND THE TICKETS, AND I'D ACT MAD AT HER. THE GUY WORKING THERE DIDN'T WANT TO HOLD UP THE LINE SO HE'D LET US GO. –TG

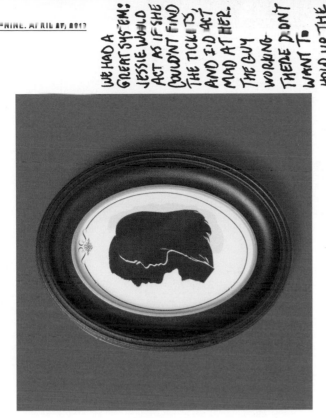

Mansion, Pirates of the Caribbean, and more. We even got our portraits done by a silhouette artist. The Magic Kingdom is an evil spectacle and I love it.

land, we walked though Fantasyland and went on the the Winnie-the-Pooh ride.

I have an Alice in Wonderland obsession and I wanted to go on the Mad Hatter teacup ride, but it was shut down for renovation. Around 2:00 PM, we wandered down Main Street. The street was lined with charming candy shops, ice cream shops, and bakeries. Tim and I split a large pistachio ice cream cone. We sat down near the sidewalk around three to watch the parade.

I have mixed feelings about this place. Or the one hand, there is something fascinating about Disney World. There is a high level of detail to every aspect of the operation and the experience, from the hand-painted signs and the technology behind the projections and holograms, to the large-scale coordinated shows that happen like clockwork. Yet, as Prince Charming passed by us waving, and I watched the little children squeal in excitement, I couldn't help but think there is something twisted about this place. This whole place just plants expectations in children's minds that make them think they will grow up to meet the perfect person who will make all their dreams come true. While this kind of storybook love is a positive and a seemingly innocent notion, it's nearly impossible to live up to.

It's interesting to think about how this kind of true love is a relatively recent concept in human history. Marriage unions used to be treated in a much more practical manner, often as nothing more than a business arrangement between families. It was only in the last few hundred years that we saw this birth of romanticism throughout culture.

Did anything interesting happen? Yes. It all began with a Mickey Mouse sweatshirt. We had dinner

Early on, I encouraged us to cut into the "fast pass" line at the Pooh ride. The "fast pass" line is there if you got tickets beforehand. However, there's a limit on fast passes you get. After the first cut, Jessie became obsessed and wanted to cut every ride. It became so much fun. We literally saved ourselves hours of waiting in line.

Did anything interesting happen? We stayed for the parade at Magic Kingdom, which is at 3:00 PM every day. They do this massive production every single day, 365 days a year. Anyway, after that we went to the

reservations at the Flying Fish Cafe on the Disney boardwalk. On our way to dinner, I realized my shoes were giving me a blister. I ran back to the hotel room to grab a new pair. We were almost at the train when Tim mentioned I would probably get cold without a sweater. He wanted me to go back to get one. I looked at the time and I realized we were already running late. I didn't want us to miss the reservation, so I suggested we go to dinner and I would buy one on the boardwalk later.

WEIRD, THE WAY I REMEMBER IS THAT WE WERE NO WHERE CLOSE TO THE TRAIN - TG

We enjoyed a nice dinner. I had scallops, and Tim had salmon. After dinner, Tim wanted to walk along the water to watch the performers and the fireworks. I was freezing cold, as Tim predicted, so we stopped in a tourist shop to get a sweatshirt. I finally found one I liked, looked at the tag, and made a comment about how pricey it was.

Tim got loud with me. He said I was forgetful and irresponsible, and that I should have listened to him. He said he didn't understand what was wrong with me, and that it was no wonder I couldn't save any money. I usually shut down immediately when I feel attacked, but I know how that annoys Tim even more. So I tried to stand up for myself, but this only pushed him further. Feeling defeated and unsure what to do, I shut down. I walked out the door toward the taxi station.

Grand Floridian resort to rest by the pool and have some drinks. However, things felt weird for me and our communication breakdowns were becoming more and more evident. Not to mention the conversation we had yesterday in the sauna started haunting me. As "40DoD–Day" is creeping up on us, I realize I do have a responsibility to let her know how I feel. It's Jessie, and I know how she needs to know. I know how she can't live with this uncertainty as day forty is hanging over us. I have to muster up an answer somehow. On a lighter note, I am so white right now! I could probably blind someone.

Did you learn anything new about Jessica? Jessie wants love. She just wants to be a great girlfriend and to take care of her man. It just seems like she wants the perfect prototype to slide into her perfect-boyfriend role.

Did you learn anything new about yourself? This trip is making everything feel very serious to me. Usually,

after two or three weeks of dating and being physical with someone, you don't go on a trip together. At least not normally. There are times I have gone on trips a month into a relationship, but there's been no pressure or countdown. However, it's very natural for Jessie to go on a weekend trip this early in a relationship—sometimes even earlier than this! That's just not me. I need time, and I don't think she clearly understands that.

How do you feel about this relationship/project right now? By the time we went to the Boardwalk resort for dinner, we were quiet and there was an awkward undertone to everything. Earlier, as we were leaving the hotel, I told her to go back and get a coat because it would get cold. She didn't want to do that. So after dinner, she was chilly on the boardwalk and we stopped in a gift shop so she could buy a sweatshirt. As we were looking at sweatshirts she complained about spending the money. Then I got annoyed and reminded her that I had told her so. I know I was picking a fight, but she always backtracks on everything and then I have to listen to her complain the entire time. Well, she didn't like what I had to say and she got loud with me. Then I got loud, and then we started arguing in the middle of the gift shop. Then she says to me, "You have issues! You're fucked up! I've been so accommodating to you, and you don't even care."

After hearing that, I just threw the paddles in the lake. I'm sick of this. I basically told her that all I want is for her to STOP being so damn accommodating. Stop worrying about what I'm doing all the time. Stop worrying about being such a good girlfriend. This is something that has consistently been wearing on me, and it's all come to a head now. All day she's been worried about me like she's my mother, constantly

After I walked out of the tourist shop, Tim ran after me and grabbed my arm. We sat down in the grass together. I asked him to think hard about what he was doing. Was he doing this as his usual defense mechanism? Is this his fear of vulnerability? If so, I was willing to work through it with him. On the other hand, I've been completely open and honest with him about who I am, and what I can offer him. If he doesn't think we are working romantically, then we should end this now and try to remain friends.

Did you learn anything new about Timothy? All of Tim's quirks and oddities seem adorable to me. The way his hair sticks up awkwardly after his sunglasses have been on his head for a while, how his pants are too short, how he eats too quickly and always leaves a mess. I even find it cute that he can become overly sensitive and takes things so personally. I find humor in these imperfections and accept him as he is.

Unfortunately, this is not the same for him. While we've been having a great two days here, Tim finds moments to slip in negative remarks. He said I'd be more attractive to him if I would gain more weight and have more curves. He said that he was bothered by how accommodating I am to him and his desires. He said I should pay more attention to my grooming. He said that it's annoying that I don't eat enough. He said it's disgusting that my nail polish is chipping off. While I understand objectively where these comments are coming from, it still really hurts.

Did you learn anything new about yourself? I had a relationship once where the guy fell very quickly for me. While I cared for him deeply, I knew he wasn't

I MADE A COMMENT ABOUT HER NAIL POLISH ONCE. I NEVER SAID IT WAS DISGUSTING. SOUNDS AWFUL! —TG

right for me long-term. Even though I recognized that I was being irrational, everything about him increasingly bothered me, from his mannerisms to the things he did. It wasn't the things that he was doing that were actually bothering me, it was him. I used these excuses as a way out. Is this what Tim was doing?

How do you feel about this relationship/project right now?

We continued to talk on the grass. He said he didn't think it was a defense mechanism with me, but that he didn't think we were right for each other. He said something about me rubs him the wrong way romantically. He said my strong feelings for him deeply worry him, and, like usual, I was moving too quickly. He said if we continued to date he would just fall back into his old habits and that he didn't want to hurt me. He said I deserve more.

Is there anything that you want to do differently?

I told him I understood. However, I can't deny feeling rejection and pain. I already loved him as a friend. After I allowed myself to open up to him and let my guard down, I've started to fall for him romantically. It seems I've repeated the same pattern again. I opened up too quickly, empathized too deeply, and I have another failed relationship to add to the list. I don't know what to do or think at all anymore.

Additional comments?

How did this even happen? Are we completely over, or is this an argument that we'll forgive and forget? I just want to escape the thoughts and feelings circling around in my head right now. When we got back to the hotel room, I took a sleeping pill with a glass of wine and went to bed. He crawled into bed behind me and held me, and we fell asleep together.

asking me what I want, what I need, who I saw, where I've been, how I feel, what I know, etc. I'm sorry, but it's not attractive to me. I've talked about this before, how she puts her man before herself, and how that's not my style. I just like a nice balance. I want to know that she knows who she is. I don't want a partner who's main objective is to be a great mate. I want to be with someone who can be herself, and someone who will let me be me without concern.

So here we are arguing on the boardwalk about this, and I can feel the whole relationship crumbling around my feet. She stomps away to go back to the hotel, clearly pissed off. But I couldn't let her go. I stopped her and asked her if we could talk about it. The look in her eyes made me want to die. She said again that she really likes me, and that she really doesn't feel like she's getting that in return. And she's right, I'm not giving it to her, at least not the last two days in Disney. I barely even held her hand today. And as much as I try to convince myself, it's obviously not working for me.

While we were talking, she mentioned that a recent ex-boyfriend of hers loved all her little quirks and all the things that make her "her." However, she broke up with him because she couldn't stand all of his quirks. Ironically enough, she said that our situation was the same, except that I was her, and that she was her ex. She deserves someone who loves her for those things. All of her quirks should be adorable to me, but it's sadly not the case here.

Is there anything that you want to do differently?

We calmed down and sat looking out at the water from the boardwalk. I couldn't believe this was going down. It's really over? It was as if I had no control, like some bigger force was making it all happen. We have

[Handwritten note, upper right:] LATER ON, TIM SAID IT WAS WORKING FOR HIM, IT WAS JUST THE PRESSURE OF SPENDING SO MUCH TIME TOGETHER. ~JW

such a kinship, yet there is so much friction between us. This dichotomy can't be sustainable. I really don't know what we can do differently at this point.

Additional comments? We got back and sat in bed together. As we sat there, we started rubbing each other and kissing. I can honestly say I've never been more aroused in my life than I was at that moment. I wanted every single part of her, but there was so much guilt. She whispered, "Should we have breakup sex?" I didn't answer her, and we slowly stopped kissing. Ten minutes later we were asleep.

DON'T CRY BECAUSE IT'S OVER, SMILE BECAUSE IT HAPPENED.

Jessica Walsh

Did you see Timothy today? Yes.

What did y'all do together? We spent the morning running around to the various rides. We didn't speak about last night's events. The constant noise and visuals at Disney's Animal Kingdom proved to be the perfect distraction from the disappointment and pain.

Did anything interesting happen? Around noon we sat down at an outdoor bar and drank margaritas. After we ate, I began to feel quite faint. The combination of the sun, alcohol, and exhaustion from the walking must have dehydrated me. Tim helped carry me out of the park. Around 5:30 we took the Magical Express back to the airport. We schlepped our bags through security, and we ate dinner at the bar of some Mexican restaurant in silence.

Timothy Goodman

Did you see Jessica today? Yes.

What did y'all do together? We stayed in bed a while, cuddling and talking. It was really nice. Finally, we got up and went out to Animal Kingdom all day, where we had a lot of fun. By the end, she got really sick from the combination of walking around in the heat and drinking alcohol. I practically had to carry her from the bus to the hotel lounge. Later, we hung out by the pool separately and I watched the Knicks lose to the Celtics. We got ready for our 9:00 PM flight back to JFK and headed out.

NOT SEEN HERE: DAY 40 VIDEO ON OUR VIMEO! —TG

OF COURSE THE KNICKS LOSE! SALT IN THE WOUND. —TG

THIS WAS THE BEST RIDE BY FAR! —JW

Did anything interesting happen? We said one word on the way to the airport, and we said maybe two words on the plane. I could barely look at her on that flight. She was downing wine, and I was doing anything I could to stay distracted. I feel horrible about what happened last night. I just feel like such a disappointment to her and myself. It seemed inevitable that all the pressure would make this blow up. I just wish I could make this a happy story. I know she's wanted that all along, and I'm sorry that I can't give that to her. Our memories are not a waste, though.

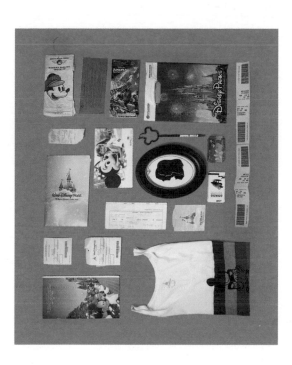

Did you learn anything new about Jessica? She's one of the best sidekicks I've ever had. Today was very carefree, and it made me feel like a kid again. I guess sometimes we can be us, even for a day. We never talked about last night—instead we went strolling, drinking, eating bad food, sneaking into rides, and

Tim watched the basketball game while I read my book. Tim finally broke the silence and suggested we address the elephant in the room. I asked him if his feelings had changed since last night, or if he wanted to try to make it work. He said he still didn't feel it was right between us. I told him that as deeply as I care for him, he deserves to be with someone he is crazy for, and I deserve to be with someone who is crazy for me. He agreed, and he said it would be better to end things now before he could screw things up even more. We boarded the plane, and I cuddled up in the window seat with a blanket and pillow. I listened to Lana Del Rey's "Born To Die" on repeat, which helped me through my last breakup. I downed a few miniature bottles of red wine to drown my sadness, and I finished the last chapter of my book.

Did you learn anything new about Timothy? What does it even mean to love someone? It seems almost impossible to universally define such a complex state of mind, since we all experience life so uniquely. I guess love is something you just have to experience and define for yourself. On the whole, I've experienced it as being committed to someone I am passionately interested in. Someone who helps me discover aspects of myself I didn't see before and for whom I can do the same. Someone I trust, respect, and share experiences with. Someone I can be my kind of weird with.

While this has certainly been the most unconventional romantic relationship of my life, Tim fits into all those categories. Even if it wasn't meant to work for us romantically, I'll continue to love him as a friend. I will be forever connected to him because of these experiences we've shared. We agreed that no matter what happens, we don't want to lose each other from our lives. We've had four great years of friendship,

SKILLZ! —TG

doing it all with ease. It reminded me why we're such good friends in the first place.

forty days of dating, and we will hopefully have many more crazy adventures to come.

THE BOOK
IS CALLED
WALT DISNEY:
AN AMERICAN
ORIGINAL.
—JW

Did you learn anything new about yourself? I have so much respect for Walt Disney. I read a book about him recently, and his personality and life story remind me of Steve Jobs'. Both were complicated and obsessive, layered with many personal issues, and were extraordinarily creative visionaries who ran successful companies. I've always thought that business and romance have many parallels. What I respect most about both of these men is not their ability to come up with numerous ideas, but to recognize which ones were worth pursuing, and to persevere through challenges and realize them. Like Steve Jobs said: "Deciding what not to do is as important as deciding what to do."

How do you feel about this relationship/project right now? We waited in line for a cab at the JFK taxi stand.

Did you learn anything new about yourself? Perhaps it's all a self-fulfilling prophecy, just playing out my role, as Jocelyn said, repeating the same pattern over and over again. I can see Jessie's complexity and it scares the hell out of me. And the parameters of this experiment didn't allow me to see things very clearly. This was like boot camp, and we learned stuff about each other that one wouldn't normally know for a long time. Maybe we should have seen this coming the whole time. While I feel exhausted from it all right now, I also feel a real sense of hope for myself. This has completely challenged my personal life, the way I conduct myself, the way I approach relationships, how I consider the consequences of my actions, and my ability to let a woman into my life emotionally. I'm forever grateful for that.

I had something I made for her before the trip, but considering what happened last night, I didn't know whether I should give it to her. Before heading to the airport she gave me an envelope that had the book

When We Were Very Young by A.A. Milne in it. There was also a sweet card inside.

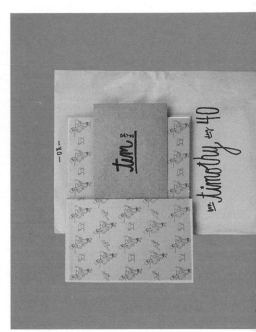

At the beginning of the wait, Tim professed his hatred for Disney World. By the end of the line he professed his love for it. It is interesting to me how we can so easily shift between love and hate. Our moods and emotions and feelings can change from day to day, minute to minute. Our relationship with Disney World, like each other, was deeply conflicted and complicated. We are so wrong for each other in so many ways, and so right for each other in many other ways. There were days Tim overwhelmed me and drove me nuts with his inability to make decisions and his constant need to exert control. Yet there were many other days filled with smiles, silliness, love and laughter. We both learned a tremendous amount about each other and about ourselves. Just because it didn't end as I had hoped doesn't mean it wasn't a success. The experiment forced me to reevaluate my lifestyle and what I want in the future. I am already happier, healthier, and more relaxed than I was twenty days ago. I was telling my friend about it, and he wrote me a nice message.

AND SHE'S
ON UM
BECOME
HEALTHIER!
—TG

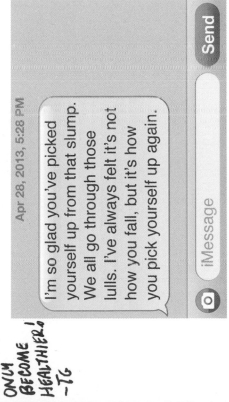

Apr 28, 2013, 5:28 PM

I'm so glad you've picked yourself up from that slump. We all go through those lulls. I've always felt it's not how you fall, but it's how you pick yourself up again.

iMessage Send

Is there anything that you want to do differently?

This experiment has made me extremely self-aware and confident in who I am, what I want, and what I am looking for. I don't think there's anything wrong with wanting a committed relationship. I know I can be very happy on my own, but life has always been even more awesome when there's someone great to share it with. That being said, there is no rush, and I want to take some time to myself after this. I want to focus on my work, friends, and family. I have no idea what the future holds, but I am hopeful and optimistic about what's next.

Additional comments?

We shared the cab ride home together. The driver dropped Tim off at his apartment first. We looked at the clock and realized it was 11:58 PM, making the forty days come to an end at the exact moment we parted. We laughed at the irony. Tim jumped out of the cab and grabbed something out of his luggage. He handed me a square package. A few weeks earlier when I was at the New Museum, I bought him a bound book of napkins that I thought he might like. He gave it back to me with illustrations of forty things he likes about me. It was one of the sweetest and most thoughtful gifts anyone has ever given to me. And as if we were in some sort of twisted fairytale, he left me at the stroke of midnight with the gift and a goodbye kiss.

How do you feel about this relationship/project right now?

Ultimately I think we make a great couple on paper, but reality is a completely different story. Selfishly, part of me wishes that she could be more of an aggressor, someone who would try to convince me to change my mind once. I know it's not her style, but, selfishly, I wish her actions showed it as much as her words. Maybe she gives up too quickly. Maybe I want someone who's gonna fight for me. Maybe that's all BS, and I'm just making cowardly excuses. Maybe she just loves love. Maybe I'm just a scared little boy who can't man up. Whatever it is, I know she deserves more. She doesn't deserve someone who is unsure about her.

Is there anything that you want to do differently? My whole life has been turned inside out from this crazy experiment. It's 3:00 AM and I'm listening to the most ridiculous Phil Collins song right now. I don't miss dating different women. I don't feel like I'm missing out on anything, nor do I want to go back to my old habits. I do want to be in a relationship. I do want something meaningful. It's been a while since I've let a woman in, and I do want to share my life with the right person.

Additional comments? In mythology, once an adventure is over and the reward has been secured, the hero or heroine usually leaves the "special world" to go back to the world where he or she first began. The final test for the hero is to realize what they're bringing back to the old world, literally or metaphorically. They have lived to tell their story and to inform society. That gives me a lot of solace. While I do feel heartbroken right now, I feel a tremendous amount of hope for my future.

On the cab ride home, we barely spoke. We did, however, agree that everything would be okay no matter where we go from here. I thought of that Bob Dylan song where he says, "I gave her my heart but she wanted my soul." And I know that what I could offer right now would never be enough for someone like Jessie. Jessie wants it all, and who am I to take that away from her? Who am I to string her along? I also know that I shouldn't string myself along either.

As the cab driver pulled up to my apartment, we laughed because it was literally 11:57 P.M. as day forty-one was approaching. I just can't believe it's over. I feel so close to her. I know now that I'm in love with her. I love her, yet I know there's nothing else I can do. We kissed. I gave her a gift. We kissed one more time. I shut the cab door, and I walked away.

I HAD NO IDEA HE FELT THIS WAY. I WISH HE HAD TOLD ME. —JW

Girls Boys Boy girls Boy girls Boy Boys Es Boys girls girls Boys girl

OUR THERAPIST

This experiment began in the name of self-discovery, so naturally we wanted to challenge ourselves in that vein as much as possible. After we decided that one of our rules had to be seeing a therapist once a week, we went in search of one who would not only get what we were doing, but who also had no prior knowledge of either one of us and could be objective. Jocelyn was one of the therapists recommended to us, and we knew right away that she was the one. We trusted our gut, and we were right. She became our "safe place," and in many ways, she helped us keep our sanity throughout the experiment and to remain friends to the present day. Below are her reflections about her experience with us. —Tim & Jessie

JOCELYN CHARNAS, Ph.D.

What makes a relationship? I read an article once about a happily married couple who decided to try an experiment in which each created an authentic profile (minus their marital status) on several popular online dating websites. They wanted to see if they would be matched with each other. Not a single site offered either of them up as a potential match for the other. I guess there's no accounting for chemistry.

What makes some relationships work and others fail can be mysterious. Are friendship, respect, common interests, and mutual attraction enough? I considered this question following my first meeting with Tim and Jessie in which they explained their project and enlisted my help. I was dubious, to say the least. If transforming their casual friendship into a meaningful romantic relationship was a realistic possibility, then why hadn't it happened naturally? My initial impulse was that such a transformation was no more realistic than me transforming, over the course of forty days, into the starting center for the New York Knicks.

Yet, despite my skepticism, I found the project intriguing. What captured my interest most was Tim and Jessie's willingness to be vulnerable—to expose their innermost selves to each other and to me, and to do so without the safety and security of an established relationship. They were venturing out on an emotional limb with this project, and I decided to join them.

Though much of what transpired in our sessions was typical of traditional couples treatments, I soon recognized that something extraordinary was occurring. The structure of the experiment begged of them to observe their relationship patterns and behaviors and the impact of those patterns and behaviors in real time, as they were happening. So much of what occurs in traditional couples therapy is in the past tense, relayed through the (often distorted) lens of hindsight and with the weight of a shared history. This project was different in that it created an opportunity for Tim and Jessie to be real-time relationship scientists—to observe their typical romantic behaviors and tendencies in the present moment and to get a firsthand account of the impact on the other party. Imagine how much you might learn about yourself if you could ask a first date what they really thought about you and the date! This is what it was like for Tim and Jessie in our sessions, which were sometimes flattering and exciting, other times uncomfortable and painful, but always illuminating.

As the project progressed, what had initially presented as common if not gender-stereotypical relationship dynamics—he, a commitment-phobe; she, a romance addict—emerged as much more complex and nuanced. It became clear that both Tim and Jessie's relationship patterns were largely related to their particular family histories. In short, Jessie's tendency to love quickly and with a marked lack of self-protection revealed itself to be deeply tied to her efforts to replicate her parents' marriage, which she highly idealizes. Tim's identification with a parental figure takes a different form—by abandoning women after brief periods of dating, he is replicating the actions of his father, who abandoned both his mother and him. In leaving women first, he beats them to the punch and thus avoids the realization of his own abandonment fears.

During their "experiment," both Tim and Jessie played out their typical relationship roles. She gave her heart away, perhaps too quickly and without the proper defenses. He abandoned the possibility of pursuing the relationship—perhaps for good reason, due to certain basic incompatibilities, but perhaps also a bit too quickly. In that sense, it was not such a departure from past relationships, but with one important distinction. Though they were engaging in many of the same old behaviors, they were doing so without wearing the same old blinders. Automatic and largely unconscious relationship behaviors were exchanged for insight and awareness. It is this insight and awareness that will, I hope, help each of them to have more satisfying relationships in the future. Their forty-day romance didn't have a Hollywood ending, but the outcome for each of them is one this couples therapist can appreciate.

—Jocelyn W. Charnas, Clinical Psychologist

What HAPPENED NEXT

We continued to keep our journals after the forty days were finished. The following excerpts reveal what happened between us over the months that followed— what we were feeling, how confused we were, how complicated things became, how we decided to do the blog, and the incredible outpouring of fans and media attention in response to it.

Jessica Walsh

April 29, 2013: It was the first day after Day 40. I was heading home from work when I received this email from Tim. I called him to talk about it. He sounded depressed. He said he had been staring at his computer screen most of the day in his apartment, trying to work, but he was unable to concentrate or get anything done. He said he felt empty, like he had lost something.

I had some time today to think about what has happened over the past few days. I am not entirely sure Tim was really ready to end things between us. I think he cares about me more than he is letting on. Even on our plane ride home, he said he wanted to keep dating, but he really feared screwing things up further. He repeatedly asked me "why" I liked him so much, as if doubting his own self-worth. It's hard to tell what was going through his head, or why he kissed me last night as if he wasn't ready to let go.

I am also not entirely sure he fully understands why he wanted to end things. Maybe it's because we were wrong for each other. Or maybe he was pushing me away to see if I'd fight back. Maybe he is insecure, and by default my interest in him makes him think he can do better. Or perhaps he does just love the chase and wasn't satisfied that I wouldn't give it to him. Maybe it's a combination of all these things. Whatever it is, I wish he could be more decisive.

April 31, 2013: Tim asked how I was holding up. Usually I feel so down when a relationship fails. I was feeling depressed in Disney World and on the plane ride home. However, since I've been back I've felt an overwhelming sense of relief and freedom. At the same time, hearing Tim's sadness on the phone the other day, but not feeling the same way myself, has brought tremendous feelings of guilt. Shouldn't I feel grief? I told my friend about my confusion. She said getting out of a bad relationship is like having a wisdom tooth pulled: You don't realize how bad it was until it's gone. My mom always said you should never chase affection; people usually show you what they're willing to give rather quickly and if it's not given freely, it's not worth having.

I've had this insight: I was so caught up in trying to make things work between us that I was blinded by how the relationship was failing me. Tim would never

Timothy Goodman

April 29, 2013: I thought about that Groucho Marx quote, the one that Woody Allen recalls in Annie Hall: "I wouldn't join any club that would have me as a member." My goodness, is this me? Is this why I walked away from Jessie? I feel like there's an internal struggle between logic and the heart going on in me. If I'm so sure we're not right for each other, then why do I feel so sad about this today? Why do I miss her so much? Will I regret this? A big part of this is guilt. I feel guilty for hurting her. I feel guilty for not being able to live up to some expectation. I feel guilty for not walking away from this experiment 100 percent "cured." I'm glad we don't have to analyze our relationship anymore, like we did during the experiment, but I wonder if Jessie and I will stay close. We're so close right now, and I feel like we'll always be there for each other. However, I know that the minute she or I gets into a new relationship those ties will change. It's very weird to not have to see or talk to her today. She texted me late last night to say how much she liked the gift I gave her. It was sweet. I wanted to call her, but I didn't know what I would say. This may sound ridiculous, but I wanted her to call me last night and fight for me. But she just let me go. Maybe she knows we're not right deep down? Maybe she was expecting me to fight for her? Maybe she's just fearing more rejection? After all, Disney World wasn't exactly a party. I didn't leave her with any grand gestures of hope. The strange thing is, I was never convinced that her feelings were truly about me. Did she love me, or was she just in love with love? I think we all want that, this idea that if the person we are with couldn't have us then they couldn't bear to have anyone. Even if that's not true, we still have the fantasy.

Apr 29, 2013, 5:43 PM

It's over, Greg. We got into a big fight Saturday in Disney World. I feel awful.

Yikes! Wait, so are you not going to see each other any longer? I'll call you in 10.

This has been very draining for ME. Maybe you and Jessie are just supposed to be great friends...

iMessage Send

really let me in emotionally in a deep and trusting way, and I want that kind of intimacy with a partner. No matter how close we became, there was always a wall up around him, as if he couldn't fully trust himself, or me. On the plane when we talked about our decision to end things, and he was wavering on what to do, I assured him if he did really like me, there wouldn't even be a need for a decision. That this shouldn't be so difficult. I told him that when you know it's right, you just know. Truthfully, though, I don't know. Maybe we could have had a chance if he had let us. Maybe we could have had a chance if I had fought for him. But I have to question why I didn't. I guess I was just tired of his uncertainty and negativity and knew deep down that the absence of emotional intimacy would always be a problem. I guess in part I was also looking for a way out.

May 2, 2013: Sometimes it scares me how my emotions and moods can waver. Earlier this week I journaled about how I felt such a huge sense of relief now that the experiment, our relationship, was over. I've felt confident and relieved to be single. Yet now, only a few days later, I am lonely. It's a Friday night and most of my friends are out of town. My sister is busy and I find myself bored, restless, and wondering what's next. After a glass of wine, I had a moment of weakness. I went online and reactivated my OkCupid account. I was immediately bombarded with dozens of messages and requests, but I didn't respond to anyone; I'm not ready to date. I guess I just needed a little ego boost, pathetic as it sounds. How can I go from complete confidence one day to falling into a hole of insecurity the next?

May 3, 2013: I miss hanging out with Tim as a friend. I hope we can get back to how things were before the experiment. I texted him to let him know:

May 3, 2013, 6:57 PM

How are you? I miss hanging out with you.

I miss you, Jessie.

iMessage Send

After his sad call the other day, I can't tell what this means. "I miss hanging out with you" and "I miss you" are two different things. I am probably reading too much into it, but I want to be careful not to mislead him. It goes back to the age-old question: Can men and women just be friends? We were friends before, but we were still, in some ways, always curious about each other. We've talked

TG:

May 5, 2013: I was talking to my married buddy today. He thinks I'm an idiot for letting Jessie go, but I can't force something that doesn't feel right in my heart. He was being like those people who judge a person based only on externals, who say a beautiful celebrity is "amazing" or a "dream girl," but they don't know them. That person has no idea how they'd vibe with someone like Angelina Jolie, or if she's a raging psycho in real life or not. Some people just assume that if it looks good on paper everything should work out. While my buddy is a great guy, with great advice, he's still unhappily married, and I need to remember to take what he says with a grain of salt. I like this funny quote: "Never trust a married guy's taste in women. It's like asking a starving guy what food tastes good." Anyway, I'm still not sure about my decision to let Jessie go, and even though a good part of me knows that we're better as friends, I can't deny that I do miss her.

May 11, 2013: Today was the first time Jessie and I have seen each other since Day Forty of the project. We met to brainstorm and go through the journals we'd kept during the forty days. While we were talking, her phone began to buzz. I looked at the phone, and what did I see? A notification of an OkCupid message! Ha! Wow, it's been only a week and a half, and she's already back at it. I knew that's how it would be. Jessie doesn't play around—she goes right into reactionary mode. I gotta let it go and not worry about it. Toward the end of our meeting we were hugging and talking about giving it another chance between us. Honestly, knowing that she can run on to the next thing so quickly is a problem for me. It's clearly my issue more than hers. Anyway, we said that we missed each other, and we hugged for a while. I wanted to kiss her, but I didn't. I knew that would make everything way more confusing. She gave me a kind of ultimatum, that we should either be friends and not talk about this stuff any longer, or we should date and give it a chance. I told her I thought it was best to stay friends. Okay, I said that, but why do I still feel so confused?

June 5, 2013: There is a lot of work to be done, still, in the creation of the 40 Days website, putting the writing and photos together, editing videos, and making the illustrations. That, coupled with an enormous amount of client work I currently have, has been stressing me out lately. I know I don't handle it well sometimes. Also, I'm noticing how different Jessie and I can be in the way we approach work. Sometimes we don't know how to navigate each other. I feel like Jessie keeps giving me a hard time about when we're going to launch this. I can get impatient, but Jessie can, too. She wants to launch it now, but we really need more time to craft everything. I feel a lot of pressure from her. Then, she'll apologize for everything, completely change her tone, and become super ac-commodating—as if nothing has happened. I know she is just trying to be nice, but I get annoyed by the way she switches tones so quickly. I need more time to process everything. But then we begin to argue again. It's been pretty stressful. I hope we can sort it out.

before about whether this experiment was a way to date each other without the usual risks. In a way, the experiment provided some sort of protection for us: It had a built-in expiration date. It was supposed to end. Anyways, I hope we can go back to being friends.

May 4, 2013: I went to Los Angeles for the weekend. I made dinner plans with my friend Nicole and her wife, Noreen. They met last year, fell in love instantly, were engaged within a few days, and got married after a few weeks. Their story is a reminder of how quickly life can change. It also makes me excited that my future in this arena is wide open and unknown. I told them about my history of failed relationships this past year, and now this crazy experiment with Tim.

Noreen told me I am probably going after the wrong guys. She said she had been searching for the right partner for years with no luck. Finally, a friend gave her a book, which said that in order to find the right person, you need to have complete clarity and focus on who you are looking for. It suggests making a list of all the qualities you are looking for in a partner and to remind yourself of the list often. So Noreen wrote her list on a chalkboard wall in her bathroom and stared at it for days. Two weeks later, she met Nicole, who embodied everything she was looking for. I'm not sure I believe all this, but it can't hurt! So I made my list:

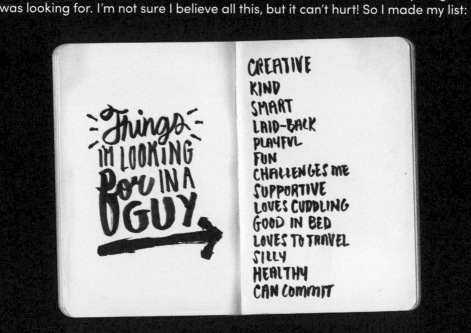

Things I'm Looking for IN A GUY →

CREATIVE
KIND
SMART
LAID-BACK
PLAYFUL
FUN
CHALLENGES ME
SUPPORTIVE
LOVES CUDDLING
GOOD IN BED
LOVES TO TRAVEL
SILLY
HEALTHY
CAN COMMIT

May 7, 2013: This week Tim and I had planned to have a final therapy session with our therapist, Jocelyn. The idea was to review everything that had happened during the experiment and talk about what we were feeling now and what we have learned. The problem is, I have a bad feeling about it. I worry that if Tim wasn't ready to end things, he might use this as an opportunity to try to start

TG:

:) ▢

Jessica Walsh
to Timothy ▾

Tim, keep in mind that we both want the best for each other and we both care about each other a lot. I'm sorry we are having these misunderstandings. Please be as direct as you can with me about your feelings and I promise I will be compassionate. I totally see how unfair that dinner was. I am always here for you.

June 10, 2013: It's been a month and a half since the experiment ended, and I've had no desire to resort back to my old dating ways. Recently I went on a date with a girl who my buddy set me up with. She was the first woman I've seen since Jessie, and she was the exact opposite of her: We ate doughnuts, drank beer, and watched the NBA finals. These are things Jessie would never be interested in, so I think I was immediately smitten by it all. We ended up sleeping together that night, and I realize how the whole thing was just some sort of rebound for me. I felt weird about it, but I tried to hang out again two nights later just to make sure. She even made me two bags of cookies, one with a San Antonio Spurs logo and the other with a Miami Heat logo, since these were the two teams playing in the NBA Finals. We had a lot of fun, and I liked her, but I knew it was a mistake. I went out with one other girl who kept saying, "Do the damn thing!" all night during dinner. Seriously? Really, eight times in one night?! I sent her home in a cab.

I WOULDN'T join ANY CLUB THAT WOULD HAVE ME AS a member

—GROUCHO MARX

things up again. Which would be fine, if he is 100 percent sure and confident about wanting to date me, but if that's the case he should man up and just say it. He shouldn't need a couples therapist to gain the courage for that.

Hey

Jessica Walsh
to Timothy

Hey! How are you? How was your weekend? Do you mind if we cancel therapy on Thursday? I had a big job come in to the studio and I am pretty busy this week. Plus, we're not even dating and the project is over. Do we need more therapy?

May 9, 2013: Tim came by my studio this morning. We had planned to go through the journal entries we'd kept during the 40 Days experiment. As we were reading through our first few entries, side by side, we were shocked at how differently we interpreted the same experiences. We found the male/female perspective to be fascinating. We knew that our relationship issues were universal and we thought people might relate to our struggles and failures, and through our story they might be inspired to seek out answers for themselves. So we talked about the idea of sharing our journal entries with the public and made the final decision to post the entries online via a blog. It will be a lot of work putting it all together, but we think it will be worth it.

As I was reading through his entries, Tim walked up behind me and grabbed me around the waist. He drew me in, hugged me tightly, and kissed me a few times softly on the side of my head. He held me like this for a minute in silence. I froze as I sorted through my feelings. What was he was doing? What was I doing? Did he want to be friends with benefits? Did he want to be with me again? I pulled away and asked him what was going on. He said he'd been wondering what it would be like if we could date without all the rules, outside of the context of the experiment. That he was afraid he had made a mistake. But he also told me that the experiment had happened so fast, and he didn't have gh perspective yet on it to know his mind completely. He said he was confused.

The uncertainty was the perfect reminder of everything that was wrong between us romantically. I don't want to date Tim again if he's still confused and emotionally detached. It's not attractive to me. I want a man who is sure of himself and of what he wants, appreciates me, and is proud to have me by his side. I told Tim he was being unfair and he should make up his mind about what he wants before getting involved again. That if he was really serious and sure about dating me, we could talk, but otherwise we should just focus on rebuilding our friendship.

TG:

June 15, 2013: Jessie and I hung out with some mutual friends last night at a cocktail party. As much as I've been trying to deny the feelings I have for Jessie, I still keep questioning myself and wavering. I'm obviously still attracted to her, and there's so much we have in common. Also, having a great friendship as a foundation is such an important part of any relationship. Being back in the dating game hasn't helped, either. All that careless fun I like to have has been utterly disappointing. I'd really love to find someone special. Gosh, I haven't had that thought in years, while I've been happily coasting from one date to the next. Now I can't help but wonder: Did I make a mistake? Am I seeing things more clearly now that we're unburdened by the parameters of the experiment? Or am I simply more interested because she's recently gone on a couple dates with some new guy? Jessie has stopped taking the sleeping pills she was taking during the experiment, and she seems so much happier and balanced now. This has undoubtedly changed my outlook on the possibility of us, too. Anyway, we shared a cab home from the party, and she ended up telling me that she thinks that I'm crazy but that she still finds me "weirdly attractive." Well, guess what, Jessie? I think you're crazy, and I still find you attractive, too. Then she immediately told me that she shouldn't be telling me that stuff. I wanted to kiss her on the spot. But I didn't. I knew that would open a whole bag of worms. Also, I wasn't sure she'd reciprocate, and I didn't want to risk that rejection. Oh boy, what a mess!

June 25, 2013: I've been wondering what would happen if Jessie and I dated in real life. We've been arguing more and more about trivial things, but my birthday was two days ago, and she sent me a really sweet email.

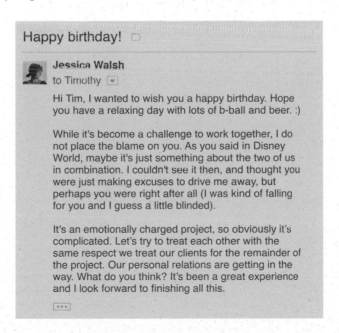

Happy birthday! ▷

Jessica Walsh
to Timothy ▾

Hi Tim, I wanted to wish you a happy birthday. Hope you have a relaxing day with lots of b-ball and beer. :)

While it's become a challenge to work together, I do not place the blame on you. As you said in Disney World, maybe it's just something about the two of us in combination. I couldn't see it then, and thought you were just making excuses to drive me away, but perhaps you were right after all (I was kind of falling for you and I guess a little blinded).

It's an emotionally charged project, so obviously it's complicated. Let's try to treat each other with the same respect we treat our clients for the remainder of the project. Our personal relations are getting in the way. What do you think? It's been a great experience and I look forward to finishing all this.

May 12, 2013: After much thought, I decided to stop going to my own therapist, who I've been seeing for almost a year now. When I started seeing him, I had developed all this anxiety about keeping up appearances and expectations, and about maintaining a certain level of achievement. Suddenly the work that once brought me joy was attached to fears. I realize now how ridiculous that mind-set was. I was putting way too much pressure on myself and causing so much unnecessary stress. No wonder I was jumping into relationships so quickly: I was looking for a distraction, anything to replace the enjoyment and love I used to get out of my work. Of course those relationships failed!

After this "boot camp" of self-reflection, along with the experiment with Tim, I feel like I am in a really great place. I've learned to let go, just be me, and go easier on myself. I've regained joy in my work and stopped caring about perceived expectations. The world doesn't end when I forget to respond to a work-related email. The world doesn't end if I take a weekend or two off or say "no" to meetings or hanging out with friends.

The other day, Tim and I were discussing how interesting it is that the experiment started out as an attempt to solve relationship issues, but how it really helped us on other personal levels. The conversation reminded me that despite the drama around the project, our friendship is special. Many people only want to talk about the superficial stuff, but I can have deeper conversations with him about life and never feel any judgment.

BERGHAIN, BERLIN

May 13, 2013: I went to Berlin with my sister on a business trip. After the conference was over we went to a nightclub called Berghain. Over the past few

TG:

I still have major concerns about anything long-term between us, but now that the dust has settled from the experiment, I have some perspective. Everything felt so difficult during the forty days, like a slippery frog that I couldn't quite catch. Also, Jessie is no longer taking those pills, which makes her a completely different person. So last week, late at night while I was enjoying some whiskey, Jessie and I were chatting on email. I told her everything I had been feeling, and I asked her what she thought about the idea of giving it another chance between us. Well, she wasn't exactly keen on the idea. She told me that this is just a chase to me, that I'm only doing it because she's moved on and has started seeing someone new. There is some truth to this: The fact that she's seeing a guy makes me feel more pressure to make up my mind. I'm not saying this is fair, but the experiment was so hard, and I'm just curious about how we would be together without that self-imposed experiment forcing us to be together. Now, since I told her this stuff, I've noticed that we've been arguing about everything: about when to launch the project, about what we've written about each other, and other things. I don't understand this; we have worked so well together for so long. But now, even when we're not openly fighting, there's this tension and a passive-aggressive vibe between us. At least I won't regret not telling her how I felt.

TWO DUDES IN TANK TOPS TAKING SELFIES

BABY BOYZ BRASS BAND

JULY 4TH

July 3, 2013: I'm in New Orleans vacationing with my brother, eating good food, and listening to the best jazz I've heard in my life. I haven't talked to Jessie in over a week. She's been kind of coy with me. Even though it's only been a month, I know she's getting serious with this new guy Zak. I called her from New Orleans, and we had a nice heart-to-heart. She told me she went to Mexico with him on their third date last week! WOW. I can't help but think how impulsive she is, at least compared to me. One relationship doesn't work, and she's on to the next one so quickly. Which, at the same time, is what's special about her: Jessie doesn't

months, she's been introducing me to techno and house music, and a few DJs she likes were there that night. I am not much of a party girl by nature. I am a homebody who would prefer to spend my Friday night in pajamas doing work or watching a TV series with a glass of wine. I'm glad she was there to pull me out of myself. When else in my life would I be dancing all night long in a dirty old warehouse space in Berlin? I had one of the most incredible nights of my life, full of perfect moments that I will never forget. We lost ourselves in the music. All insecurities went out the door. It made me appreciate being young, being single, and having the freedom to have these experiences that may not be so appropriate one day. At sunrise, they rolled the windows up in the warehouse, where we were all still dancing. My sister and I hugged and talked about how much we loved each other.

May 18, 2013: I hadn't looked at OkCupid in the weeks since that lonely night when I reactivated my account. However, a friend suggested I start dating casually. It can't hurt to have a little fun. So I set up a date with a guy to meet at the Bourgeois Pig in the East Village for wine.

On paper he looked pretty awesome, and it sounded like we had a lot in common. It was a disaster! We barely had anything to say to each other. I paid after one drink, politely left, and met some friends at another bar where we laughed about it.

May 25, 2013: I had a date tonight with Zak, a guy I met on OkCupid recently. We met at a little bar in Williamsburg called Post Office. I couldn't believe how easy and natural conversation was between us. He has a very laid-back and easygoing personality. He made me feel instantly comfortable and didn't stop making me laugh. We were able to talk about so many topics, and it felt like we related on many levels. He is a cinematographer and seems to genuinely love his work. To top it all off, I am very attracted to him. The night passed quickly, and I left around 11:00 P.M. to meet up with some friends for a birthday party. After a few other disastrous dates this week, it was nice to finally have one good one!

TG:

play around, she knows what she wants. This reminds me of a quote in the film *Blue Valentine* when Ryan Gosling's character, Dean, says, "I feel like men are more romantic than women. When we get married we marry, like, one girl, 'cause we're resistant the whole way until we meet one girl and we think I'd be an idiot if I didn't marry this girl because she's so great. But it seems like girls get to a place where they just kinda pick the best option…'Oh, he's got a good job.' I mean, they spend their whole life looking for Prince Charming and then they marry the guy who's got a good job and is gonna stick around." I wonder, is this what Jessie's doing? Only Jessie can know what's right for her. Despite my love for her, this is one of the reasons I had a hard time imagining us together. I really wish her the best with Zak. I just don't want her to get hurt, that's all. Now back to my jazz. According to Miles Davis, "Sometimes you have to play a long time to be able to play like yourself."

July 9, 2013: Tomorrow we're launching the 40 Days of Dating website, but today we launched through social media and other venues what we're calling teaser videos. Essentially, they're four fun videos we made to get people interested and curious about the project. They received an amazing reception, especially the "behind the scenes" video, which was the perfect metaphor:

TEASER VIDEOS: SUMO

TEASER VIDEOS: GLUE

The two of us are staring at each other, trying to stay focused, while everything around us (sumo wrestlers, emotions, fears, habits, etc.) is trying to distract us from that focus. We worked hard on them and spent a lot of our own money, so it was gratifying. It was nice for a change to do something more artful and abstract that didn't involve the emotional burden we've been carrying through this whole thing. In a way, this project was an endurance test. We got a drink tonight at the Flatiron Lounge to celebrate the launch.

I NO LONGER HAVE THE ENERGY TO MAINTAIN MEANINGLESS FRIENDSHIPS, FORCED INTERACTIONS, OR UNNECESSARY CONVERSATIONS

— JOQUESSE EUGENIA

June 5, 2013: Tim is experiencing a lot anxiety about all the work we have to do to launch the 40 Days blog. He was driving himself a little crazy over it, so I tried to give him advice and take some of the load off his plate. That backfired: He said I was being too motherly but also that I was too accommodating. After a long string of misunderstandings and an angry phone call, I ended up getting a little worked up myself. I just don't understand our communication breakdowns. We never used to fight like this before we dated. Anyway, he wrote me a nice email, and we both apologized about it in the morning.

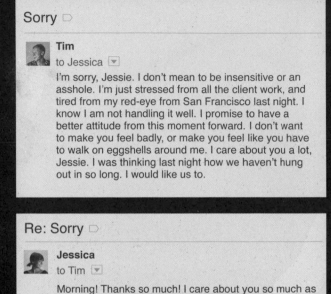

Sorry ▢

Tim
to Jessica ▼

I'm sorry, Jessie. I don't mean to be insensitive or an asshole. I'm just stressed from all the client work, and tired from my red-eye from San Francisco last night. I know I am not handling it well. I promise to have a better attitude from this moment forward. I don't want to make you feel badly, or make you feel like you have to walk on eggshells around me. I care about you a lot, Jessie. I was thinking last night how we haven't hung out in so long. I would like us to.

Re: Sorry ▢

Jessica
to Tim ▼

Morning! Thanks so much! I care about you so much as well, which is why it kills me when you are sad / stressed / uphappy. It's in my nature to try to help out people that I care about and help find solutions. But I can see how it could have been annoying or motherly, and I am sorry it upset you further. Let me know if I can help you out or take things off your plate in the meanwhile.

Yes, let's hang out soon.
xo
···

June 10, 2013: Tim and I have been going over the details of launching our diary entries on the website. It's been a little stressful creating the website with him. I talked to a friend about it. She observed that it's funny how Tim and I have fairly stereotypical gender-specific issues in relationships, but when it comes to other aspects of life, like my work, my personality is much more typical of a man. I can be very direct about what I want, I'm less emotional, and I talk about

220

TG:

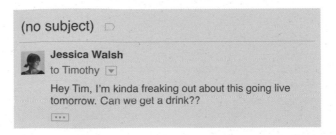

(no subject)

Jessica Walsh
to Timothy ▼

Hey Tim, I'm kinda freaking out about this going live tomorrow. Can we get a drink??

July 13, 2013: My buddy Greg just told me he's moving in with his girlfriend. He was the last of my good friends who was single, and I'm feeling a bit more sensitive to relationships and my own single status post-experiment, especially because of this project. I still feel the way I did at the end of the forty days—I understand how awesome it is to be in a relationship with someone that you love and connect with. Anyway, now that my buddy is moving on, I feel like I'm getting left behind. It's like that Kanye West song when he raps, "My friend showed me pictures of his kids, and all I could show him was pictures of my cribs." Except my line would be more like, "My friend told me he's moving in with his girlfriend, and all I could say is that I dated a girl on the Internet." I know, it doesn't rhyme, but you get the drift.

July 24, 2013: Tonight Jessie and I got into a heated text message conversation about our relationship and what happened at the end of the experiment back in April. I don't even know how this happened, but I ended up telling her that I felt like I loved her at the end of the experiment. Since we've only posted up to Day Twelve on the blog, she has no idea yet what I wrote on Day Forty. She didn't seem happy to hear it. We kept going back and forth by text, and I was surprised at how affected she seemed to be by the news. I realize she's in this other relationship now, but why would telling her that I loved her three months ago, at the end of the experiment, affect her right now? Anyway, I do feel like Jessie and I have unfinished business. We (or I, at least) haven't yet found closure. I wonder if this is healthy for us—time has moved so quickly, and we shifted gears into creative mode right after the experiment. We still haven't had enough space or time away to reflect on it all, which has been difficult for me. It's a funny thing, because as open as I am, I find it difficult to truly open up to someone once I know them. Maybe that's why I didn't tell Jessie my feelings at the end? I can easily tell my entire life to a stranger or share my feelings with friends, but once I let someone into my life romantically, I find that I put up walls. For instance, I've had no problem talking about my absent father or a painful breakup or a childhood experience to a group of strangers, or on the 40 Days website, but it's difficult for me to talk about these things one-on-one with someone I care about and who actually cares about me. Mainly because I don't think the other person can truly relate, and also because I don't want their sympathy. Then, later, I second-guess myself.

issues head-on. Tim, on the other hand, can be very sensitive to my criticism and indirect about what he wants. He keeps things that bother him to himself and lets them fester until he's so frustrated that they suddenly boil up and he gets angry with me.

Meanwhile, I've been texting and emailing a lot with Zak. Our conversations have been lighthearted and funny, and they're a nice distraction from all the drama with Tim. Zak is pretty persistent about keeping up the conversation, and keeps texting that he wants to hang out again soon. I want to see him again, but I'm purposefully trying to slow things down. I don't know if I am ready for something serious again.

June 15, 2013: I was telling Tim about this care package I received in the mail from some guy I've never met. The guy found out my favorite foods from my Facebook profile and sent me a big box of avocados, chocolate, and coffee. There was also a USB stick with a presentation he designed that contained mood boards of options for our first date. It was quite involved, made me feel obligated to say yes to a date with him. But I canceled when I found out I was going to Barcelona for work. He then proposed we meet up in London, while I was over there. Here I was thinking that I moved fast! I told Tim about it:

June 15, 2013, 6:32 PM

Of course I am not going to London with him, do you think I am crazy?!

Um, yes I do! "The only people for me are the mad ones, the ones who are mad to live, mad to talk, mad to be saved, desirous of everything at the same time, the ones who never yawn or say a commonplace thing..."
Jack Kerouac

iMessage Send

222

TG:

July 29, 2013: Earlier today, Jessie told me she's quitting the whole thing, and then she told me to "fuck off" by text. This was really surprising, because she's normally calm and level-headed about these things. Things have been getting worse between us. Jessie is crazy busy at work, and lately I feel like I'm taking most of these calls with agents and setting up meetings for us. So I try to hold it in because I don't want to add to the drama, but then it just comes out indirectly and we get into a big fight. Last week, we got into an argument, and we both hung up on each other at different times. There are just so many layers and misunderstandings between us, blurred lines, decisions to make, hurt feelings. Now there's a new kind of pressure because we've been getting more and more publicity. When pressure builds, sometimes Jessie shuts down while I do the exact opposite—I go into full-blown annoying soldier mode.

Tim and I decided to meet up later at a cocktail party. I got pretty tipsy, and I was wearing five-inch high heels, and at one point in the night one of my heels broke off. We were laughing at my waddling around this very fancy venue like a penguin. At the end of the night Tim had to practically carry me out of the party. We shared a cab home and were having a great time. I still care for him deeply. There was a moment when I wanted to kiss him, but I held back. I was drunk, and I knew I'd regret it later. We're not right for each other, and I don't want to complicate things more than they already are.

June 18, 2013: A few days ago I met up with Zak for a second time; we had a brief lunch date. Last night we continued the conversation at a bar in Williamsburg. His honesty and forwardness with intimate and emotional details about his personal life were refreshing. I felt like I could pretty much tell him anything without any judgment. He seems at peace with himself and with life, and he has such a great energy. There doesn't seem to be any sort of "front" or "facade" with him—he wears his heart on his sleeve and is confident about it. The most striking thing about him is how relaxed and calm he is. We talked about how much we both hate drama. I slept over at his place. This morning we went to breakfast at a cute little place called House of Small Wonder and were talking about how we were overdue for a trip to the beach. He told me about this beautiful spot in Mexico called Tulum that isn't too touristy. Zak joked that we should just run off for the weekend, and I said, "Why not?" I was joking, but next thing I know, he pulls out his iPhone and buys the plane tickets. I love how spontaneous he is! Why is it that I meet an awesome guy when I'm not looking for one?

ZAK MULLIGAN

TG:

Not only have we been doing interviews all day with the press and taking phone calls from Hollywood film studios and agents, but we're still doing a lot of work (illustrations, etc.) on the daily posts that requires a lot of time. Not to mention, we're both trying to manage all of this in addition to our regular work. We're trying our best, but it's not working out well. I also think a lot of this is connected to the "love" stuff I told her earlier in the week. I should have kept my mouth shut! But she would have found out anyway.

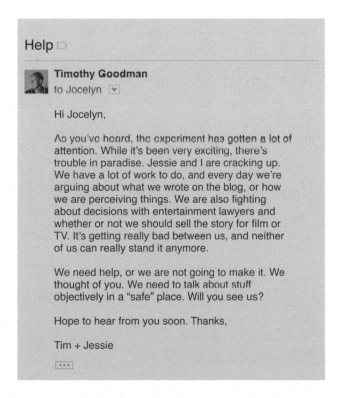

NORMAL PEOPLE ARE JUST PEOPLE YOU DON'T KNOW WELL ENOUGH

— ALFRED ADLER

M I

ss

June 19, 2013: Parsa emailed me this note today. He's the ex-boyfriend who broke my heart last December and left me completely confused about what went wrong. I blamed myself for everything. He made me question myself and how I approached relationships. It was part of what drove me into the dating experiment with Tim. Even though it's been over six months, it was really nice to hear from him and get clarity on what went wrong. I finally feel like I have some closure on that relationship now. It also was a nice reminder that it is never too late for apologies. I probably owe a few to guys I may have unintentionally hurt in the past.

Part Trois ▷

Parsa
to Jessica ▾

Now you may have no interest in hearing from me, in which I fully understand that sentiment, but I've felt the need to write you for the past week. Maybe it's because *The National* has been part of my playlist more and more as of late, or maybe because being in Rome and having the chance to reflect on the past year, but I wanted to say first and foremost that I am sorry.

I'm sorry for popping out of your life so quickly and not giving you the respect to be open and honest with you and willing to work on what we had. In hindsight so many of the things that seemed to bother me, all seem quite trivial now in the grand scheme of things. It makes me realize how un-ready I really was for you. In large part I don't think I knew how to get back into a real relationship given that, truthfully, my heart was still in pieces from a previous relationship. It was unfair for you to be on the other side of that. You didn't deserve the way I handled everything.

You're a pretty incredible woman. My intention with writing you is just to tell you that I'm sorry for what we lost and how we lost it. I do hope our paths cross again sometime, Jessica. I hope you are doing well and that you are happy. You deserve it.

⋯

June 21, 2013: I received this email from Tim the other day:

So... ▷

Tim
to Jessica ▾

Hey, so, what if I said I was interested in talking more about us again? What would you say to that?

TG:

August 5, 2013: So I've been regularly hanging with this great girl for the last five weeks, and I totally blew it with her last night. She asked me to come to an event with her, and I completely forgot about it. I've been so busy trying to juggle everything that's happening with 40 Days of Dating and my design clients that I've literally been working nonstop. I woke in the morning to see a text message that she sent around 3:00 A.M. In so many words, she said it was over. Sigh. I feel awful. We had a lot of fun together. She has been super cool with this project, too, considering she's reading all about me on the blog at the same time as she's getting to know me in person. A part of me wants to fight for her, but I just don't want to make promises that I can't keep right now.

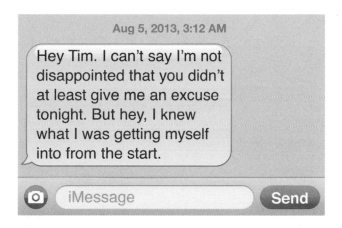

Aug 5, 2013, 3:12 AM

Hey Tim. I can't say I'm not disappointed that you didn't at least give me an excuse tonight. But hey, I knew what I was getting myself into from the start.

iMessage Send

August 10, 2013: Since that relationship ended, I've been feeling rebellious and disappointed by the idea of relationships in general. And on top of it all, it's insane how many women have been reaching out to me. I never expected this—I thought my dating life would be over because of this project—but random women are coming out of the woodwork, emailing, Facebook messaging, Instagramming me notes, and tweeting at me. On the one hand, I don't know if I have the strength to stay away from these requests. I can't deny that it feels good, that it boosts my ego. I mean, this doesn't happen every day. On the other hand, it's kind of creepy. They all think they know me. I'm constantly worried that I'm getting catfished.

Haley Hey would you wanna get a drink sometime?	**Sarah** If you don't end up with Jessie, can I have a shot?
Michelle You like flirting, i like flirting...so we should be flirting with each other.	**Raiza** Hi Tim, do you ever find yourself coming out to San Francisco? Let's hang out :)

Re: So... 🗩

Jessica
to Tim ▾

You are killing me. I asked you several times after the project if you thought we made the right choice. You said we were better off as friends. You've told me before with other girls how you just like the challenge. That you want what you can't have. When I was interested and you could have me, you didn't want me.

I want to be with someone who is sure they want to date me. Who sees what I have to offer. You aren't there yet, you're still confused about what you want.

Plus, isn't it curious that now that I told you I am starting to date this guy and I really like him, now all of a sudden you are interested? I like Zak. I want to see where things go with him.

`...`

So... 🗩

Tim
to Jessica ▾

I'm not confused anymore. I want to see/date you and see what happens. It has nothing to do with this guy. I've thought about it every day since the project ended. But when it comes to all this "you have to be sure of me," see, that is where you lose me. That's a fraction of the things you do that scare me :) I guess what I can offer right now wouldn't be what you want or risk. I'm off to bed. G'night, Jessie, safe travels.

xo

`...`

Afterward we had another conversation on the phone. I asked him why he was changing his mind now. He said he felt like he had fucked up. He said he truly wants to try to date me again, but he sees now that he waited too long and now I'm gone. He said the idea of a relationship with me always scared him. He said for years he felt like I was "a girl you marry, not date," and that this idea put too much pressure on him. He's sure, now, that he wants to try dating me. I probably would have tried dating him again if he had told me this sooner and with more confidence. Life is all about timing, and it is not on his side. Zak, on the other hand, has let me in closer emotionally in only three dates in ways that Tim never did. There was always a barrier with Tim. This gives me more confidence that Tim and I were just not the right match. Even if we had tried dating again, I don't think we would have lasted. I hope with all my heart that Tim finds someone he is completely comfortable with, who he can let his barrier down with. He deserves that.

TG:

> **Andriana**
> I wouldn't mind dating you for 40 days ;)

> **Alsa**
> You were in my dream last night...

> **Nina**
> If you want, I'm grabbing a drink with a friend in the East Village. Join us!

> **Rene**
> Come to London so I can feed you Japanese whiskey and flirt with you.

Some have even found my phone number, and total strangers are texting me in the middle of the night. Do they think they can change me?

Anyway, we've been going out to LA and meeting with agents who want to represent us, and we finally decided on Creative Artists Agency and signed

do not
chase people.
work hard
and be you.
the right people
will come and
find you
and stay.

—WILL SMITH

THEN
I'LL BE
TIRED
OF YOU

JW:

June 30, 2013: I jetted off to the beautiful sandy beaches in Tulum, Mexico, with Zak this weekend. I didn't tell Tim I was going, even though he kept asking me what I was doing during the weekend. I felt bad since he had told me he wanted to get back together. I didn't want to hurt him by rubbing it in his face about Zak. The trip was truly magical. The landscape in Tulum was almost surreal. In the mornings we'd do yoga and hang out on the beach together. In the afternoons we drank cocktails, explored the Mayan ruins, and went cave diving in the cenotes. At night we stayed up for hours talking about all aspects of life. While we met only a month ago, he's been very forward about his fondness for me. He told me how he never expected to meet someone like me. That he's been searching for a long time, that he had almost given up.

Tulum

Mexico

COQUI COQUI

ZAK

TG:

with them today. I was feeling celebratory, and I love LA, so I wanted to have some fun. A woman who lives out in LA had gotten in touch with me through Facebook last week. I found her very sexy. So I told her I was in town and asked her if she wanted to hang out. She met me in my hotel lobby that night, we had a few drinks on the roof bar, and she came back to my room. I remember lying in bed with her later in the night, and I asked her why she's single. She said, "All the guys are either my age and they're not very serious about life, or they're your age and they're not very serious about me." That made me sad.

August 12, 2013: We're coming back from LA today, and I'm not happy about some recent arguments with Jessie. One big reason we were out there was to meet with this production studio. I know she greatly cares about this project, but all Jessie could talk about was meeting up with Zak. I mean, she was even talking to our lawyer about it. I was annoyed, and I guess I was being kind of an asshole about it, but I was disappointed. After our meeting, she wanted to go straight to see Zak, but I wanted her to have drinks with me and the rest of the team. I didn't think it was a big deal to hang out with them for a couple hours—that's why we were there—but she seemed to feel I was being controlling. I get it, she's in love, but she will have all weekend to see her boyfriend! Thankfully, she joined us for drinks. I think Jessie believes I have a problem with her relationship, but all I want is for her to be focused on the project with me.

August 15, 2013: I'm feeling dizzy! The past week has been insane with interviews and meetings: CNN, *Elle* magazine, *London Times*, *Fast Company*, *Time* magazine, talk show requests, and meetings with Hollywood studios, producers, and actresses about selling the film or TV rights. All of a sudden our project is "intellectual property." I literally can't believe my calendar, and our 40 Days of Dating email inbox is jaw-dropping. All from this little idea? Insane and very humbling. We met a photographer at Washington Square Park for *Elle* magazine recently, and we got stopped about seven times by people who were fans of the project. One

July 4, 2013: For the Fourth of July I went to a dance party on a Brooklyn warehouse rooftop with Zak and my sister. We danced all day long until the sun set behind the Manhattan skyline. Later we sat by the waterfront in Brooklyn, listening to music and talking. Zak turned to me at one point and said, "One day, eventually, you're going to get mad at me. I want you to remember how happy and how perfect everything is in this moment, and I hope you'll find it in your heart to forgive me." I can't even imagine ever being mad at this guy. He is so perfect for me, and I've never been happier. I told Tim I was falling for Zak, and he did not seem very happy about it. He warned me to be careful and not let another situation like Parsa happen again. While I am aware that love makes me vulnerable, I don't want to hold on to fear and let it run my life. I know Tim sees my ability to love people without much reservation as a weakness, but I believe he is mistaken. The vulnerability that love requires, the complete openness and trust—this is not something everyone can handle. You need strength to be vulnerable. I believe that running from it or putting up walls only makes you scared, not strong.

"all Day I Dream" PARTY

BROOKLYN, NEW YORK

July 11, 2013: Tim and I launched our journal entries to the public a few days ago via our blog, www.fortydaysofdating.com. I have a bit of anxiety about it. I am pretty open and honest about my most intimate thoughts and feelings during that time. I wonder what my family, clients, or even work colleagues will think about it? And I worry about how Zak will react when he reads the intimate details about my relationship with Tim. I hang out and talk with Tim

TG:

young girl told us that she had had cancer (and beat it!) recently, and after battling depression, she built up the courage to pursue her dreams after reading our story. It was so touching and overwhelming to hear that. The more this project has grown, however, the less control I feel I have. I wonder if all this attention (both from fans and the media) is screwing with my pysche? Here's what I know: When you win an award for a design project, people will recognize your work. It's a very different thing when you present your own life on the Internet and are recognized by people outside of your work. For good or bad, people seem to think we're two-dimensional characters in a movie. Now we're just riding the wave and trying to juggle everything that comes along with that. I couldn't imagine being a celebrity. Your anonymity is taken away from you and everyone wants to know you and be with you and have a piece of you. No wonder so many famous people are crazy pompous asses.

ELLE MAGAZINE SHOOT

August 20, 2013: Last night we had dinner with a reporter from *Newsweek*. It did not go well at all, to say the least. She was egging me on from the moment we sat down, and throughout the entire dinner she kept poking at the fact that some women think I'm misogynistic, and how everyone just "loves Jessie." She clearly had an agenda, which was disappointing. There hadn't been much confrontation from the media so far and I was not prepared for this, so naturally I started getting very defensive—which only helped her case (i.e., angry misogynist getting angry at the female journalist). At one point, I told her that I felt like a zoo animal, and that I was ready to leave because we had already spent over two hours with her. I was tired, and I felt like she was monitoring my every move, patronizing me whenever she could. She continued, making remarks when we were ordering like, "Oh, but you don't like to share, right?" (A reference to Day Nine on the blog, when Jessie and I were at the Knicks

Fri, August 23, 2013

40 Days of Dating: An Interview with Jessica Walsh and Timothy Goodman

by ALICE NEWELL-HANSON

When a friend sent me the link to FORTYDAYSOFDATING.COM a couple of weeks ago, I thought, Ugh, stop sending me links to online dating sites guys. But then I read it, realized what it was, and kept reading it until one in the morning. 40 Days of Dating is an experiment conducted by graphic designers and close friends Jessica Walsh and Timothy Goodman. Both troubled by unsuccessful recent relationships, Jessica and Tim decided to see if they could change their dating habits (Jessica: hopeless romantic; Tim: serial dater) and date each other exclusively for 40 days. An overview of the rules: they had to see each other every day, there had to be at least three dates a week, they had to go to couples therapy once a week, and they each had to fill out a questionnaire about their experiences at the end of each day.

Would they fall in love? Would they hate each other? Would they have sex? If they did fall in love, would it really just be Stockholm Syndrome? And would they stay together after the forty days were up? I had as many questions, including "Should I try this with my best friend?" The answers to all of these (except maybe the last) have been hinted at, explored with total honesty, and illustrated in beautiful typography contributed partly by Jessica and Tim's friends, over the past several weeks. Now the project was carried out in full. The results have been published daily this summer. The final four days will be rolled out starting on September 3rd and I am DYING to know what happened during Tim and Jessica's final weekend at Disney World—so I sent them some.

'40 Days of Dating,' Jessica Walsh Project, Gets Hollywood Adaptation? [VIDEO]

By Reporter, EnStars | Aug 19, 2013 08:41 AM EDT

Like 11 Tweet 5 +1 0 Share

Tags 40 days of dating , timothy goodman , jessica walsh,

Jessica Walsh and Timothy Goodman (F

OF DATING
COUPLE CHRONICLES ATTEMPTS TO FALL IN LOVE

TODAY.COM

full screen CC transcript clip & share

Published: September 6, 201

Metro.us ▸ Lifestyle

By Cassandra Garrison

What happened after 40 Days of Dating? Jessica and Tim's big reveal

Followers of the viral social experiment 40 Days of Dating have been anticipating the

'40 Days of Da and everythi

What happened whe days and blogged a through all of thei

CLOCK MODE LOL win omg cute EPIC wtf

Days Of Dating Creator "We o Interest In Making Some om-Com"

er making a movie, but, you know, a good one.

Why Season 5 Of "Parenthood" Is The Perfect Jumping On Point

Laura Prepon Will Return For Only One Episode Of "Orange Is The New Black"

WORLD

Krispy Kreme Is The New McDonald's — In Russia

Get more World Buzz ,

Back to just friends! Couple who dated for 40 days as an experiment reveal they have already broken up but remain 'very close'

PUBLISHED: 18:41 EST, 9 September 2013 | UPDATED: 05:44 EST, 10 September 2013

View 22 comments

55 shares

Share Tweet +1 Share

Two friends who dated for 40 days as a social experiment have revealed that they broke up on the very last day.

Jessica Walsh, 26, and Timothy Goodman, 32, both designers based in New York, had been friends for four years; but after finding themselves single at the same time, they decided 'dating' each other would be a worthwhile experiment.

Despite the fact that it didn't blossom into a relationship, both said on the Today show they felt it was a success, because we learned so much about ourselves and each other,' explained Jessica.

Scroll down for video

FRIENDS DATE FOR 40 DAYS IN ART EXPERIMENT

NEXT

all the time, and I wonder if that will start to bother Zak once he reads about what happened between us. On another note, Tim continues to tell me about his dating escapades. He's clearly frustrated with himself for falling back into his old patterns with women.

40 DAYS WEBSITE

July 15, 2013: The response to our 40 Days blog has been crazy. We've had hundreds of emails from the press wanting to do interviews, and today we got our first emails from producers in Hollywood about turning the experiment into a movie. I am completely shocked. I never imagined our little dating story would go viral. The attention has been exciting but overwhelming. I feel like there aren't enough hours in the day to respond to everyone.

July 23, 2013: I got this text from Tim:

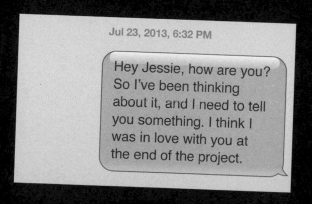

Jul 23, 2013, 6:32 PM

Hey Jessie, how are you? So I've been thinking about it, and I need to tell you something. I think I was in love with you at the end of the project.

TG:

game and I asked her to order her own dessert.) I really did not understand it. Was she projecting her own issues on the way I live my life? Is she just angry at men? She seemed interested only in stirring things up to create a story. For Jessie and me, the whole point of this experiment was to work on our issues. We acknowledged our issues and then volunteered to call attention to them in the hopes of learning and evolving from the experience. Why attack me for it? I've generally been okay with the criticisms, but of course it can get to me at times. As we walked away from the restaurant, Jessie told me that she didn't like how I had behaved. Well, what does she expect? This journalist obviously had it in for me. We've both been getting a fair share of criticism that isn't always easy to swallow, but it's also very obvious that more people are on "team Jessie." I guess it's easy to root for the one who "loves love." Today, Jessie agreed that the *Newsweek* reporter was unfair, and she wrote me a nice email.

:) ▭

Jessica Walsh
to Timothy ▾

Tim, keep in mind that we both want the best for each other and we both care about each other a lot. I'm sorry we are having these misunderstandings. Please be as direct as you can with me about your feelings and I promise I will be compassionate. I totally see how unfair that dinner was. I am always here for you. Hugs, Jessie

August 21, 2013: Reliving the forty days all over again, with the world reading and chiming in, has been painful at times. Obviously, we didn't anticipate how big this would get, so there was no way to prepare for all this. I talked to my friend Les tonight. In regards to all the press, as well as the difficulties Jessie and I are having with each other, he gave me this fantastic piece of advice:

Aug 21, 2013, 2:44 PM

Let go. See that the forces are stronger than you and just accept that. If you can finally see that, then you'll find them to be interesting, rather than competitive.

iMessage Send

I love you now. And then I was in love with you, but something didn't feel right at the same time.

No you weren't. You pushed me away at the end of the experiment.

Yes I was.

Well if you were, all your actions said otherwise.

You're one of my closest friends and I love you. It's all good. I kinda messed up, but it's probably for the best.

The more I think about it, the more frustrated I become. I can't figure out if he is just playing games or if he really believes this. I don't know which is worse. If he's making this up in one last attempt to get back with me, it's not going to work. Even if he does believe he feels this way, what purpose does it serve now? He knows I've fallen for Zak, so what's he doing? Is he trying to sabotage our friendship? Some things are better kept to yourself. I've always believed words are cheap and it's a person's actions that speak the loudest. Tim never did anything to show me these feelings, and I just don't understand where this is coming from right now.

July 29, 2013: Lately it has become more and more difficult to work together with Tim. We have so much work to do on the artwork and videos for the blog, and this is on top of our regular work. Ever since launching the site, we've been bombarded with fan mail and interest from Hollywood. I am doing my best to do as much as I can, but it never seems to be enough for Tim. Maybe he's frustrated that I didn't reciprocate the "I love you" message. There have been angry

TG:

August 22, 2013: Today Jessie and I decided to see our therapist, Jocelyn. It's been four months since the experiment ended, and we're constantly at odds about everything. Last week we were literally fighting about how we each interpreted an old fight between us! It's gotten out of control, so we decided that if there's any hope for us to continue as friends and as future business partners, then Jocelyn's the only one who can help us right now. The pressure from this project, from the press, the demands, and the attention we're getting from Hollywood has just become too overwhelming. We needed to hash it all out and get to the root of it all, like what happened in Disney World. I know it might seem counterproductive to open up these wounds, but they haven't been cleaned out properly. We both felt like we needed this. Jocelyn said that so many of our issues are probably based on the fact that deep down Jessie felt rejected by me, but also that my telling her I loved her was damaging to our friendship. It was extremely difficult to go through the session, but it did feel good to discuss this with an objective third party.

September 1, 2013: When the blog first went live in July, I was getting stopped on the street once a week, but now it's happening two or three times a day. It happens in the grocery store, on the train, on the street, in LA, you name it. Sometimes they want to take selfies with me, but usually they just say, "Hey, I love your blog!" or they ask, "Did you guys stay together?" However, lately it's been getting a little weird. First, I noticed on Twitter that people were taking pictures of me on the street then posting them! This made me nervous, to say the least. Second, I was

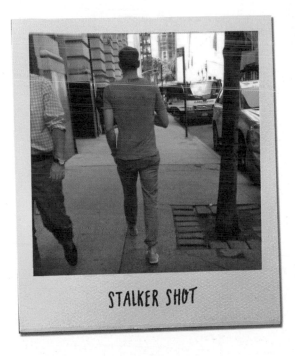

STALKER SHOT

Annie

to Jessica & Timothy ▾

Is there a place to find out the status of Tim and
Jessica's affair now? I'm DYING... practically dying to
know. ESPECIALLY with Tim's last comments of love...
c'mon Tim! I hope he told her. I definitely need to know
(and most likely all the other readers as well).

Desperately seeking answers,
Annie

40 Days of Dating ▢

Francesca

to Jessica & Timothy ▾

You were seriously brave and very crazy. You created
a beautiful love story and I think you will both make
some lucky people very happy some day. By day
14 I was so invested, you made me laugh and you
made me cry. And I really hope you stay friends. If
I were single and I had the courage I would try and
do what you did.

Intrigued ▢

Abbey

to Jessica & Timothy ▾

I just wanted to write an Email to tell Jessica and
Timothy how much I loved their "experiment." Once I
started reading it, I could not stop, I couldn't sleep till I
knew the outcome. And like Timothy said in one of his
last answers, it was almost known that you two
wouldn't work out, but yet I caught myself wishing that
you two would, or did. I think if both of you took the
time to read your own responses again, and one
another's, you might see that you two would make a
great relationship.

On a personal note, your experiment actually helped
me a lot with the way I go about my relationships and
my dating experiments. Reading both your mistakes
and positives of what you both do in relationships
helped me look at my own. The way you went to
therapy and dissected your past relationships also
helped me dissect my own past relationships.

I just wanted to say thank you, and i loved it! Do
something else this interesting for all of us to read! (or
make a movie).

Something to chew on

Alex

to Jessica & Timothy ▾

Hi, guys,

I'm no shrink or whatever. But there's something
special about you two and I tend to believe you're both
stupid. No offence, it's not about your IQ. It's about
your EQ (emotional). Don't get me wrong, that's not a
bad thing. Who am I to judge? I have my own
skeletons in the closet. But, as probably many other
have told you, you should be together. I know, it
sounds naive and maybe silly, but none of you
understood the essence of what the fuck love means:
it's about understanding and giving the best of you. It's
not about "she deserves better" or about "I hate the
fact that he didn't want to fight." Because, basically,
this is how you'd summarise your relationship.

Why am I writing this e-mail? No, I don't want to
change your decisions. They're yours. It's your future,
not mine. You're both 21+ and vaccinated, hence
responsible and somehow experienced. You're both
naive. Love is about compromises and fighting. It's
about tolerance and giving lots of breaks to each
other. I don't want to seem too naive, but the fact is my mother is Cancer and one of my
exes is Scorpio. For what it's worth, I'm Gemini and my

Ariel

to Jessica & Timothy

I AM VERY UPSET ABOUT THE DELAY IN
WEBSITE UPDATES.

First of all, I'm in Cairo. The world is ending here.
I have a curfew at 7pm. Some days I can't leave my
house. Some days it's Arabic lesson, go home, eat, go
to sleep, repeat.

Second, I am moving to New York when I get back to
the States in October, I am a 22-year-old
sometimes-polyamorous romance addict and I have
been using the story of your 40 days as a distraction.
From the noise outside. From the chaos. Way better
than rom-coms.

Most days, I refresh the webpage at least every hour.
Waiting for updates. Not cool, y'all. Not cool. DO YOU
KNOW WHAT IT'S LIKE TO BE A 22-YEAR-OLD
STUCK INSIDE AFTER 7PM? NEVER IN MY LIFE.
I dyed my hair black today to look more Egyptian. I
lived on ramen, candy, chips and pepsi from the corner
market for two days. This is the only HATE mail I've
ever sent.

(On a side note, thank you for giving me an excuse to
use caps-lock. Really refreshing).

With disdain,
Ariel

Thank you! ▢

Brianne

to Jessica & Timothy

I wanted to write you to thank you for sharing your
experiment with the world. I recently ended a
relationship with someone and have been struggling to
come to terms with why it/what happened. Reading
through your (Jessie's) entries helped me to not feel
so alone in certain feelings I was experiencing, and
reading through your (Tim's) feelings helped me to
understand some of the thoughts and emotions my ex
was probably, and undoubtedly having. It helped me to
understand that it was just not meant to be, and that's
OK! I'm a firm believer that things happen for a
reason, and the universe will lead us in the direction
we're meant to go, but not until after reading the 80
entries you both so fearlessly shared - the reason for
my relationship ending seemed unfair and
unreasonable.

It's mind-boggling how much dating has changed from
when our parents/grandparents were young. I often
feel like mine think I'm insane, and it's nice to know
that I'm not the only one out there experiencing some
difficulty. Thanks for giving me a new sense of hope. I
wish nothing but the best for you both!

Thank you ▢

Camden

to Jessica & Timothy ▾

My friend introduced me to your experiment this
morning, and I've spent all day admiring your
commitment to your project and the marvelous way
you chose to represent it. Today is September 5, two
days after the promise of your final post. I am hopeful
to read the conclusion of your experiment soon.

Thank you for your honesty and for sharing your
experiences with the world. Reading what couples
therapy is actually like is just the push I needed to find
a therapist for myself and my husband. We are
committed to our relationship, but we need help
communicating.

Anyway, thank you both.

David

to Jessica & Timothy

40 Days of Dating is
easily. Makes me u

Thank you ▢

Cassie

to Jessica & Timothy

I started following '4
There are so many
stirred up for me in t
though I also feel kir
telling you this and s
it's really important,
your project. I'm also
notes from people te
way. So why am I si

The simple answer i
completely good wa
overwhelmed with g
for me to tell you this
ones who will end u
hope you are!). Your
commitment to these
to witness, and I am

Thank you.Thank yc
friendship, about co
of yourself and your
you for making me r
around relationships
shying away from m
allowing me to strug
right along with you.
you for your vulnera
and artistry and atte
inviting me (and the
engaging me, and fc

The world needs mc
I've only witnessed t
you're both beautiful
I wish all the best fo

Couldn't stop watchi

Chad

to Jessica & Timothy

Tim and Jessica, I s
because I am thinkir
single guy. I have re
websites about bein
This was the only pr
exactly know why bu
tremendous pathos
really rooting for Tim
relate to and see ma
and some I still do in
are all on our own pa
order to gain oursel
heart broke as the re
felt Jessica's pain as
The strange thing at
person that doesn't
them but we also ha
the loss.

To Jessie ▢

Dave

to Jessica & Timoth

Speaking as someo
many times) what de
lists on what makes
it's clear to me that



il project in the world,
rrorism.

ating' on Day 10.
t you both have
ral weeks, and
d voyeuristic even
this email, I also think
one of the points of
e gotten millions of
ilar things along the
iting this?

overwhelmed - in a
roject. And I am
it's really important
ou are actually the
s email or not (but I
lnerability, and
ve been so inspiring
teful to you both.

g me about love and
, and how to take care
relationship. Thank
of my assumptions
ess. Thank you for not
truggles public, and
about my own life
or your bravery. Thank
you for your creativity
il. Thank you for
) in, for deeply
e think.

ke this. Even though
p of your lives, I think
eative individuals, and
.

ss your website
a blog on being a
blogs and different
nhood, dating etc.
ly moved me. I don't
ecause there was a
ment for me. I was
reakthrough. I can
ave done in the past
empathetic that we
lose a lot in life in
ain. However, my
rumbled so quickly. I
ationship didn't work,
d dating is each
es part of us with
tunity to learn from

ws first hand (and
Reading your parents
l lasting partnership
the same page. Heading

Cathy

to Jessica & Timothy

Hi Jessica and Tim,

My Dad was rediagnosed with cancer almost exactly a year ago. It's his third time around so there are no treatment options available. This time last year we didn't think he would make it to Christmas, he was declining rapidly and had lost interest in everything. He was given 1-18 months to live.

My Dad is a retired physics professor turned photographer. As a scientist he makes a project out of everything. He's done studies on which way really is the right way to hang the toilet paper roll and has proven the earth is flat.

My Dad without a project is not someone I recognize. The last year has been up and down. He was doing great at Christmas (wrote three books and learned sign language) and poorly this spring. My sister introduced him to your website in August and he quickly became obsessed. He's a closet romantic minus the closet. He reads Pride and Prejudice once a year and much prefers When Harry Met Sally to any action movie.

Needless to say he fell in love with you guys. He fell in love with your honesty and your story. He woke up and became more alive than I've seen him in months. When you took your break, his obsession drove him to create his own website, tracking all the places you went on your dates. He's housebound these days so it was a chance for him to "travel" to NYC and live vicariously.

He tinkers with his site almost every day, adding links to interviews and articles now that the project is over. When I mentioned to him that I posted it on facebook and it got 10 likes, he quickly signed up for his own account and is now taking and posting a photograph every day after not taking pictures for months. He's of course also posting anything he can find about 40DoD.

This is all to say THANK YOU! I can't tell you how wonderful it's been to see my dad engaged and alive again. You've inspired him to live, literally. I think you're both brave and beautiful for sharing your story.

All the best to you both

...

How do you do this?

Chris

to Jessica & Timothy

Hello Timothy (and Jessica),

Thanks for this very very interesting project, I love to read it. But I'm always totally shocked when I read stories like yours, because I feel like the most ugly, most stupid and most boring person on the planet then. How the hell is it possible to have 65+ dates in your life ? How do people do this? How for god's sake is it possible to even have 3 dates a week? Absolutely no offending, I say this with a large amount of respect and envy.

I'm trying to find ONE date for more than 15 years now. I had 2 in my entire life. Most of my friends are in similar situations. I'm an architect (and developer), working in nightclubs, deeply involved in the Berlin club scene, going to concerts, raves and parties a lot. Working out, no mental or physical diseases, not shy, not arrogant, with a healthy level of self-reflection. From a neutral point-of-view, that's definitely not how a typical "loser" looks and lives like.

I've focused my life on having a date. My last girlfriend is 8 years ago, my last date 5 years, my last sex 8 years. The point is, I really cannot understand how people have dates so easily, so intentionally, so regular and in such an extremely large amount.

to Jessica & Timothy

Hi, I'm a married guy with two kids. Your story was simultaneously raw and wonderful, real and sublime. I don't know either of you personally, but if I was your friend, I would encourage you guys to try to make it work and get married. It's not always fun-- that transcendent 'I'm-so-in-love-it-hurts' feeling comes and goes. But the bond of marital commitment holds you together.

Being together with another human being exposes flaws without a doubt. But love enables you to stay with someone despite those flaws. And marriage teaches couples that love, while it often involves deep feelings, also involves choosing not to act on selfish feelings for the betterment of the other and the longevity of the relationship.

But alas, you both will do what you want. I just hope you will want to be together. Then again I'm one of those lame people who only likes stories with happy endings.

...

This is not okay

Girl please

to Jessica & Timothy

What... hold up... no. You can't just end it like that! It's called "40 Days of Dating" not, "40 Posts Then We Leave You With Nothing But Wonder". Listen you opened up your lives for the public, it's only the truth. I know lives, so it's not weird that I want to know what happens next.

It's really simple, you just say if you two worked out. That's all. To be honest I was rooting for you the entire time. Sometimes it hurt my brain how difficult you guys were being, but I couldn't stop reading. You started this, finish it damn it! ...Please... :)

...

Hi

Jeff

to Jessica & Timothy

Hi Guys,

I have no confidence that your dating will develop into a relationship with one another, but I love that you're taking this on and giving it a shot. I didn't marry until I was 43. And while I enjoyed dating, for the same reasons Tim seems to enjoy dating, it did get to the point where all of my friends were married and I began to wonder whether I would find the right person. So I guess I'm saying I can totally relate to both of you. And all I will say is, when you meet the RIGHT person, the stars will align, everything will be cool, the silliness will be over, and you'll know it's the right person.

...

From an Enraptured Reader

Tia

to Jessica & Timothy

Hi, I'm from Indonesia, I have read the 40 Days of Dating. I am really, really curious about what you are up to nowadays. I think you two are so matching. Like spoon and fork, left hand and right hand, left shoe and right shoe...

...

I want to try

Andrew

to Jessica & Timothy

Hi. I was wondering if I could get the daily questionnaire so I could try out this little experiment

JW:

texts, dozens of emails in the middle of the night, and frustrating phone calls between us. I told him that if we couldn't work together professionally, I was going to have to quit the project. I won't let a blog ruin my life or our friendship. He wrote back suggesting that we go to therapy again. As crazy as it sounds, I am willing to try anything if it makes things right between us. We made an appointment for a few weeks later.

August 3, 2013: Things are more strained with Tim. There is so much pressure between my work and the blog and finding time for Zak, and Tim makes me feel so guilty that I can't do more. Agents have been pursuing us because of the blog, and we are trying to decide who to go with. We do not see eye-to-eye about certain things, and we're still having constant communication breakdowns. I woke up in a sudden panic at 4:00 A.M. and I couldn't breathe. I felt like everything was out of control and falling apart. Zak calmed me down, and helped me slow my breathing, but my mind wouldn't stop racing. I changed into my running clothes and went running up and down the West Side Highway for five hours. Five hours. I've never run so far or for so long in my life. I wanted to wear myself out to the point that there was no energy left for worry or stress.

August 4, 2013: Zak was worried about my panic attack, so he booked us a room at the Standard Hotel for the weekend. Being with him was just the calm I needed to unwind and relax, away from the pressures with Tim, the lawyers, and the media. Every experience we have together continues to come with such ease and joy, and the relationship continues to get better with each day. Like me, Zak is a kid at heart: We had lots of silly moments that weekend, like romping around the hotel wearing fake moustaches and ridiculous outfits, and spontaneously dancing in the middle of the lobby.

TG:

walking down the street tonight, and this girl from inside a restaurant sees me and runs out of the restaurant to talk to me. She was frantic, out of breath, and very excited. We took a photo together. Is this real life? I had a coffee date with a girl last Saturday, and we were walking around Williamsburg enjoying the wonderful weather. She wanted to stop by her apartment to pick something up. While I was waiting outside for her, I casually checked Twitter. I saw three different people tweet that "Dude from 40 Days of Dating is on a date in Williamsburg!" I freaked out and made us jump in a cab immediately.

Conley Spotted Tim (the dude from 40 Days of Dating project) with another chick. Now we all know that experiment didn't work.	**Rodrigo** Omg! Street sighting of @jessicawalsh and @timothyogoodman. Doh! I should've said hello. #fail
Maryellen I saw him in Gramercy on Saturday. This is my creeper shot:	**Selena** Spotted: @timothyogoodman of #40daysofdating
Angela Totally just saw the guy from 40 Days of Dating come out of a (his?) apartment in the city lol	**Tiffany** Just peeped the 40 Days of Dating guy hailing a cab on 7th Avenue. He's much taller in person!

Some people want relationship advice from us. Yesterday, some girl stopped me on the street by Union Square, told me all about her current relationship, and asked for my opinion. I find this particularly funny, because the very reason Jessie and I did this experiment was because we're bad at relationships! Yet, now, people see us as some sort of "experts" on the matter.

September 6, 2013: About a month ago we signed with the talent agency, CAA, but since we're not in show business, everything has been completely new territory for us. We're not sure who to trust or what advice to follow. We've been learning on the fly. Thank goodness we have each other. Things have been going much smoother for us since we went to therapy. Even though we can still piss each other off, we're miles ahead of where we were a couple weeks ago. It's been really nice. Anyway, we've made a couple trips out to LA recently, and we went back out there this past week for meetings. Our agents put us on this crazy ten-hour-a-day schedule full of meetings, coffees, and dinners with all kinds of people in Hollywood. We're not quite sure if we want to turn 40 Days into a movie or a TV series, so this was extremely important. We got to meet some of the most amazing people in Hollywood this week. I'm not going to rattle off all the names, but I want to say that Kristen Bell and her friend/writing partner, Laura Moses, are so cool, and some of the most fun and down-to-earth people I've met. Also,

Tim called and became angry when he found out I was at the Standard with Zak. He couldn't believe I was taking the weekend off when we had so much to do. I know it's unfair of me when he is doing so much, but I tried to explain to him that I needed a break for my own sanity.

August 5, 2013: Today, Zak and I sat on the rooftop of the hotel overlooking the New York skyline. I was telling him the most embarrassing story from my past, and he stopped me mid-sentence and told me he was in love with me. I couldn't wait to say it back. It's hard to put into words my feelings for him; I am not even sure there are words for those feelings. If there are, I certainly could not say it in a concise way. The best I can come up with is that it feels like we share a secret, like we understand each other in a way that no one else does. We see the world in a way that no one else sees it. Everything in life seems possible with him, like we could take on the world as long as we are together. He gives each new day so much excitement and meaning and joy.

August 12, 2013: Tim and I agreed to be in Los Angeles today to meet with a production studio about making a TV show based on our experiment. We also were meeting with potential agents who would represent us for film and book deals. I wanted to leave a day early since Zak was already there filming a movie, and I hadn't seen him in a week. When I mentioned taking an earlier flight to see Zak, Tim flipped out on me. He cringes every time I say his name. He said the only reason I wanted to go to LA was to see Zak, and that I didn't care about him or the experiment any longer. That is so hurtful to hear. Everything is so complicated now, and I wish Tim would cut me a little slack. I try not to mention Zak, but it's difficult to never mention someone who is a huge part of my life. I wish this hadn't gotten so messy.

August 16, 2013: These past few weeks have been a complete whirlwind. Tim and I have been nonstop in interviews, photo shoots, meetings, and magazines.

TG:

we had drinks with Zooey Deschanel yesterday. Of all the people we've met in Hollywood so far, I must admit that I was most excited to meet her. I've literally been listening to the new She & Him album all summer. Because of the nature of this project, everyone naturally opens up to us about their personal relationship histories. It's been very humbling to hear this from fans of the project, but it's been utterly fascinating to hear stories from people we consider "stars." It's amazing to create something that so many people, from so many walks of life, can relate to. It reminds me of this quote from the French painter Françoise Gilot: "I've never believed in doing work for 'the happy few.' I've always felt that painting must awaken something even in the man who doesn't ordinarily look at pictures, just as in Molière there is always something to make the very intelligent person laugh and also the person who understands nothing. In Shakespeare, too. And in my work, just as in Shakespeare, there are often burlesque things and relatively vulgar things. In that way I reach everybody."

NIKKI J + ME

VENICE

WARNER BROS.

September 9, 2013: Jessie and I were live on the *TODAY* show this morning. There are no words for Matt Lauer. On Friday, we posted Day Forty on the blog, and I believe we had over 300,000 hits. All I remember is being in the green room, sitting next to CeeLo Green with a pound of makeup on my face and having Jessie say to me, "You need to do all the talking because I'm blacking out right now." Ha! After the show, I got calls and emails from the most random people: neighbors, friends' sisters, old lovers, old neighbors, you name it. I haven't heard from some of these people in twenty years! Also, Jessie's boyfriend is not happy with me. While we were doing the show, they asked us to hang out on a couch for ten seconds while they filmed us then cut to a commercial. Jessie was extremely nervous, so I told her that I'd be stupid and try to make her laugh and make her feel better. So I said something like "Oh, baby, you look so hot right now," and as it turned out, unbeknownst to me, the mic was on. Anyone who

It's crazy and humbling that our little blog is being read by millions of people around the world. I have mixed feelings about all the press and attention. In part, I am thrilled that our project has reached and touched so many people. It's unbelievable to read some of the letters our readers send us and see how it's changed their lives. Some people say that our project inspired them to make positive changes in their own relationships, inspired them to seek therapy, or inspired them to date that friend they were always curious about. At the same time, I am overwhelmed. The other day I was recognized by strangers six times in SoHo.

ELLE GIRL SHOOT

I was stressed about it and went to the gym, where a girl tweeted that she was "working out across from the forty days of dating girl." Another person tweeted that that he saw me with Zak and that I was "cheating on Tim." I never realized how much I value my privacy until now.

Sorry

Tim
to Jessica

You're not going to like this, but I have to admit that it burns me that I was an idiot at the end of the experiment and didn't try to date you after the project ended. I just move slow. I moved way too slow.

TG:

knows me knows that I'm always messing around, and I'm always innocently flirting. I meant nothing by it! Anyway, I wouldn't blame Zak for being upset or suspicious of me, but it was only a joke.

@ NBC TODAY SHOW

September 12, 2013: I'd be remiss if I was anything but appreciative, but since we were on *TODAY* a couple days ago, I've been feeling increasingly down about everything. It's been such an unreal high the last two months: All the attention Jessie and I have received has made this the most profound and exhilarating time in my life. We're still getting hundreds of messages from people. Some write us novels about their personal lives and their relationship history, and some are asking for advice on their own relationships.

Today I decided to answer this random girl's Facebook message. She's going through a difficult time in her relationship, and she wanted advice. I'm not one to shy away, so I gave her some advice! But by connecting with her, I felt like I was working on my own relationship questions post-experiment. We're all going through the same thing in different ways, no matter who we are.

> **Laura** 9/11, 10:41am
> Can I ask you a question. Has it been difficult going from being in a relationship with Jessica to just being friends with her? I am going through this transition right now and I was wondering if you have any advice for me?

JW:

August 18, 2013: Tim emailed me this morning and I didn't know what to write back. He knows I love Zak, and I wish he had more respect for that. I hope he meets an amazing girl soon, someone who makes him realize how wrong we were for each other. I don't want there to be any resentment or jealousy or disappointed feelings. I want him to be happy.

August 22, 2013: Today we had a session with the therapist we went to during the experiment. Tim said he thinks I am angry because he "rejected me" in Disney World. Rejection is the last thing I feel right now: I feel like I dodged a bullet. I didn't tell him that, though. I admitted that while it's true I may have tried dating Tim again if I hadn't met Zak, I still didn't think it would have worked out between us. We also talked about my frustration over his declaration of "love" for me a few weeks ago. It hurts me, because I am in a loving relationship with someone else, and I wish he could accept it and be happy for me. I just want to mend things with him. I have to remember that we are under extraordinary pressures in utterly unique, some might even say bizarre, circumstances. We need to stay strong, support each other, and work together as a team.

August 24, 2013: I was up last night until 4 A.M. working because I knew I had a long day of important work meetings and deadlines ahead. I had so much to wrap up and accomplish before I left on a four-day trip to India that Zak and I have had planned for a while now. But everything was instantly put into per-spective when I was awakened by a 6:00 A.M. phone call from my mother with news that my grandmother had passed away. I canceled the meetings and the trip and grabbed a cab uptown to my parents' apartment.

TG:

Timothy 9/11, 12:58pm
Hello. Well, we were great friends first, and that has helped. While there's been some awkwardness at times, it hasn't been so bad. Also, obviously we only 'dated' for 40 days (really only 20 days of being physical). However, things can get very complicated and lines do get blurred. So many layers! You're not alone, it's never easy. After a while, sometimes you have to make a decision on whether or not being friends is possible, too. That's happened to me before in my past relationships, especially if I date someone for a long time.

Laura 9/11, 1:24pm
Yeah, we have been inseparable friends for a couple of years. Last year, when I was in Africa, I felt this huge void being away from him. Shortly after I came home our feelings continued developing. After six months of playing the possible outcomes, we decided to take the risk. We dated for 10 months, and we broke up two weeks ago. It's just difficult because we have years of art work that we created together, years of playlists, years of traveling, years of highs and lows, yet I cannot sit in a room with him without feeling this huge weight. He just wants to be friends now. Last month we were shopping for an apartment together, and now I can't even look at him.

Timothy 9/11, 1:26pm
So he broke it off?

Laura 9/11, 1:34pm
Yeah. It was 100% unexpected. We got into an argument, he pushed me out of his room (he has NEVER been aggressive in any way prior to this). Then he got his stuff and left. I should have just let him go, but instead I followed him out and said, "I am not angry with you, but don't ever touch me like that again." He replied, "We're done," and drove away. The next day he apologized for what happened and said he was angry with himself. He also said that he doesn't deserve me

Timothy 9/11, 1:38pm
Wow. That's unfortunate. He should NOT be touching you, no matter how angry he is! And yes, he is right, he does NOT deserve you. You really want him back, huh?

Laura 9/11, 1:45pm
Wow, nobody has actually said that to me yet. I mean, I have only talked to four people about this. Yeah, I do want him back, but part of me wonders if I will be happier moving on. I don't want to be one of those people who just gets sucked back into a relationship because it's more comfortable than having to start over.

Timothy 9/11, 1:49pm
No doubt it's tough. I think whatever you do, just make sure you're responding and not reacting. It's easy to get comfortable. Take your time, please.

BEWARE
WOMEN GROWN
OLD
WHO WERE
NEVER
ANYTHING BUT
YOUNG

– CHARLES BUKOWSKI

JW:

My grandmother had been sick for many years, so my emotions were mixed between sadness and relief that she is free from her pain. I spent the day with my family reflecting on memories of her. My mom told us how my grandma was a bit of a rebel growing up: always wearing red lipstick to school against her mom's wishes, marrying a Jewish boy (she was Italian), and working outside the home—all unusual in the 1950s. She loved the simple things in life: friends, wine, fashion, and socializing. But most of all she loved her family and always tried to make us happy. Whenever I told Grandma about a guy I was seeing, she'd ask me, "Jessie, is he the one? When are you going to get married? When are you going to give us great-grandkids?" I'd say, "No, Grandma, you don't understand; I'm way too young." A few weeks ago when I visited her, I had felt an unexpected and sudden urge to tell her I had found an amazing man who I loved and thought I might want a future with. It was too late, though. Her dementia was so bad that she didn't even know who I was. Times like these are a reminder of how fleeting life is and how quickly things can change. Nothing is permanent. Everything changes, evolves, and eventually dies. Impermanence can be a beautiful thing—it reminds you how precious and meaningful life is.

Dearst Jessie — 5/31/08

You've got to find what you love. And that is as true for your work as it is for your lovers. Your work is going to fill a large part of your life, and the only way to be truly satisfied is to do what you believe is great work. And the only way to do great work is to love what you do. If you haven't found it yet, keep looking. Don't settle. As with all matters of the heart, you'll know when you find it. And, like any great relationship, it just gets better and better as the years roll on. So keep looking until you find it. Don't settle.

Love always & forever
Mom & Dad

I was going through old photos of my grandma when I stumbled across a card my parents gave me six years ago at graduation. My mom had written me a long letter filled with wisdom. She quoted Steve Jobs, who said, "Our time

TG:

September 18, 2013: It's official: We agreed to a film deal with Warner Brothers! We're crazy excited to finally make a decision after a month of meetings and Hollywood courting. This is just bananas. The amazingly talented and very cool Lorene Scafaria will be adapting the story into a screenplay. I still can't believe that our little project, with no budget, no publicist, and only a wish to share our story, has gotten to this point. We're also about to land a book deal with Abrams very soon. Pinching myself!

September 28, 2013: Since the beginning, there has been a good amount of hate expressed toward us and this project, which is predictable, I guess. I'd say that most of the comments, about 75 percent, have been positive. I get it, because launching something so personal and controversial will inevitably bring the haters. We put our love lives out there, so in a way, we asked for this. But reading awful comments from strangers on CNN or in *Time* magazine is one thing. Hate coming from peers in my own industry—people I know, people I've had drinks with—is another thing. Obviously, it hurts. To me, 40 Days of Dating is so much more than just a design project. Thinking only as designers would have limited the project. As designers, we are able to tell great and memorable stories; we have the tools to use our lives as catalysts to connect with people of all walks of life, all over the world. That little kid in St. Louis is excited when he opens his new *Nike* package, or his new iPhone, just like that girl in Minnesota who is touched by our 40 Days story and after reading it feels like she has the courage to tackle her own relationship fears. This is what we can do with design. We have voices, and Jessie and I chose to use ours in a different way. We created this from the ground up, with no publicist, no budget, and no real motive beyond telling our story in a meaningful way. It was a huge risk, both professionally and personally. I think we should all use our voices and our talents to have a larger dialogue, to show the world new ways to think about life.

October 12, 2013: Jessie and I were invited to the premiere of the Spike Jonze movie *Her*. I was super excited about this. After the premiere, we went to the after-party at the Standard Hotel. Jessie got drunk and ended up telling me, like she always does, that she thinks I'm crazy. We shared a couple of nice

is limited, so don't waste it. You've got to find what you love. That is as true for work as it is for your lover. The only way to be truly satisfied is to love what you do. If you haven't found it yet, keep looking, don't settle. As with all matters of the heart, you'll know when you find it, and like any great relationship, it just gets better and better as the years roll on." In that same speech, he said that knowing you will die someday is the most important decision-making tool, as almost all external expectations, all pride, all fear of embarrassment or failure—these things just fall away in the face of death. It shows you what is truly important. As complicated as we often make life out to be, I sometimes think it's rather simple: Find what makes you happy, and who makes you happy. My grandmother had found happiness and love with my late grandfather. Her passing, and going through all these emotions, makes me deeply cherish and appreciate the love I have with Zak, great family, and friends like Tim.

at PARAMOUNT PICTURES

September 9, 2013: Tim and I flew to Los Angeles last week to meet with all the possible movie and TV producers. We were in back-to-back meetings all day with famous writers, producers, and movie stars. The experience was so surreal. I couldn't believe so many people in Hollywood knew us and cared about our project. It was fascinating to get a peek inside this industry that I had always been curious about, and I was genuinely impressed by how nice and sincere everyone seemed. Tim and I have been getting along much better since our therapy session with Jocelyn, so I was finally able to take in, enjoy, and appreciate these remarkable experiences.

TG:

moments, and I was reminded of why I love Jessie as a friend so much. As much as we drive each other crazy sometimes, and as much as I'm now sure it would never work out between us, we still have an undeniable connection. I mean, what we've gone through together is not natural, and we've pretty much worn every label two people can possibly wear: friends, lovers, exes, creative partners, and now business partners who are going through the insanity of this all together. It's kind of amazing, actually.

October 15, 2013: Since the random hookup in LA, I've been on very good behavior as far as women go. I've gone on plenty of dates and had some nice times, but I haven't been leading anyone on. I'm sincerely trying to meet someone I can connect with. A couple of weeks ago I met an LA girl who was in NYC for work. We hung out for the entire week. I really liked her. I made plans to go out to LA and visit her this weekend. Everything was set, plane trips were booked, and I was excited. But only days before my flight out, she canceled on me. Apparently she decided to get serious with a guy she's been seeing on and off for the last couple months. I'm pretty shocked by this rejection. Another girl that I had a couple of good dates with turned out to have dated a good friend of mine a couple years ago, and he's still very much hung up on her. He told me that he'd have a problem with it if I dated her. I have no interest in damaging our friendship, so I'm walking away from this one.

November 12, 2013: Jessie is moving in with her boyfriend. I was just telling someone how Jessie has learned to slow down in relationships because of the experiment. Well, I guess not. As long as she's happy. Jessie and I had coffee today, and she broke the news that I'm not invited to her housewarming party. At first, I understood. They're starting a life together, and they want some space. The next day it began to bother me. Aren't there other options, like asking me to bring a date? As much as I understand, it still hurts. Jessie was sweet and ended up apologizing to me a few days later.

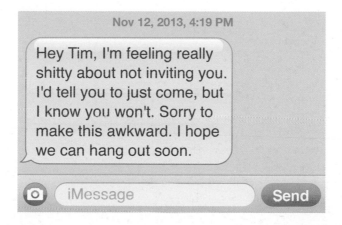

Nov 12, 2013, 4:19 PM

Hey Tim, I'm feeling really shitty about not inviting you. I'd tell you to just come, but I know you won't. Sorry to make this awkward. I hope we can hang out soon.

JW:

We flew back to New York yesterday morning and appeared on the *TODAY* show. Before our segment, they filmed a quick preview of us. Tim didn't realize his microphone was on, and he leaned in toward me and said, "Oh baby, you look so hot right now." They aired the clip with the audio for everyone to hear, including Zak, who was watching from Los Angeles. He called me and sounded a little sad. He told me it was heartbreaking to hear this from an ex-boyfriend of mine, on national television no less, but he trusts me. Zak has put up with this project and has been amazing. It can't be easy for him to be with me while I'm posting intimate details online about a past, but still very recent, relationship. But we talked again today and he was already completely over it. This is one of the thousand things I love about this man.

While I felt bad pretty bad for Zak, I also felt terrible for Tim. Tim had only been joking, but the media didn't see it that way. There were articles afterward calling him a "sleazy douche bag," which is clearly not true, and I can see how much it hurts him. It has always perplexed me: Why do people love to hate and feed off other people's slip-ups and failures? It reminds me of this quote: "Promote what you love, instead of bashing what you hate."

September 17, 2013: After weeks of calls with various producers and studios who have been interested in turning our story into a movie or television series, we finalized a film deal with Warner Brothers out in LA. We have a talented writer, director, and production company on board. We're going to help consult and take a first stab at doing some of the graphics for the movie. I can't wait to see how it all pans out.

After the deal was finalized, Tim and I met up at the Soho House for celebratory drinks. Ever since the stress of posting the blog online, and the arguments we had over our entries, Tim and I have become close again. It feels great to

TG:

November 20, 2013: Okay, I think I've gone on a downward spiral to my old ways since I was rejected last month. On the one hand, I'm not leading anyone on, nor am I "dating" multiple people at the same time. But I am meeting a lot of different women right now, going out on many dates, having fun and sometimes being intimate, but usually always feeling disappointed. Here's what my current dating life looks like:

1. Last month, Jessie and I were in LA having dinner with our agents. We headed over to the Palihouse for some drinks afterward. Jessie was tipsy from her usual three drinks, and I ended up hitting it off with our waitress. She had dirty-blonde hair, and oddly, she was wearing a Denver Broncos pin. I'm no big football fan, but I made a few comments about Peyton Manning, and the next thing I knew I was leaving with her phone number. I was amazed by how flirty she was with me in front of Jessie—for all she knew, Jessie could have been my girlfriend. We went out the next night and had a lot of fun.

2. A couple of weeks ago, I was out on a third date with a woman I met at a birthday party, and she said to me, "To be creative is to be fearless. There are women who will take care of you and there are women who will inspire you. Rarely will they be both. I want to be your muse." I knew it was over then.

3. I met a very pretty woman at an industry event, we met up for drinks later that night, and she came back to my place. We went out again a week later, but she was one of these super soft-talkers and it was driving me bonkers. I literally had to ask her the same question three times to finally understand what she

find
WHAT
and
WHO makes you
HAPPY

JW:

have my friend back. Zak joined us for a few drinks, which was also a big event. It was the first time they have met. I want them to get to know each other, but neither has seemed too excited by the prospect. It would mean the world to me if they could at least tolerate each other, and who knows, maybe one day we could all hang out as friends.

October 12, 2013: Tim and I went to the premiere of *Her* by Spike Jonze. It was one of the best movies I've seen all year: It was touching, emotional, and beautifully shot. At one point Joaquin Phoenix's character says, "I've been sitting here thinking about all the things I wanted to apologize to you for. All the pain we caused each other. Everything I put on you. Everything I needed you to be or needed you to say. I'm sorry for that. I'll always love you and you helped make me who I am. I just wanted you to know there will be a piece of you in me always, and I'm grateful for that. You're my friend to the end."

I looked right at Tim during this moment. It sums up pretty well how I feel. I do feel in a large way that the experiment and experiences we've been through have changed me and helped shape who I am. I feel sorry for all the pain we caused each other when we got caught up in all the media attention. What we went through was crazy and complicated, but that's life. I feel lucky we stuck together through it all, and came out of it even closer as friends.

October 18, 2013: I've been visiting Zak every weekend in Los Angeles this past month. I take the late-night flight from JFK out to LA on Friday nights and return on the red-eye on Sundays. It's been tiring, but every moment with him makes it worth it. I promised to make him a love letter for every day we spend apart. We both travel often for work, so there will always be a lot of time spent apart in our relationship. Quite ironically, today I finished his fortieth letter. Oh, the crazy things we do for love.

TG:

was saying. And she was a big fan of 40 Days of Dating, talked about it way too much, and ultimately that was a big turnoff.

4. I recently started hanging out with Alma. She has no interest in being serious with me, she's dating other men, and she's generally into the idea of us just using each other physically. I've never met anyone with that name, and I can't help but think of that chapter "Alma" in Junot Díaz's incredible book *This Is How You Lose Her*. The ending goes like this: "Instead of lowering your head and copping to it like a man, you pick up the journal as one might hold a baby's beshatted diaper, as one might pinch a recently be-nutted condom. You glance at the offending passages. Then you look at her and smile a smile your dissembling face will remember until the day you die. Baby, you say, baby, this is part of my novel. This is how you lose her."

5. Today, I met an absolutely gorgeous woman for coffee. She's one of those women who makes you look at yourself and think, "Damn I'm ugly." She lives in LA, and we first met on Facebook months ago. We've been periodically chatting online ever since, and she was in NYC for the weekend to see her family, who live here. We met at a coffee shop in SoHo. Apparently, some guy there recognized me and did a play-by-play convo on Twitter about my encounter with her. I only know about this because he messaged me later in the day saying, "Great to see you in action, playa!" Wow. Pretty scary, but admittedly I thought it was funny. Meta on meta on meta on meta.

> **Double**
> @missmorgan100 The guy from 40 Days of Dating is at the same coffee shop as me.

> **Morgan**
> @doubleduez WHATT. Alone...?

> **Morgan**
> @doubleduez Ahahahahaha. My god, it is him!

> **Double**
> @missmorgan100 Actually, he looks like he's meeting someone here. I'm gonna watch.

> **Double**
> @missmorgan100 And she's gorgeous.

> **Double**
> @missmorgan100 I wanted to say "appreciate your work, Bro" but I was afraid of salting his game. Haha!

Tim was also supposed to come out to Los Angeles this weekend to visit a love interest. He's been pretty excited about this girl who lives out here. The other night, she canceled on him. I felt pretty terrible about it, so I changed my tickets to fly into LA earlier with him. We had lunch and then a nice dinner, and we enjoyed a few drinks afterward at one of our favorite spots, the Palihouse. Tim managed to pick up our waitress and secure a date with her the next night! It continues to impress me how easy it is for him to pick up girls.

The weekend was full of amazing experiences with Zak. He had had a tough week at work so I wanted to surprise him with a little getaway. I rented an Airbnb apartment for a night in the Hollywood Hills. Zak had the silly idea that I should try to hike up to the Hollywood sign. What a disaster! The hill going up to it is never-ending and only gets steeper and steeper. I was stubborn and kept wanting to climb, until we realized there were helicopters all around us and a guy on a loudspeaker was telling us we were trespassing and could be arrested! We hid from the cop cars, snuck into our car, and drove off. He told me this weekend that he hopes to spend his life with me. I was a little taken aback, but I have been feeling the same.

November 1, 2013: Things have been going so well with Zak that we sponta-neously decided to live together. We moved in today. We both lived in studio apartments, and we'd been talking for months about the dream of one day having a separate bedroom, so we looked in Brooklyn, where you can get more space for your money. Plus it's filled with artists and creative types and some of my favorite restaurants and shops. We ultimately found an amazing place in Williamsburg, where almost all my friends live. Now the only friend I have left in Manhattan is Tim.

PHOTO BOOTH at PARK AVENUE ARMORY

TG:

> **Morgan**
> @doubleduez Wait, that's spectacular. (!!) Also, so was she... how does he do it?

> **Double**
> @missmorgan100 Do what?

> **Morgan**
> @doubleduez Get all these beautiful women!

> **Double**
> @missmorgan100 I heard a "nice to meet you". So...Tinder?

> **Morgan**
> @doubleduez Ooooo...or a set-up?

> **Double**
> @missmorgan100 Yea, perhaps. He was definitely meeting her here. I was about to leave but now spying.

> **Double**
> @missmorgan100 He's disheveled and energetic, a distant gaze but focused on the conversation. Animated and devoid of his phone. She's grasping her phone, involved in the convo but not animated, distant, yet accepting. Great physical poise.

> **Morgan**
> @doubleduez Hmmm. He's good at this, I'd say the interest isn't necessarily quite genuine. Her, well...don't you think she googled him?

> **Double**
> @missmorgan100 She teases her hair and still texts. He seems bothered but focused on meeting up later, after her dinner plans. He's still good looking, interesting, successful and charming. I never google a girl, do people do that?

> **Double**
> @missmorgan100 The point when he asked about after dinner changed it all. She put her phone away and started chasing and he seems to not care. That was his move.

December 19, 2013: Tim and I met with one of the producers of our movie at the Bryant Park Hotel. Afterward we went to Lady M and had some green tea cake and talked about life and love. It was just like old times when we'd do our weekly catch-ups after teaching classes at SVA. Tim seems a little upset with himself that he is still messing around with several different women, and frustrated that he hasn't found a great girl who holds his interest. I'm proud of him because he seems to be making an honest effort to be more careful about his actions. I told him to go easier on himself. As long as he is being honest with these women about his intentions, he's not doing anything wrong. But it seems that, more than ever, he really craves meeting an amazing girl who blows him away. Tim also talked about wanting to be a father someday soon. Tim's talked about this before, and I always told him he was crazy! Life is complicated enough as it is, and I have never had a strong desire to be a mother. Well, as we were talking about it, I suddenly realized how much my perspective on this subject has changed. I guess being with Zak has brought out some sort of maternal instinct in me. I am actually starting to think I might want a family one day.

December 23, 2013: I can't believe where the time has gone. It's been over seven months since I met Zak. Our love has matured; the passionate "honeymoon" phase is over. I knew this would happen, because it happens in every relationship. I read an article about scientific studies that show that passionate love usually only lasts during the first six months, when our brain is releasing dopamine. When those dopamine levels taper off, many relationships start to go downhill. You start to feel like the other person is not making you as happy as they once did. But it's not our partners who have changed; it's us. We're just not as happy as we used to be when the dopamine was high. This lower state allows us to become more bothered by the other person's flaws, and everything begins to feel more routine.

I've experienced this all too many times in the past. But with Zak, it feels entirely different. I've certainly come down from the "love high," but my affection and love for him still grow. As our lives become more intertwined, I realize more and more with each passing day that he's my ultimate companion. No matter where in the world we are together, with him it always feels like home.

For his birthday I decided to surprise Zak with a getaway to Tulum because it's where we first started falling in love. Without revealing anything at all, I was going to whisk him away in a cab to JFK, but it didn't pan out. At the last minute he was offered a lucrative job and, still oblivious about my surprise, he took it even though he had promised not to work on his birthday. When I revealed all how the flights and hotel were already booked, he canceled. We still had an amazing trip and stayed in clay huts on a beach called Coco Coco.

January 12, 2014: Zak and I got engaged this morning, and I couldn't be happier! We've talked about spending our lives together, so while it shouldn't be a surprise, I somehow am in a bit of shock. I guess I didn't expect it to happen so soon!

TG:

> **Morgan**
> @doubleduez Wow, have I forgotten how this game works. Can't figure it out...not set up?? (And is her dinner with friends?!)

> **Double**
> @missmorgan100 I dunno. It all left me very curious. Fun to have seen him in action!

December 16, 2013: Last night I heard the best feedback I've ever received about this project: This woman I met at a Christmas party told me that after discovering that I was a mentor at Big Brothers Big Sisters on 40 Days of Dating, it inspired her to join BBBS herself. Now she's a mentor for a young girl. I was so incredibly touched by that. It's just another example of why we put this out there, and how many different ways we can connect with people as visual storytellers.

In other news, the media onslaught continues. A couple days ago we were guests on *The View!* You better believe my mom and all her friends were excited. It was nice to see Jessie, too. For the most part, things have finally calmed down between us. However, we haven't been in nearly as many meetings or done nearly as much press lately, so we haven't seen each other much lately, outside of the early stage of working on the 40 Days book. It was great to see her, and really fun to talk about the experiment again.

SELFIE W/ JENNY McCARTHY

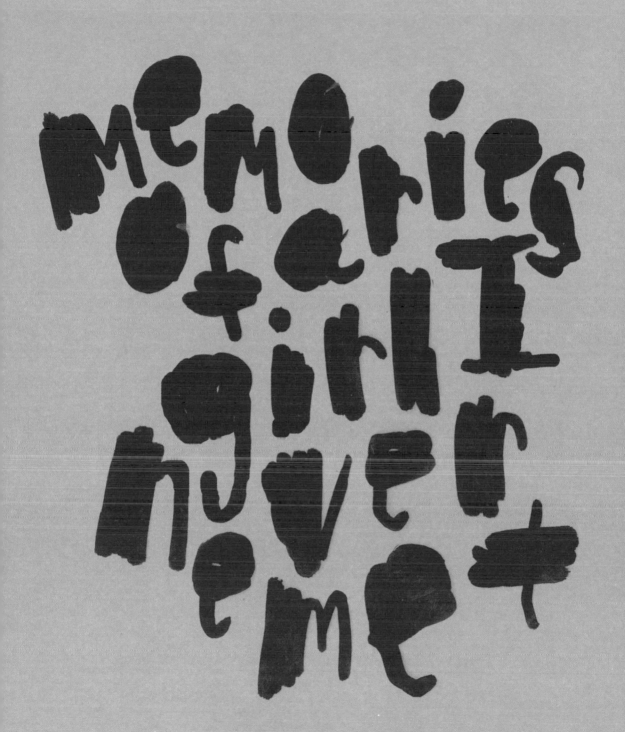

memories of a girl I never met

JW:

Right after his proposal, he had to leave for the airport for a job in Guatemala, where he'd have no cell phone service. He called me from the airport right before he had to board the plane—he wanted to tell me one last time how much he loved me. I feel like the luckiest girl on the earth, and I am glad I never gave up on my search and never settled. I am glad I did the experiment with Tim, which in many ways led me to meeting Zak. I cried for joy after that call. I just can't believe this is all actually happening to me! I texted him right after.

THE RING

January 14, 2014: To most of my friends, the engagement was not a huge surprise. My sister, who has been the harshest critic of every boyfriend I have ever had, said she knew right after she met him that he was going to marry me. He's the first guy I've dated who she loves and approves of. My parents are thrilled. The only person left to tell was Tim, and I wasn't sure how he'd react. We had plans to meet up with a group of our friends at Kingston Hall in the East Village last night. I didn't want to tell him at the same time as everyone else—I wanted to be more personal than that. When he arrived at the bar I pulled him aside, bought us a round of champagne, and told him the news. He seemed taken aback, but genuinely happy, and he gave me a big hug. Next thing we knew, Beyoncé showed up at the bar and was standing right behind us! We drank champagne and whiskey with our friends, the same group of friends we went to Miami with last December when we first came up with the idea of 40 Days of Dating. The whole crew was there: Lotta, Dan, Michael, and Maayan. We

TG:

January 14, 2014: Last night we had a reunion with our mutual design friends (all of whom were on that trip with us to Miami when we first had the idea to do the experiment). Safe to say, nothing has been the same since that trip, and it's been a long time since all of us have been together. It was nice to see everyone. We met at a little dive bar in the East Village. When I first got there, I noticed that Jessie seemed chirpy and light, which is when she's at her best. She immediately said to me, "Let's go get a drink." On our way to the bar, she told me that Zak had proposed to her the previous night and that she said yes. It seemed like she braced herself for some sort of negative comment or extreme reaction from me, but I wasn't going to do that. Did it hurt me? Yes, but not because I think Jessie and I should be together, or that I made a mistake by not staying with her. I love our friendship, and I think we both know that we don't belong together. I'm very happy for her and Zak. The next day, I still couldn't quite figure out why I felt so down about it. I was talking to my buddy Greg, and he gave me some amazing advice that put it all in perspective.

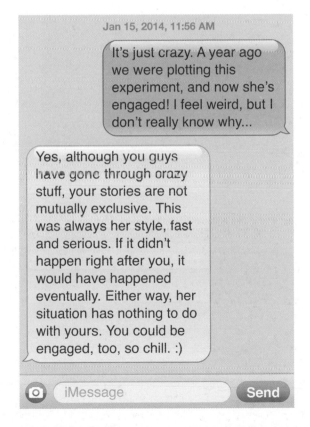

Jan 15, 2014, 11:56 AM

It's just crazy. A year ago we were plotting this experiment, and now she's engaged! I feel weird, but I don't really know why...

Yes, although you guys have gone through crazy stuff, your stories are not mutually exclusive. This was always her style, fast and serious. If it didn't happen right after you, it would have happened eventually. Either way, her situation has nothing to do with yours. You could be engaged, too, so chill. :)

iMessage Send

Basically, what it comes down to is this: I went through a deeply profound and very unique experience with Jessie, someone who I truly care about. So now she's

273

talked about how crazy this past year has been and how remarkable it is we have stayed friends through it all.

February 14, 2014: Zak was in Los Angeles today for work, so I had no Valentine's plans. He still made the day special by mailing me the sweetest letter and a planter of roses and hiring a guy with a very heavy Indian accent to sing me a Valentine's song. I couldn't understand a word of it, but it put a big smile on my face the rest of the day. In the afternoon, Tim texted, asking me if I could grab a drink after work before I left for Montreal. Some coworkers pointed out that it was strange that Tim and I were hanging out on V-day, though I didn't think much of it. I emailed Zak just to make sure he was okay with it. He sent me this reply:

There is nothing sexier than a man who doesn't get jealous.

Tim and I met up and we reminisced about everything we've been through this past year. It was a year ago that we made the final pact to do the 40 Days experiment. At that time, I was frustrated and lost and ready to give up on love and dating. Wow, how much a year can change everything. Life moves so quickly, and it's easy to fall into daily routines and just go through the motions of life. I've had months go by in a blink of an eye and I couldn't even tell you what happened. This experiment with Tim allowed us forty days out of our lives to pause and reflect. To analyze behaviors and patterns and to learn more about ourselves, dating, and love. We took a huge risk together, and while our romantic relationship didn't work out, the experiment was a success.

They say everyone you date is either a blessing or a lesson, and I think Tim was both. While at times we drove each other nuts, we challenged each other in ways that most friends never have the courage to do. The experiment made us more self-aware and stronger. Seeing how we interpreted the same experiences so differently was enlightening. No matter how clear we think we are in our words, it's almost impossible to know exactly how someone is feeling or what they are thinking or how they will perceive us. This has given me more empathy and patience, and has helped me stop overanalyzing situations. The experiment also helped me focus on what I wanted and it gave me confidence and clarity, and shortly afterward, I met Zak. Coincidence? Fate? Who knows. Life is kind of crazy like that.

TG:

going on to marry someone, and naturally I feel a bit envious. I automatically felt like I should be in love and getting married, too. However, I have to remember that we're on different paths, and that this is her path. For good or bad, she moves quickly and it is what it is. As complex as Jessie is, she's quite simple when it comes to matters of the heart—more so than I am. I have my own path, and this isn't some competition. Things will happen as they happen for me.

Thirty minutes later, randomly, Beyoncé shows up at the bar we're at! Queen Bey was straight chillin', martini in hand, booty shaking, bodyguard lurking.

February 14, 2014: Jessie and I met for drinks tonight. We've been trying to find time to hang out, but I got sick early in the week, and this was the only night I could meet up. I didn't expect her to say yes to Valentine's Day, but she did (Zak was out of town). We hung out drinking and eating for nearly two hours, having great conversations and lots of laughs. As we were leaving, she gave me a note that she had made for me. I was pleasantly surprised by this, and I didn't read it until I got home. I don't get easily sentimental about this stuff, but I was completely touched by her words.

DEAR Tim, HAPPY VDAY! I WAS THINKING LAST NIGHT ABOUT EVERYTHING WE'VE BEEN THROUGH AND HOW MUCH I LOVE YA AS MY FRIEND. EVEN WHEN WE DRIVE EACH OTHER CRAZY SOMETIMES IT'S ALSO NICE TO HAVE YOUR HONESTY - YOU ARE SOMEONE WHO CHALLENGES ME IN LIFE AND PUSHES ME FORWARD. YOU ARE AN IMPORTANT PART OF MY LIFE. HOPE YOU HAVE A WONDERFUL YEAR FILLED WITH LOVE AND JOY. XO JESSIE

During our night out, we had been joking about how remarkable it is that we're still so close after everything we've been through in the last year. It was at that moment that I realized that what makes Jessie and me so different as people is actually what makes this entire thing work. Though we have completely different styles, tempos, and energies, we work well together simply because we respect and love each other. We didn't work out romantically, but now we have this incredible connection and a creative partnership to boot, which has made all the ups and downs worth it. 40 Days of Dating was a once-in-a-lifetime opportunity. We went for it despite the huge risk to us both personally and professionally. We went for it because we wanted to learn more about ourselves and because we had each other as friends, first, and I believe we always will.

never settle or give up

Why did you decide to do this for forty days?

The old adage goes it takes forty days to change a bad habit. The number forty is auspicious in many cultures and religions. In the Old Testament, the Hebrew people lived in the Sinai Desert for forty years, and Moses received the Ten Commandments during a forty-day period in the desert. In the New Testament, Jesus spent forty days fasting in the desert, and in the Quran, Muhammad fasted in a cave for forty days. An Arabic proverb says, "To understand a people, you must live among them for forty days." And, of course, Josh Hartnett's character didn't masturbate or have sex (well, he almost made it) in that movie *40 Days and 40 Nights*.

What do you say to folks who believe you carried out the experiment and created the blog purely for notoriety and money?

People will believe what they want to believe. The fact is, we really had no idea what the outcome of our experiment would be, and we had no idea the blog would get so much attention. Our experiment took place back in March and April 2013. In the interest of keeping it as real and honest as possible, we did not create the site, make the artwork, or take any of the photography during those forty days. It was not until after the forty days were over, and we had a little time to reflect on it, that we both realized what a profound effect the experiment had had on our lives. It was at this point, in May, when we shared with each other for the first time a few entries from the journals we kept during the experiment and compared them side by side. It wasn't until then that we realized that other people might find our experience interesting or might even relate to it. After all, our experiences and stories are very common. Even then, we were nervous about releasing it to the world—it's more personal than anything either of us has ever shared, and we knew it was a risk to us both personally and professionally. We had no idea it would go viral. The level of attention and feedback we got came as a huge shock to us, we were completely unprepared for something like that. It kind of took over our lives for two months.

Was there ever any concern about being so forthright on the Internet?

Yes, absolutely. We knew that if we were going to launch a blog we had to do it with as much sincerity as possible, and we had to go the full distance. We went back and forth several times about whether or not it was a good idea. Releasing our story to the public was difficult, but also, in a way, very liberating and humbling.

Do you think that dating in New York City is different from dating in other American cities?

Yes, dating in New York is harder than in some other cities. Part of it is the numbers: There are just so many single women here, a lot more than men. While dating sites like Match and OkCupid are great, they have some downsides—many people end up falling into the trap of believing they have access to a neverending source of options through these sites, which creates a tendency for men and women to take it for granted when they do find someone special—or to just quickly move on to the next option, just a click away. Aside from that, in New York everyone is so busy and career focused that even if you do find someone great, it's often hard to develop a deeper relationship when you can barely squeeze them into your calendar. We tend overlook the opportunity of someone great because we're caught up.

Were you nervous that this experiment would ruin everything?

Yes! We were in a constant state of anxiety before we began the experiment. The biggest risk was hurting a great friendship. Would we destroy it, or would it survive? We didn't know. We just had to trust our gut and believe in ourselves and in this project.

You did the experiment a few months before it went online. How did the actual experiment compare with the experience of reliving it online and watching the world react?

We didn't read each other's posts until the night before they went live on the Internet, so in a way, it did feel as if we were reliving the forty days all over again. Going through each other's posts definitely brought up many of those emotions again. Many arguments and blurred lines followed the launch of the blog. Since we were revealing so many intimate details and secrets about ourselves, we started to feel certain pressures, expectations and accountability, especially after the website went viral.

What did your friends say about the experiment, or did you not tell them?

Surprisingly, some of our mutual friends weren't so keen on it. While we were on that Miami trip, we told the friends we were with that we were thinking about it. One of them started crying at the dinner table. They just didn't want us to ruin a great group dynamic. Fortunately, we didn't, but things were never the same again.

Do you think this experience is going to influence your future work as designers?

Yes. One of the main goals for both of us is to put ourselves into our work more and to connect with people through our work. We've received thousands of emails from people around the world telling us how our story has touched them. Some say it forced them to confront their own relationship issues. Others say it inspired them to reflect on themselves and has been a catalyst for positive change. Others say it has given them the courage to finally go to therapy. Others tell us how it has helped them better understand the male/female perspective. Others tell us it gave them the courage to finally date their best friends. This has all been incredibly inspiring to us, hearing the effect the blog has had on so many people. This project makes us want to do more work like this in the future.

How did you find the therapist you visited during the experiment?

We didn't want to go to someone who already knew us; we wanted this person to be objective. We got references to three therapists and picked Jocelyn. After Googling her, we saw that she was featured in *New York* magazine, so we said, "Why not?"

If you hadn't set an end date for the experiment, would you still be dating now?

Really difficult to know but probably not. We both feel we're better off as close friends.

Did you two hook up at all after the experiment ended?

No, we did not.

How has all of the media attention impacted you?

We're very happy that the story touched so many people but we definitely felt stressed at times. We were managing quite a lot in our daily lives posting the entries on the blog, responding to the media, and figuring out next steps in terms of the movie and book inquiries. This was all on top of balancing our full-time jobs and trying to maintain our own relationship with each other in the midst of all the craziness that was going on. It was difficult to manage all at once, but we're very humbled by it.

Was all the imagery on the blog created during the experiment, or after?

We kept various items during the experiment as mementos, but everything else (website, photos, illustrations, videos) were created in May and June—after the experiment, and before we launched the blog.

How much creative input will you both have in the development of the film? Are they allowed to take liberties with your story?

We signed with Creative Artists Agency soon after the website went viral, because there were so many studios and producers interested from the film, scripted TV, and unscripted TV worlds. It was our property at the time, so it was our decision who to sell the rights to. Ultimately, Warner Brothers offered us a great package. From there, we'll be consulting on the film. We'll also have the first stab at doing the movie titles.

Do you have any regrets?

Not at all. We never set expectations or tried to define what success might mean. It was an experiment, a study, a chance to get a glimpse into our dating habits and fears with help from each other. When else can you do that in life? Our main focus was to come out of it as more self-aware individuals, regardless of whether we fell in love or not. It was a once-in-a-lifetime opportunity that we decided to embrace together.

Essays on LOVE

and DATING/RELATIONSHIPS/HEARTACHE

We asked some friends to tell us their own tales of love and woe.
We gave them no direction—they had the freedom to interpret this request
in any way they wanted. Here's what they gave us.

ONE *is* AN AWESOME NUMBER
by LAURA MOSES

A guy I once dated described all single women as highly functioning sociopaths. Charming, right? This absurdity is reinforced by the strange smear campaign waged on the Single Woman that paints her as a tragic character. I used to be one of those girls who always had a boyfriend, but when I found myself single at twenty-eight and cramped inside my West Village studio apartment, I realized I'd never felt so completely free. I watched an entire season of *Mad Men* in one fell swoop because I didn't have to wait for anyone else to catch up. I flew to Ireland on a whim. I ate Pinkberry for dinner because it's the most delicious food on Earth so why not? Suddenly singledom wasn't tragic—it was empowering.

If you're single, you're in charge. You get to fill your calendar with drinks/art openings/game nights, and you better enjoy it because someday your significant other will have drinks/art openings/game nights, and you're going to have to go along. In this seemingly selfish phase you're actually doing something worthwhile—getting to know yourself without the influence of someone else's perspective. When people in bad relationships say, "I don't want to be single again," like it's a death sentence they need to have some sense (lovingly) shaken into them. They'd rather share their time, memories, and bed with someone only because subpar companionship is better than being stuck with their shitty selves? Hint: It's not

Learning how to be alone forced me to learn what I want (and what I don't want) in a partner. And when you're single you're not really alone; you're hanging out with the one person you'll be stuck with forever and ever—YOU—so you might as well make nice. And along the way, you're likely to pick up one skill that every single woman should have: being able to spot the actual sociopaths out there. Now go out and have some fun. Or stay home! It's your choice.

CONTAINER of GOOD
by PAULA CHU

I had what I thought was a very good marriage. We were very compatible, made each other laugh, rarely argued and parented together well. He was my very best friend and I was his. When I found that I was deeply drawn to Laura, I told my husband immediately that I was falling in love with a woman, that I felt scared, and that I needed to talk about it. And we just couldn't. He couldn't comfort me, couldn't hear anything other than threat and betrayal. I was more shocked by the brittleness of our connection than by the resulting divorce.

Now, having been with Laura for over twenty years (we married once in the nineties and once again after it became legal), I know much more about how to talk about the hard things—how to talk about them all the way through. Real conversation is difficult because you don't know where it is going, and you have to listen deeply, speak deeply. You are discovering your

truths together, and you are totally off script, trailblazing as you go. Laura and I don't stop until we are done. Really DONE. "Do you feel done?" "Mmm...not quite." "Okay let's keep going." We keep going until the connection is totally clean again. Once or twice it has taken all day.

The connection between two people in a good marriage is strong enough to bear your whole weight, to bear both people's whole weight. You can say, "I'm feeling disconnected," and the relationship is well-maintained enough so that the other person can drop everything and say, "Oh, no! Let's talk about it. Tell me more. Tell me more." And you tell them and they listen.

You gain a tremendous amount of freedom knowing that your partner is a champion for your inner growth and well-being. My mom always told me that marriage doesn't imprison you, it gives you freedom, and this is absolutely true. In a good marriage, you can share all the difficult thoughts and feelings that come with being human. When inner struggles are shared in the space between two people who love and trust and respect each other, the burden lifts and the darkness fades.

It's essential to be able to repair the inevitable nicks and tears in the connection within a marriage, and it helps to delight in each other's company. But over the years, these things are sustainable only when you know the other person is actively safeguarding your growth and well-being. As Augusten Burroughs wrote about his own marriage: "Even when we fight, it is in a Container of Good." In a good marriage, both people trust that they are held by a Container of Good. That way, they can safely talk things all the way through.

MAYBE? YES! NOT REALLY...
by ZIPENG ZHU

I am twenty-three years old and have never ever been in a relationship. I grew up watching Disney cartoons, which are full of princesses and princes having happy-ever-afters. Along the way, I also watched all the chick flicks and read a lot of romance novels. These were my only guides to love, and they made me want exactly what I saw on the screen and page, which, I guess, pretty much gives me the love maturity level of a nine-year-old.

I grew up in China, in a conservative environment, where I never had a chance to explore my sexuality. When I came to New York, one of the gayest cities in the world, I finally got to embrace myself. Now, as I walk along Twenty-Third Street, I feel like Carrie Bradshaw from Sex and the City (the HBO show and the first movie, not the second one), and I feel like I am ready to take over the world. But at the same time, because of my lack of experience, I feel like Alice, right after she fell down the rabbit hole on her way to Wonderland.

One day on my way to my usual waiting spot on the subway platform, I saw him: pale face, round glasses, dark and super-curly hair. I could tell he had a lean figure underneath a thick charcoal-gray jacket and a beige backpack. He was standing in front of a poster, looking a bit serious, but definitely smart and handsome.

Just as I was thinking "how cute," he saw me. But, like every single time I make eye contact with a handsome man, I became super shy and immediately turned away. But

of course, in my head were flashing images of our whole future lives together, and all the cute things we would do happily ever after.

I glanced at him again and thought, "OH MY GOD, he's still looking at me, with a slight smile on his face!" I looked away again. My heart was racing. My face felt like it was getting hotter. I really hoped he was looking at me, and not at a hot, tall, skinny model behind me, and this thought left me no choice but to look at him again, just to check. I pretended to look around the subway station, while trying to see if his focus was still on me, and—YES! He was still staring at me with that little witty smile. I could not have felt more excited and shy and happy and scared, but then I realized he was walking toward me.

At that moment I froze. I felt like twenty million fireworks had exploded inside me, from head to toe. Every neuron was numb. Inside I was screaming, "THANK GOD! Finally someone sees how much I need a man in my life. This is the most romantic thing ever to happen on the planet! I have been waiting twenty-three years for this moment! Then I thought, "What is he gonna say to me? How am I gonna respond? How do I look?" And a million other anxious thoughts flew into my head, all while he was moving closer and closer to me.

Then he was in front of me. He leaned in toward me.

Just at the moment I thought he was going to kiss me. Just at the moment I was about to close my eyes and let him. Just at the moment I thought, this is the best winter ever. Just at the moment I thought happily ever after really does exist . . .

He said, "Sir, I think your zipper is open."

FIRST SIGHT LOVE
by STEFAN SAGMEISTER

I have never believed in love at first sight. I got to be fifty years old and it had never happened to me. I considered stories about it fodder for fourteen-year-olds and romantic comedies.

Then a woman stopped by at my place to set up an interview for a German art magazine, and swoosh, swoosh, half an hour into the meeting I had to hold back the urge to ask her if she wanted to be my girlfriend.

I did ask her the next day. She said yes.

Two weeks later I asked her to marry me. She said yes!

This was almost two years ago. How much would I love to tell you that we got married in Bali, that she is pregnant now, and that we both can't wait for the little girl to emerge, but this is not how it turned out: We broke up.

Love at first sight sadly has little to do with being able to make a relationship work. We were fantastic at falling for each other, but not so talented at being together.

DATE UP, MARRY DOWN
by LORENE SCAFARIA

I recently had dinner with a group of friends, some couples, some singles, and like most dinners I go to, it ended with me driving home thinking of everything I wish I hadn't said. Highest on the list was when I defended my theory,

or should I say tweet, that advised women to "DATE UP, MARRY DOWN" which caused one guy, the guy I thought maybe had a crush on me, to call me a "failed romantic." Okay, let me explain: It is a much more terrifying thought for a guy to look at a girl and think, "This is going to be the last person I have sex with." Of course women are also afraid of this, but it is inherently, sadly, biologically, more of a wrestling match for men when deciding whether or not to commit to one person. It is also (99.9 percent of the time) on the man to propose marriage, so it takes a lot for them to look at a woman and think that it is scarier to live without her than for her to be his last sexual partner. Therefore, most of the time, the man has to feel like he couldn't do any better.

Does this sound incredibly cynical at a dinner party? Yes. Did the recently engaged couple at the party want to hang out again? No. Does it make me feel good thinking that my ex-boyfriends' wives are settling for them? A little bit, yeah. Am I a thirty-five-year-old unmarried, childless failed romantic doomed to bitter-dom? Gosh, I hope not.

In truth, I know a lot of lovely couples in healthy, balanced relationships. I don't like thinking about the differences between men and women. I don't like that men seem comfortable with women thinking they're stupid. I don't like that women seem comfortable with men thinking they're crazy. I worry that women are too competitive with each other, too critical of each other. I worry that men are all letting each other off the hook. I worry that women lost the battle of the sexes a long time ago, and that we'll never win the war on "caring less."

When I first looked at Tim and Jessica's blog, I was

nervous. But what unfolded was actually a beautiful tale of how different men and women are, of how we should embrace the differences, and try to appreciate both sides of the story. It showed how sometimes we can be quite similar, but express ourselves so differently, and sometimes we don't express ourselves enough, or honestly. I may be wrong about my "marrying down" theory. I want to be. I want to believe that we're more similar than we think. What I do know to be true of men and women is this: Men can't think until they have sex. Women can't think after they've had sex. And maybe that's the way it's supposed to be, or we'd never get anything done.

MY FAIR LADY
by BRIAN COLLINS

First, it was her eyes. I stared at her. She smiled back. Her two gloved hands held a pink parasol aloft. Behind her parades of people were dancing and singing. Beside her, a middle-aged man appeared, wearing a tweed hat, cocked at an angle. He smiled at me, too. I smiled back. Both of them were painted on a big movie poster in the window at the Lexington Cinema, my town's tiny movie house. Surrounding the poster were small color photographs of scenes from a film: A British racecourse. An elegant ball. Waltzes. Evening gowns. London at night. The movie house played vintage and second-run films. I saw *Lawrence of Arabia*, *Doctor Zhivago*, and my first James Bond movie there.

I was about to turn twelve. My father, eager to plan my birthday, had just asked me what I wanted to do that year. He had already taken my friends to the circus, the Larz Andersen Auto Museum, the Boston Museum of Science, and, most recently, horseback riding.

"Everyone seemed to like that a lot," my father said over breakfast. "Want to do it again?"

"I had a different idea, Dad."

"What? Better than horses?"

"Uh, maybe. What if we went to a movie, instead?"

He paused. "A...movie?"

"Yeah. There's one playing in the center I really want to see. *My Fair Lady.*"

"*My Fair Lady*? Really? You want to take your friends to... *My Fair Lady*? For your birthday?"

"Yes, I do."

So we went.

For two and a half hours, seven other boys and I were transfixed as we watched the story of Eliza Doolittle unfold in Panavision. First, as a poor flower girl. And later, as a princess. When she spoke, she suddenly was a princess. The heartbreaking part was that Eliza Doolittle had no idea how beautiful she was. But I knew. And I knew what she deserved. It was easy: A lovely dinner. A night of dancing. A goodnight kiss. Flowers sent to her the following afternoon. Poor, suave middle-aged Professor Higgins clearly did not understand this. And he never would. But at twelve, I knew.

WORST DATES

Some of the most entertaining stories we've heard have been about people's trials and tribulations in their dating lives. Here are a few experiences from friends who knew pretty quickly they had not found that special someone.

JOHN FULBROOK

One day I met this girl at the school commons. She was smart and hot, and I somehow convinced her to go on a date with me. But on the day of the date she called to say she was sick and couldn't go out. So, thinking fast, I offered to bring her soup, attention, and humor while she lay in bed sick. In my mind, I was skipping the "date" and going straight to the bedroom. She took the bait. Sweet! I showed up with the soup, and sat on her bed. She was in her PJ's, and I was drooling. We flirted. Then she asked me, "Do you smoke pot?" I most certainly did, but I said, "Not that much, only sometimes." I tried to play it like I was an upstanding citizen. Then she leaned in close and whispered, "You know what would be fun? Smoking up and really getting to know one another." I thought, "Wow! Is this really happening?" I jumped up and said, "Let's do it! I have some pot in my room!" She then sat straight up, pulled away from me, and said, "I was just seeing how into pot you are, and now I know." OUCH! It was a test! I failed hard-core. In minutes it was ice cold in her room, and I left sheepishly, knowing I would never see her again.

TIM

I once went out with a girl who turned out to be an absolute bore. We were at a place I love in the West Village called Little Branch. Perhaps my breath smelled that night, or maybe hers did, I don't know—all I know is, she wouldn't talk. Totally exasperated, I searched for any topic to discuss: work, family, friends, movies, books, music, politics, food, clothes, technology, religion, horoscopes, zoo animals, aliens, melted plastic—you name it. I got through it, but I wanted to die. Later, a friend of mine had an idea: I should have pulled out a gun and shot myself at the dinner table—that would've given her something to talk about at her next date!

JESSIE

The worst date I've ever had was at Freemans on the Lower East Side. The food is amazing, but they don't take reservations so there is always a one- to two-hour wait. By the time we sat down to eat, I had received detailed accounts of every past relationship he'd ever had. He spent dinner talking about how amazing and successful he was, how lucky I'd be to date him, and what an amazing boyfriend he'd be to me. He barely let me get one word in during the whole dinner. He ordered an enormous amount of food, but I had only one appetizer because my stomach was in knots. When it came time to pay, he fumbled around in his pockets— he had forgotten his wallet! I had to pay the $250 tab.

ANNA OSERAN

At one of my first college parties, I met a guy named Alex and became immediately smitten. We started hanging out, and after about three months, I felt it was time to have the DTR (Define the Relationship) talk. One night, after countless beers at a frat party, we stumbled back to his house where he lived with a bunch of roommates. I told him we needed to talk about "us." He replied, "Okay, sure. Just give me a second. I'll meet you in my room." I lay down on his bed and went through the bullet points of our upcoming talk in my head. When he came in, he flopped down on the bed, held me close, and whispered, "I just took an Ambien. You have five minutes." Suffice it to say, I never spent another night in that shitty house again.

NAME WITHHELD

I had been dating this guy for a short while. He had his pilot's license, so one day he picked me up in Tampa, Florida, in a four-seater plane and flew us down to Key West for the day. During the flight back to Tampa, he told me he had to go to the bathroom really bad and that we were going to make a pit stop in Naples. Um, okay. A little while later, before we got to Naples, he told me he wasn't going to make it. I thought, "Okaaaay...how the heck is this gonna work?" Then he asked me to hand him the vomit bag, which I did. Then he told me he had to go No. 2. Ohmigod. I dug around for the flight map, unfolded it, and held it up between us in this tiny plane no larger than a compact car to give him (and me!) some privacy. He put the plane on auto-pilot and did his business. He kept the bag full of... on his side. We finally arrived in Tampa and said our good-byes. I never saw him again.

MAAYAN PEARL

I went on a date with this guy I met online who seemed interesting and well traveled but who turned out to be a compulsive liar and a sleaze. We went for drinks at Brooklyn Social, one of my favorite bars in Carroll Gardens. He arrived twenty-five minutes late and glued to his BlackBerry. Terrible first impression. The conversation was strained but it might have gone better if he hadn't kept answering his phone for "work." He claimed to work for the Department of Homeland Security and was supposedly orchestrating some kind of drug bust. This was an impressive first-date story line. I found out later that the entire time he was getting "work" calls it was some girl calling him. Fail!

RACHEL SHECHTMAN

I went out with a guy who liked to hear himself talk so much that I started counting how many words I could get in edgewise. He was handsome and nice, so in the beginning I had hopes it would be a good night, but after I asked him a few questions, he just kept talking. He just kept going and going and going— he made the energizer bunny seem slow! To entertain myself, I turned it into a game to see how many words he would allow me to say. If memory serves, it was around fifty words. I should have turned it into a drinking game!

Love

travel

cuddling

N
Y
C

making

pooping

things

DE
S
IG
N

COF
FEE

WINE

AVDCDO
ADS

JESSICA'S
TOP 5

CLOTHING DESIGNERS
Helmut Lang
Alexander Wang
Rag & Bone
Alexander McQueen
Acne Studios

ARTISTS
Maurizio Cattelan
Jenny Holzer
Salvador Dali
Urs Fischer
James Turrell

MUSIC ARTISTS
Bon Iver
Vampire Weekend
The National
James Blake
Beirut

CITIES
New York City
Berlin
Paris
Los Angeles
Istanbul

BOOKS
Just Kids by Patti Smith, *The Little Prince*
by Antoine de Saint-Exupéry,
On Love by Alain de Botton, *Lolita*
by Vladimir Vladimirovich
Nabokov, *Through the Looking Glass*
by Lewis Carroll

TV SHOWS
House of Cards
Breaking Bad
Game of Thrones
Homeland
Dexter

MOVIES
Princess Bride
Fight Club
Requiem for a Dream
Amélie
The Matrix

FOOD
Motorino Brussels Sprout Pizza
Milk Bar Birthday Cake Balls
Bozu's Sushi Bomb
Brooklyn Star Mac & Cheese
Cookshop Bloody Mary

TIMOTHY'S TOP 5

ARTISTS
Red Grooms
William Kentridge
Paul Klee
Greg Ligon
Jim Dine

BOOKS
The Autobiography of Malcolm X by Alex Haley, *The Fountainhead* by Ayn Rand, *In Search of the Miraculous* by P.D. Ouspensky, *A Hero with a Thousand Faces* by Joseph Campbell, *Nothing If Not Critical* by Robert Hughes

MUSIC ARTISTS
Bob Dylan
2Pac
Led Zeppelin
Miles Davis
TV on the Radio

FOOD
Peanut Butter
Cheese
Broccoli
Bacon
Blueberries

COMEDY

STAND-UP COMEDIANS
Chris Rock
Dave Chappelle
George Carlin
Louis CK
Robin Williams

MOVIES
Ferris Bueller's Day Off, Manhattan, Roman Holiday, The Royal Tenenbaums, Hoop Dreams

BASKETBALL PLAYERS
Carmelo Anthony
Mark Price
Dominique Wilkens
Tim Hardaway
Reggie Miller

TV SHOWS
Felicity
Sopranos
Daily Show with Jon Stewart
Cosby Show
Seinfeld

#loveis_____

sone_oppa designed by the devil to make you lose focus on what's important.

Cristina Arce Sm and not even kn

Julia Amann Love is a disease with all kinds of beautiful and bad side effects and no chance of healing

Monica N. Samuel Love is like fire; it burns but still keeps you warm about an hour ago

Heissel Carvajal So So needed yet so h but when found...H

flickster Love is holding your child for the first time

Garland Marie Watkins caring for someone's happiness and well-being over your own.

lesliemambriz Unconditional

And_Agency: Love is to evol_ve forwards

Kenneth B. Rodebert Love is always a risk. What if it does not work out? Ah, but what if it does.

dom_isdabest Love is pain in every imaginable way

Monica Leigh Stebbing Precious and all around us

xnonHipsterfrede an illusion

Patryk Klos visit in another dimension without gravity

emilyzirimis Love is hones

Cortnie LaBaire Tango when your differences make no difference

lisaschneller Love is life itself. Without it we would not be human.

Najmi Rosdi...intangible

sassci Love is v in happiness a give come in hu

kmtabish Blind... :)

Eduardo Gonzalez The reason why you wake up every day

Flávio Miguel Dos Santos waking up in the night, hugging her so tight and falling a sleep again

Jerry Tamburro Is never selfish

Avinash Jai Singh a mirage

MolliRossDesign L how I like my coffee

Seet Chareli a good snack of cup noodles at 3am.

AMNoe Coffee never about possession. But appreciation.

**Mon you expe

TylerDeeb not accomplished in 40 days.

larational liking all of the same tv shows as someone else

Monica N. Samuel Love is like fire; it burns but still keeps you warm

Matt Priest A 5 year old boy once told me that love is when you hold someone's hand and you never want to let it go.

TaraVictoriaL so cool! "Love is an adventure!"

Gayatri Makhijani Patience.

Drew_Lowther Love is a killer.

_sarisabel beautiful

Kristen Echevarria The best drug in the world.

stephaynee Love is free. fierce unconditional. commitment. active. dynamic. helping another person be better and letting them make you better.

kiminthir your food second th

brittmeyer9 Love is madness and sublimity; two mirrors facing each other, catching a glimpse of infinity.

Elsa Laino a burning thing

Denisse Villa Complete vulnerability

Kate Trotter The pain in your chest and the butterflies in your stomach.

Laura Taylor Love is how I feel about Jessica, but not how I feel about Tim #ladybias

Mihir Deo sex without the guilt after finishing

Tara Seprita Supono motivation to be the best version of ourselves

Rachella Dubbeldam Ending up black and bruised after an amazing pillow fight.

Tom Cavill doing someone's toast just the way they want it

ember_2 Love is Patience and Compron

ratsimihah Love is a b*tch.

Yoko Ono Love is the force of life. It keeps us alive, spread it and heal.

eggsnraam a motherfucker.

mirandamarie292 Love is hard.

Alex Peterson A decision. 40 years down the road when things are harder, it may still be a feeling for some, but to others it's a decision to keep going.

g all the time, g why.

Goutami Kkota a priced commodity... for which there is demand, but which is supplied without qualitative differentiation across a market.

jra3086 Worth it

hakepn7 both simple and complicated.

mon yet so rare. given. So hard to find nto it.

holameri Not having to explain your favorite ice cream flavors are raspberry and cinnamon, and that they do go well together

HughLangis Love is a burrito

lesliehill1 love is a choice.

Lucy Bonner hugging your dog when you first get home from work

Cindy Liang Warming up the car for them before they go to work in the morning

ManeeshSidhu @jessicawalsh daring to be vulnerable.

JCA914 Love is when I can order your coffee, dinner, or drink for you because I already know.

Ian Wells Effortless when right, charity work when tried, and hard labor when forced.

RySwiers Love is a warm blanket

n your faith our desire to an form.

John Morgan Love is a blank canvas that we should paint on

Hoodad Moslemi Nejad Love is a complicated mystery

andrehyna Love is the one thing we look for in life, whether we admit it or not.

KerrySmith92 life's greatest mystery

RyanWakeUp Love is finding someone just as weird as yourself.

LoveShackable Love is life.

lolthai Love is 2/3 the greatest joy you'll ever know and 1/3 the worst pain of your life.

melissanurre "Love is the closest thing we have to magic."

him knowing

Fam Armanious Giving o another person and not g anything in return.

walkwithwah is like a long marathon. You never know how it ends though you might have given it your all

chelpants love is my husband.

Timothy Stroh Love is like sampling a teaspoon of a tablespoon of the finest chocolate syrup running down the stem of a cactus all the while getting poked by its myriad of spines. If you are lucky enough to lick up a little sweet and come away smiling, one might know if the search for love was actually worth it.

bellsq Love is not about happy endings. Love is keep going forward with happiness.

Gerard Lopez Love is a blank canvas that we should paint in

Stephtacular22 Love is being unselfish. Their happiness is the only thing that matters to you. Even if it means letting go.

lisaschneller Love is life itself. Without it we would not be human.

Mari Zuñiga waking up at 5 am because our countries have a 15 hour difference

Sharing thout having ghts.

alibops87 bloody marvelous (and occasionally devastating) hopefully the former more often

Agustin Contreras Love is giving someone everything they want, no matter how much it destroys.

Jexpo1976 Love is a term used by many to describe the things they like. Real love is complicated.

philenetanlove is when the other person's happiness is more important than your own

Hallo_Kai a never ending compromise. tricky.

SimonCheadle evol backwards

YuhinaL Love is finding a common honesty in the grey areas

Nili Askari Love is accepting someone for who they are and not trying to change them, flaws and all!

Alyssa Ramirez love is unselfish

João Abreu Love is—a fire that burns without being seen...

NateDaubert dangerous

andsherants Love is coffee.

DATING MAP

The map shows some of our date spots from the experiment. We've also included many of our favorite spots in New York.

1. The Fat Radish: 17 Orchard Street, NYC 10002

▸ We had our first date here. Excellent food and cocktails on the Lower East Side/Chinatown border.

2. Lucille Lortel Theatre: 121 Christopher Street, NYC 10014

▸ We went to the play *Really Really* here on Day Three.

3. Ace Hotel: 20 West 29th Street, NYC 10001

▸ One of our usual hangouts. On Day Six of the experiment we went for drinks with mutual friends.

4. Madison Square Garden: 4 Pennsylvania Plaza, NYC 10001

▸ We went to a Knicks game here on Day Ten. Tim's favorite.

5. Aire Ancient Baths: 88 Franklin Street, NYC 10013

▸ Steam rooms and thermal baths in Tribeca. One of Jessie's favorite spots. We went here on Day Thirteen.

6. The Grey Dog: 242 West 16th Street, NYC 10011

▸ We went here for breakfast on Day Fourteen. A nice local coffee spot for lunch and dinner dates.

7. Mandarin Oriental MOBar: 80 Columbus Circle, NYC 10023

▸ A cocktail bar near Columbus Circle with beautiful city views. The Mandarin Oriental Spa is also a favorite spot.

8. City Bakery: 3 West 18th Street, NYC 10011

▸ One of our usual breakfast and coffee hangouts. This place has the best pretzel croissants, and their hot chocolate is to die for.

9. Trailer Park Lounge: 271 West 23rd Street, NYC 10011

▸ A fun, kitschy place decorated like a trailer park. It's a regular local spot near Jessie's office for Tater Tots and margaritas.

10. Middle Branch: 154 East 33rd Street, NYC 10016

▸ Cozy jazz-infused speakeasy lounge with great cocktails and bar snacks. It's a slightly hidden spot on Third Avenue near Tim's apartment. We went here on Day Twenty-Four right before the jazz show.

11. Jazz Standard: 116 East 27th Street, NYC 10016

▸ One of Tim's favorite jazz clubs. We went to it on Day Twenty-Four.

12. Ports Coffee & Tea Co.: 251 West 23rd Street, NYC 10011

▸ Cozy espresso and tea bar across from Jessie's office on 23rd Street. A regular spot where we meet up.

13. The Smile: 26 Bond Street, NYC 10012

▸ A great dinner spot in NoHo that we both love.

14. Pure Food and Wine 54 Irving Place, NYC 10003

▸ One of Jessie's favorite date spots. Romantic backyard patio and an all-raw-food cuisine.

15. Chelsea Piers: 62 Chelsea Piers, NYC 10011

▸ On Day Thirty Three we attempted to hold hands for the entire day. We went bowling and played pool.

16. Bluebell Café: 203 Third Avenue, NYC 10010

A usual hangout spot for wine after we teach design classes at the SVA in NYC.

17. Whole Foods: 4 Union Square South, NYC 10003

▸ Tim has a history of meeting women here.

THANK YOU

We can't thank those who made this book possible without first thanking everyone who helped us carry out the experiment and the website.

Our eternal gratefulness goes to all eighty of the illustrators who helped bring the website to life. A huge thank you to Eric Jacobsen for his tireless work building a magnificent site (and for putting up with our design snobbery).

ERIC JACOBSEN ↙

Our deepest gratitude goes to Santiago Carrasquilla and Joe Hollier for shooting and editing lovely videos.

↑ **SANTIAGO & JOE**

We're grateful to Deborah Aaronson, Andrea Danese, Anna Oseran, Emily Albarillo, True Sims, Danny Maloney, and the entire Abrams family for publishing our book.

Thank you to the always precise Kevin Brainard, Jason Nuttall, and Raul Aguila for designing one hell of a book.

KEVIN BRAINARD ↑

Also to Esther Li, Jordan Shevell, and Rikke Elverdam for all their help. We're additionally thankful to Bo (RL Fahs) for catching our grammar and spelling mistakes along the way. Huge thanks to our therapist during the experiment, Jocelyn Charnas, for taking on a couple of crazies like us and for contributing to this book.

We're very thankful to all the wonderful people we met along this journey, who showed interest in our project, and who gave us great advice, including: Ray Javdan, Nancy Schuster, Sarah Schechter, Joy Gorman, Lorene Scafaria, Michael Sugar, Michael Suscy, Michael Costigan, Kristen Bell, Scott Stuber,

LORENE SCAFARIA ↑

Sophie Mas, Brian Grazer, Julia Brownell, Zooey Deschanel, Josh Schwartz, Reese Witherspoon, and Bruna Papandrea, as well as Cait Hoyt, Michelle Weiner, Matt Rosen, and Ryan Ly of CAA.

A huge thank you to our extremely talented and lovely friends who contributed stories: Erik Marinovich, Brian Collins, Laura Moses, Stefan Sagmeister, Julia Hoffmann, Esteban Apraez, Nicole Jacek, Noreen Morioka, Laura Danforth, Paula Chu, Lorene Scafaria, Zipeng Zhu, Rachel Shechtman, John Fulbrook, and Maayan Pearl. We're honored to have you in our book.

DON MOORCROFT ↙

Our hearts go out to all the fans who followed us and connected to our story, who reached out to us via email or through social networks, and who were inspired by our story to tackle their own fears and habits in relationships.

Also, a quick shout-out to Don and Cecilia Moorcroft for sharing their story with us—we were driven to tears. Finally, thanks to the many media outlets around the world that covered and shared our story.

FROM TIM

I am forever grateful to my mom for always supporting me without judgment; to my wonderful grandparents for their constant inspiration; to Dave Suster for always being the father-figure; to my brothers, Zachary and Jeremy Goodman; to my "brother from another mother,"

Dave Suster

Aaron Taylor; and to an amazing group of family, friends, and mentors—you know who you are.

Aaron Taylor

Also, thank you to all the art teachers I had at Cuyahoga Community College and at the School of Visual Arts—your encouragement inspired me more than you know. I am additionally thankful to Sarah Walsh, for managing our email inbox (we literally would have died without you), and to Joe Walsh, for lending his suport and time when we were trying to make important business decisions. My sincere appreciation to Stefan Sagmeister for all his support of our project.

Lastly, my deepest gratitude goes to my friend and coconspirator, Jessie. What an insane journey we've been on; I'm truly honored to have you in my life.

FROM JESSIE

First of all, a huge thank you to my family. Mom and Dad, thank you for your constant love and support of this (and every) endeavor. Mom, I love you with all my liver! Thanks for helping us manage our email inbox and press. Dad, thanks for your business advice and our AIM conversations. Lauren, thank you for always being a source of joy and humor; your free spirit and confidence are always an inspiration. Thank you, Zak, for all your love,

Mom, Dad, Laur

support, and patience as you endured the publicity around this crazy project.

Stefan Sagmeister, I am eternally grateful for your support and contribution to the project. Watching you take risks in your own work and *The Happy Film* gave us the courage and inspiration we needed to launch our story in public.

Stefan Sagmeister

Finally, thank you, Tim, for your honesty, support, and friendship. This was one of the craziest journeys I've ever been on—I couldn't have done it with anyone else.

KEETRA DEAN DIXON
fromkeetra.com

ROANNE ADAMS
roandcostudio.com

JOHN FULBROOK III
johnfulbrook.com

RICH TU
richtu.com

DEBBIE MILLMAN
debbiemillman.com

SABINE DOWEK
sabinedowek.com

ANDREI ROBU
robu.co

MICHAEL FREIMUTH
michaelfreimuth.com

JOHN PASSAFIUME
johnpassafiume.com

JON CONTINO
joncontino.com

KATE BINGAMAN-BURT
katebingamanburt.com

JANINE REWELL
janinerewell.com

MATT LUCKHURST
mattluckhurst.com

MATT DORFMAN
metalmother.com

JOON MO KANG
joonmo.com

ANISA SUTHAYALAI
bydefault.org

DAREN NEWMAN
meandmypen.com

SAM POTTS
sampottsinc.com

PAULA SCHER
pentagram.com

EIKE KÖNIG/HORT
hort.org.uk

HENRY HARGREAVES
henryhargreaves.com

ALICE CHO
alicecho.net

LUDVIG BRUNEAU
bureaubruneau.com

SHARON HWANG
mycookingdiary.com

CLAUDIA DE ALMEIDA
claudiadealmeida.com

VERENA MICHELITSCH
cargocollective.com/
verenamichelitsch

DARREN BOOTH
darrenbooth.com

RANDY HUNT
randyjhunt.com

LELAND MASCHMEYER
leemaschmeyer.com

JULIA ROTHMAN
juliarothman.com

M. ALCOCK & R. MASON
marcalcock.co.uk

JON NEWMAN
daydreamsandnight
schemes.com

STEFAN SAGMEISTER
sagmeisterwalsh.com

KATE MOROSS
katemoross.com

WILLIAM MORRISEY
wmwmw.com

ELLEN FLAHERTY
ellenflaherty.com

RYAN ESSMAKER
ryan.is

JOE SHOULDICE
joeshouldice.com

OLIMPIA ZAGNOLI
olimpiazagnoli.com

KIM BOST
kimbost.com